The American world is full of beautiful things and the men who think it no shame to take their own from the past and present, for the delight of their own people, are largely assembled in the Academy and in its mother society, the National Institute. That fact alone is an achievement of enormous import: we exist as an element of national life.

— W ILLIAM M ILLIGAN S LOANE
President of the American Academy of Arts and Letters
February 22, 1923

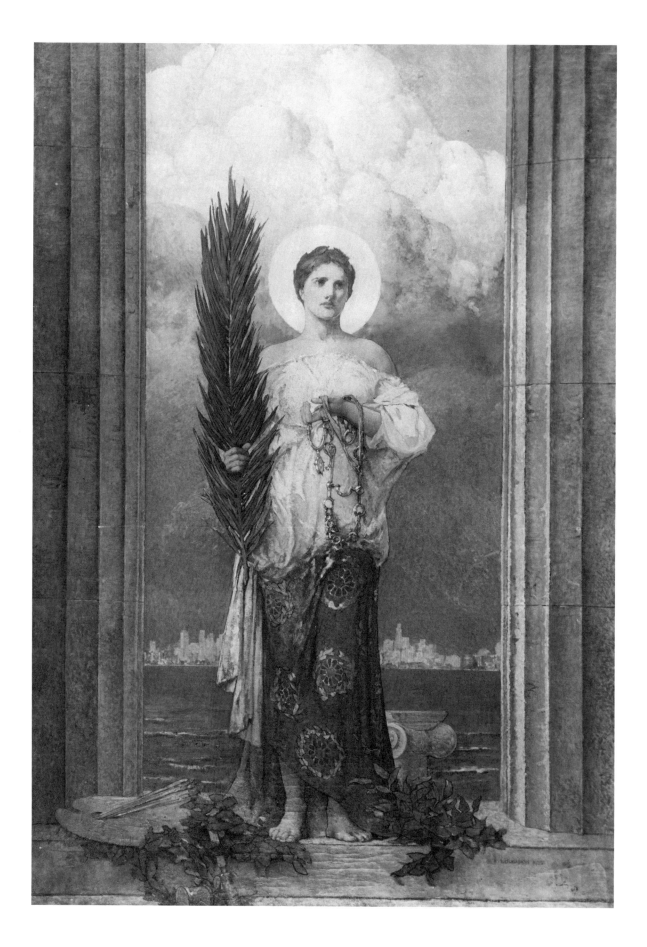

PORTRAITS
FROM THE
AMERICAN ACADEMY
AND INSTITUTE
OF ARTS AND LETTERS

BY

LILLIAN B. MILLER

AND

NANCY A. JOHNSON

WITH AN INTRODUCTION

BY

JAMES THOMAS FLEXNER

NPG
TWENTY-FIFTH
ANNIVERSARY
1962-1987

PUBLISHED BY THE

NATIONAL PORTRAIT GALLERY
SMITHSONIAN INSTITUTION

WASHINGTON CITY

1987

This catalogue has been made possible by a generous grant from the
American Academy and Institute of Arts and Letters with additional
support from The Clarence and Jack Himmel Foundation.

AMERICAN ACADEMY AND INSTITUTE OF ARTS AND LETTERS

MARGARET M. MILLS
EXECUTIVE DIRECTOR

NANCY A. JOHNSON
ARCHIVIST/LIBRARIAN

LARRY LANDON
ART PROGRAMS COORDINATOR

NATIONAL PORTRAIT GALLERY

ALAN FERN
DIRECTOR

BEVERLY J. COX
CURATOR OF EXHIBITIONS

SUZANNE C. JENKINS
REGISTRAR

NELLO MARCONI
CHIEF, DESIGN AND PRODUCTION

FRANCES STEVENSON WEIN
PUBLICATIONS OFFICER

EXHIBITION ITINERARY

NATIONAL PORTRAIT GALLERY
WASHINGTON, D.C.
MAY 29 TO SEPTEMBER 20, 1987

AMERICAN ACADEMY AND INSTITUTE OF ARTS AND LETTERS
NEW YORK CITY
NOVEMBER 5 TO DECEMBER 13, 1987

Cover Illustration
William Merritt Chase 1849-1916
Institute, 1898; Academy, 1908
By Augustus Saint-Gaudens 1849-1907
Institute, 1898; Academy, 1904
Bronze bas-relief, 74.9 x 55.9 x 5.2 cm. (29½ x 22 x 2 1/16 in.), 1888
Collection of the American Academy and Institute of Arts and Letters;
gift of Mrs. William Merritt Chase, 1918
[Catalogue number 5]

Frontispiece
Academia by Edwin H. Blashfield
Oil on canvas, 366 x 218.4 cm. (144 x 86 in.), 1925
Collection of the American Academy and Institute of Arts and Letters

CONTENTS

ACKNOWLEDGMENTS

Audubon Terrace, flanked on one side by the Administration Building of the American Academy and Institute of Arts and Letters, the Numismatic Society, the Museum of the American Indian, and the Hispanic Museum, and, on the other, by the Exhibition Hall of the Academy-Institute, has for a long time held a very special place in my memories: its courtyard provided a sunny area in which to wheel my baby carriages, and its exhibition halls, together with those of its sister institutions, became a source of comfort and encouragement during the difficult years of attempting to juggle the careers of mother and scholar. Therefore, it was with a certain amount of excitement that I returned to that wonderful Renaissance building in 1985 and invaded its library and archives, its contents now pertinent to those scholarly interests fostered so long ago. It was with even greater excitement that I emerged from those archives and storage rooms, for here I found a treasure of materials relating to all the great names in the history of American art, music, and letters, from the Gilded Age to the present. To Margaret Mills, director of the Academy-Institute, and to Nancy Johnson, librarian, I am most grateful, first for making the archives so freely available and my work in them so pleasant; and second, for sharing my enthusiasm for an exhibition in Washington, D.C., of a few of the institution's treasures so that the general public would become acquainted with its important collection. I am also very grateful to Alan Fern, director of the National Portrait Gallery, for re-sponding so immediately to the idea. Carolyn Carr, assistant director of the Portrait Gallery, and Beverly Cox, curator of exhibitions, were also instrumental in bringing these portraits to the Gallery for exhibition and in helping to plan the catalogue that accompanies it.

As in all these kinds of enterprises, many individuals participate, and I am happy to acknowledge their much appreciated assistance. James Thomas Flexner encouraged our plans and graciously contributed an Introduction as a present member of the Academy-Institute. Susan Hobbs of the National Museum of American Art shared with us information concerning Abbott Thayer and Henry James. Marion-Clare Kahn, assistant librarian at the Academy-Institute, helped in organizing the Academy's archives, making work in it easy and rewarding. At the National Portrait Gallery, Frances Stevenson Wein, publications officer, Dru Dowdy, assistant editor, Josette Cole, assistant registrar, and Nello Marconi, chief of design and production, were all of immeasurable help in producing the catalogue and the exhibition. We especially appreciate the services of Rose S. Emerick of the Peale Family Papers staff, who contributed useful editorial suggestions along with a superlative typing job. To our colleagues, friends, and families, who suffered our enthusiasm and concerns through the months of preparation of this exhibition and catalogue, Nancy Johnson and I extend our most grateful thanks and deep appreciation.

L.B.M.

FOREWORD

Mark Twain's friend, essayist and editor Charles Warner, once characterized the interests of the American Academy and Institute of Arts and Letters as being equally focused upon "Tradition and Freedom." He might as well have been referring to the National Portrait Gallery. Of course, Warner was trying to chart a passage between the extremes of conservatism and modernity in the arts; in his formulation, the Academy was devoted to encouraging new departures in the arts based on an understanding of the values of the past. At the Portrait Gallery, like the Academy, we turn from an understanding of the past towards the future. Our purpose may be different, but in common with the Academy we hope that we will stimulate free reflection and future action in many fields of endeavor based upon a knowledge of those who have shaped our traditions. Thus, it is particularly suitable that this collaboration between the American Academy and Institute of Arts and Letters and the National Portrait Gallery should be one of the signal events of the Gallery's twenty-fifth anniversary year.

The realm of the fine arts is only one of the areas encompassed by the National Portrait Gallery, which is charged with the study and display of portraits of men and women who have contributed notably to the life of the United States of America. Among the people represented in the Gallery are those who have made their mark in politics, business, the sciences, exploration, and warfare, but no category is more fully represented than that of the visual, literary, and musical arts. In part, this may be because painters, writers, actors, and musicians have always been closely in touch with those who painted and sculpted portraits, and regarded a portrait by a friend as both a tribute and a souvenir of shared artistic ideals. But, in a larger sense, the prevalence of portraits of notables in the arts may say something about the impact these people have had on our perception of the world. Artists often feel themselves to be outside the mainstream of activity, scorned by the general public and misunderstood by leaders in the world of affairs. Yet artists have defined the past; Gilbert Stuart and Charles Willson Peale have described George Washington as vividly as James Thomas Flexner has done, and the American Midwest is as indelibly traced for most of us in the writings of Mark Twain, Sinclair Lewis, or Carl Sandburg as in the paintings of George Caleb Bingham or Grant Wood.

It is curious that artists have felt ignored by our national establishments. European nations have long had their academies, through which creative people have impressed their mark on national policies, but America was slow to establish such forums, and when they were established they lacked the influence they might have had. The American Academy and Institute of Arts and Letters was founded to correct this imbalance. It assumed its present form in stages, beginning in 1898 as an offshoot of the American Social Science Association. The Institute can have 250 members, but the more select Academy, which started after the turn of the century and was incorporated by Act of Congress in 1916, has a membership no larger than 50. From its inception, the Institute and Academy have included many of the most influential painters, authors, architects, sculptors, and educators in America, and they are notably represented in the portraits gathered here.

Lillian B. Miller, the editor of the Peale Family Papers at the National Portrait Gallery and a distinguished

chronicler of American cultural history, has recently been exploring the history of cultural organizations in the United States. Her work naturally took her to the Academy and Institute, where she found a remarkable collection of paintings, sculpture, drawings, photographs, and memorabilia, most of which are unfamiliar to those who have not visited their premises, in the Upper West Side of New York City. Dr. Miller's suggestion that there be a showing in Washington of some of the portraits from Audubon Terrace was enthusiastically received by Margaret Mills, Executive Director, and the Board of the Academy and Institute; this book, and the exhibition upon which it is based, are the result. All of us are grateful to Miss Mills and to Nancy Johnson, as well as to James Thomas Flexner, for their special contributions to this enterprise, and to the members of the Academy and Institute for their willingness to share their treasures with a larger public.

ALAN FERN
Director, National Portrait Gallery

INTRODUCTION

THE ACADEMY-INSTITUTE TODAY

BY

JAMES THOMAS FLEXNER

MEMBER, AMERICAN ACADEMY AND INSTITUTE OF ARTS AND LETTERS

Lillian Miller's valuable essay reveals that the founders of the American Academy and Institute of Arts and Letters in the 1890s were dedicated to reforming America's "slack" fraternalism of democracy by imposing "the aristocratic absolutes of art."[1] They would surely be displeased by their successors today. We try to identify and honor highest artistic achievement in all the variety that is one of the glories of democracy.

Dr. Miller's account indicates to how great an extent the dominant founding members were only secondarily creative practicers of the arts. The most influential figure, Robert Underwood Johnson, was a magazine editor whose literary achievements were a few commemorative poems which he privately printed. College presidents abounded: Nicholas Murray Butler of Columbia University; Andrew Dickson White of Cornell; Daniel Coit Gilman of Johns Hopkins, and the president of Princeton University, Woodrow Wilson, who became President of the United States.

Socially correct gentlemen of British stock and taste, our founders agreed naturally on a single line of standards. No such unanimity would be possible in our present ranks. The break came in the 1920s when the shielding walls crumbled. Women were elected, immigrants often from impoverished backgrounds, Jews, Catholics, and blacks. This brought to the Academy-Institute a diversity of taste, which is further encouraged by the absence prevailing in our own times of a single artistic standard.

How can the Academy-Institute, dedicated to honoring the best American artists, carry out its mission under such circumstances? All worldly considerations have to be ignored; the criterion has to be solely and purely quality of achievement. But determining that quality is made much more difficult by the lack of accepted rules and by the necessity to judge artists' work on their own terms, according to their individual predilections.

Such a task would be impossible if there were as many basic styles as there are writers, artists, and composers. But there are only so many movements which, according to the most tolerant view, seem at one period of time fruitful. And the new developments are never altogether *sui generis*. To a greater or lesser extent they diverge from the paths already charted. It is the hope and intention of the Academy-Institute that the older pathfinders are already among our membership. We rely on them to call to our attention probable future members.

Toward this end our election procedures are very well suited. Each of the three divisions or departments of the Institute has its allotted share of the 250 members: literature, art, music. Vacancies caused by death or—rarely—resignation are open to be filled at the annual elections. Any member may make a nomination in whatever suitable category. There is no limit to the number of nominations and for the support of each a written statement is prepared by the proposer. A preliminary vote in each division, artists selecting artists, composers composers, and so on, reduces the candidates to one, two, or three more than the number of vacancies, and these are submitted for a vote by the entire body.

It is a saving grace that this procedure is entirely different from admission to private clubs where failure may be regarded as repudiation. Candidates for the Institute are presumably not informed (although there are leaks) that

1. Charles A. Fenton, "The Founding of the National Institute of Arts and Letters in 1898," *The New England Quarterly* 32, no. 4 (December 1959): 436.

their names have been proposed. In any case, no nominee is turned down: he or she will merely be one of a group who was not elected on one occasion, due to the limited number of vacancies. It is customary for a nominee to be proposed several times before the road opens.

Critics of the Academy-Institute like to point out that some artists who were never elected to membership have become more celebrated than many who were. This is, of course, inevitable when aesthetic criteria are so various and the future is hard to prophecy and there is a limitation on the total number of artists, writers, and composers who can be elected—250 for the entire United States. But we do hope that the men and women who will receive the greatest institutional recognition in the arts in the United States—election to the Academy-Institute by their peers—will indeed merit this distinction.

The constitution of our organization allows us to select seventy-five honorary foreign members: those chosen are officially inducted by the American ambassadors to their respective nations. Among those currently with us are: Pierre Boulez (France), Janet Frame (New Zealand), Carlos Fuentes (Mexico), Milan Kundera (Czechoslovakia), Leopold Sedar Senghor (Senegal), Josef Tal (Israel), and Kenzo Tange (Japan).

In response to frequently voiced criticisms that the Academy-Institute does not recognize artists in the fields of the film, choreography, and photography, in 1983 the organization established an American honorary membership consisting of ten persons of great distinction in the creative arts whose work does not easily qualify them for membership in the traditional departments of the organization. The current American honorary members include Berenice Abbot, Martha Graham, Billy Wilder, and Frank Capra.

We have an endowment which is from time to time enriched. Much of the income is expended in honoring younger artists with cash awards. The sums are not munificent, but again our position helps. The recipient generally values the recognition of his achievement more than the cash he receives with the award. Some of our selections have turned out very well. Wystan Hugh Auden, James Baldwin, Eudora Welty, Tennessee Williams, John Cage, and William Schuman were given awards when they were in their thirties. Slightly older were Isabel Bishop, Raphael Soyer, Hannah Arendt, and Willa Cather. All are given their awards in a public manner at our ceremonial.

In addition to the ceremonial, there are many meetings of committees, of juries for the awards, and of the governing board. Every year there are a number of dinners and luncheons for members, which frequently include spouses and other guests. These gatherings bring together, from all over the United States, top professionals in different arts and modes who would otherwise never meet. Conformity is by no means the result; instead, these meetings become extraordinary opportunities for the exchange of ideas, deepening of aesthetic understanding, and the development of mutual sympathy among outstanding artists, writers, and composers. In George Kennan's words, such "interaction is useful not only to those persons themselves but to the nation's cultural life as a whole."

PORTRAITS

FROM THE

AMERICAN ACADEMY
AND INSTITUTE
OF ARTS AND LETTERS

THE COLLECTION OF THE
AMERICAN ACADEMY AND INSTITUTE OF ARTS AND LETTERS

BY LILLIAN B. MILLER

HISTORIAN OF AMERICAN CULTURE, NATIONAL PORTRAIT GALLERY

From 1915 to 1940 the American Academy of Arts and Letters accumulated an impressive collection of paintings, sculptured busts and relief portraits, photographs, manuscripts, and memorabilia relating to its history and membership. Developed purposefully but without thematic plan or particular direction, the Academy's collections recall an era and society at a transitional point in American cultural development—a time when prevailing social and artistic values were being sharply questioned, even while their stylistic expression was leaving its permanent mark on the design of the country's buildings, in its art works, and in its literature. This was the period enthusiastically proclaimed as the American Renaissance by a group of American painters, sculptors, architects, writers, and composers seeking to establish on these shores the rich integration of the arts that they believed had endowed Florence and Rome with grace and beauty in the sixteenth and seventeenth centuries. Because the American Academy and Institute of Arts and Letters was founded at the height of the Renaissance movement—its actual organization and stated principles reflecting that movement's ideals and purposes—its collection becomes an interesting historical document as well as a group of pleasing aesthetic objects. As a record of some of the Renaissance's important participants and ideals, the collection illuminates and visually illustrates a significant episode in American cultural history.[1]

The American Academy and Institute of Arts and Letters was founded as two separate societies, each serving an honorable purpose. Both were intended to become the most prestigious and dignified intellectual institutions in the United States. By providing recognition and status to the finest American artists, writers, and composers the country had produced, both the Institute and the Academy, its founding members believed, would protect and further the interests of literature, music, and the fine arts.

The National Institute of Arts and Letters was originally a department of the American Social Science Association, one of many national societies organized during the late nineteenth century to encourage scholarship and to develop and maintain professional standards. Meeting in Saratoga, New York, in 1898, the Association accepted the resolution offered by vice-president Dr. H. Holbrook Curtis (1856–1920), throat specialist and amateur in the arts, which provided that any one of the Association's six departments could establish itself as an independent institute when sufficient interest and support for such a step existed among its members. Curtis's resolution was not spontaneous: during the year preceding this meeting, 145 new members—"men eminent in literary, musical, and artistic pursuits"—had joined the Social Science Association probably in anticipation of such a development. These men took the Department of Arts and Letters out of the Association, increased the membership to 250, and named their new organizaton "National Institute."[2]

For four years the National Institute muddled along with a program consisting of "satisfactory" dinners, stimulating discussions for those members who happened to be in New York, and an annual meeting held in different cities to justify its claim to national status. Dissatisfaction with the organization's lack of definition, however, was expressed from the outset. "In my opinion," wrote Curtis, the man most responsible for the Institute's independence, *the Institute simulates today, a parcel of players, performing*

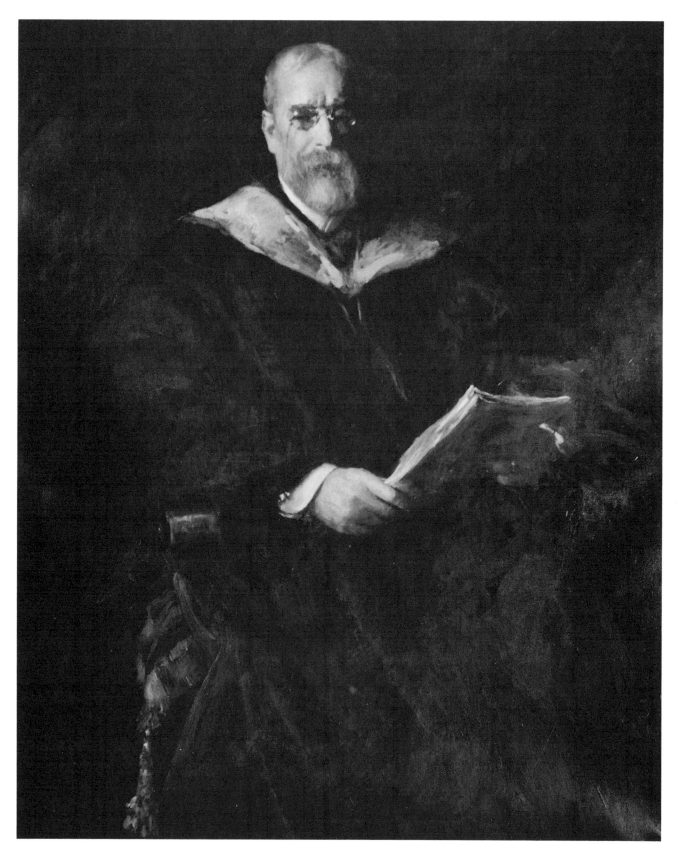

Figure 2. *Robert Underwood Johnson* (1853–1937), oil on canvas by William Merritt Chase, 1909–1913, 39.7 x 104.2 cm. (55 x 41 in.). Collection of the American Academy and Institute of Arts and Letters.

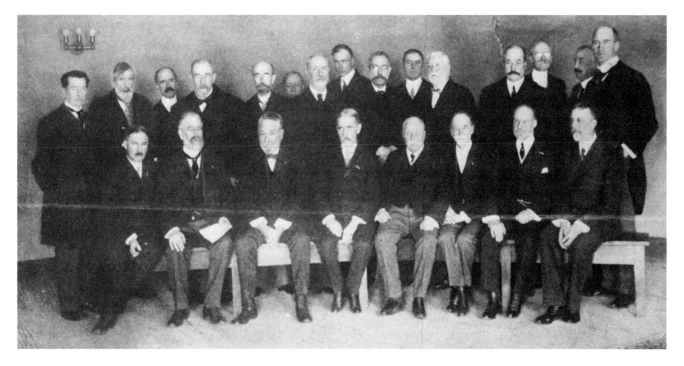

Figure 1. "The American Immortals in New York," *Leslie's Weekly*, December 22, 1910, photograph by Paul Thompson. First row, left to right: Harrison Morris, Robert Underwood Johnson, James T. Rhodes, Henry Van Dyke, William Dean Howells, George W. Cable, John Ames Mitchell, and Arthur Twining Hadley. Second row, left to right: George W. Chadwick, H. Mills Alden, Daniel Chester French, St. Clair McKelway, William Morton Payne, Hamilton Wright Mabie, William Crary Brownell, Bliss Perry, Brander Matthews, Augustus Thomas, Thomas R. Lounsbury, Nicholas Murray Butler, Edwin H. Blashfield, Francis D. Millet, and Charles Dana Gibson. Academy-Institute Archives.

with no scenery, and no defined background. The one live act of the Institute to date has been the laying of a wreath upon the coffin of a dead member. Thirty-seven members have died before even the existence of the National Institute has been known to the outside world. However glorious the conception of the idea, no possible good can emanate from the body, unless it is a recognized power in the world of Literature and Art.[3]

What was needed was money. It was quite clear from the beginning, wrote Robert Underwood Johnson [FIG. 2], assistant editor of *The Century Magazine* and acting secretary of the organization, that, "if the Institute was to have any other function than that of a debating society, it would need larger means than it could draw from the annual dues and the dinner subscriptions of its members."[4] For any kind of program that would exercise intellectual and artistic influence, an endowment was required.

Indefatigable, Johnson pushed the Institute to establish a committee to consider ways of obtaining "private subvention." Consisting of himself, stockbroker and poet Edmund Clarence Stedman [FIG. 3], and musician and composer Edward MacDowell [FIG. 4], the committee almost immediately concluded that if the Institute was to appeal to potential donors, it required an impressive membership list.[5] Forced to choose between what Charles A. Fenton has called "the slack fraternalism of democracy and the aristocratic absolutes of the arts," the three men without hesitation opted for the latter.[6] Unspoken, but very much in the air, was the sense that the extensive membership of the Institute diluted the honor of election and therefore weakened the association's effectiveness as the national arbiter of good taste. The search for an endowment led directly to the committee's decision to recommend the formation of an Academy within the Institute, consisting of the thirty—later increased to fifty—best men the Institute had to offer.[7]

The establishment of an Academy did not diminish the group's anxiety to obtain permanent funding, but between 1904 and 1914 the Academy's members concentrated on defining their program in order to demonstrate the usefulness of their purpose. Most of them undoubtedly hoped to make their organization exercise power in the cultural realm like the Académie Française; and in the

draft of a constitution, they included among the organization's proposed activities "the examination and criticism of current work within the lines of its studies and pursuits"—a duty that was eliminated in the final draft.[8] As "a community of taste and interest," the Academy's members agreed to meet regularly for the expression of "artistic, literary, and scholarly opinion" and for the awarding of prizes that would promote "the highest standards." Such a program, however, was still too vague to be effective, and it was understood that if the Academy was to be regarded as more than a private club devoted to mutual admiration, it would have to include specific educational projects.[9]

The need to obtain a national charter from Congress that would enable it to take and hold property gave an urgency to the Academy's effort to develop a program that would justify its claim as an educational institution. "Set on foot" early in March 1908 under the sponsorship of Senator Henry Cabot Lodge, the campaign to obtain House approval continued into 1916. In 1912 and again in 1915, bills incorporating the Institute and Academy were passed unanimously by the Senate and recommended to the House by its Committee on the Library—to no avail: representatives, particularly from the West, objected to the regional cast of the organization's membership— its preponderance of easterners—and questioned the need for national incorporation. Some Congressmen opposed granting Federal charters for nongovernmental purposes, while others were "indifferent to the interests represented by the Academy."[10] To meet this criticism—at least partially—the Academicians hastened to elect westerners; but it was more important, as Johnson "respectfully" pointed out, to prove the Academy's worth as an educational association capable of undertaking practical work in art and letters.[11]

By this time the organization's first Permanent Secretary, Johnson saw the possibility of merging its need for an educational program with its search for permanent support. In 1914 the philanthropic art collector, poet, and Spanish scholar Archer Milton Huntington [FIG. 5] responded to Johnson's appeal for help with an offer of $100,000 toward an endowment and a building lot at Audubon Terrace in upper Manhattan, where he had recently built a home for the free library and museum of the Hispanic Society of America (1905-1908). Almost immediately, the architectural firm of McKim, Mead and White—the partners all being members of one or both of

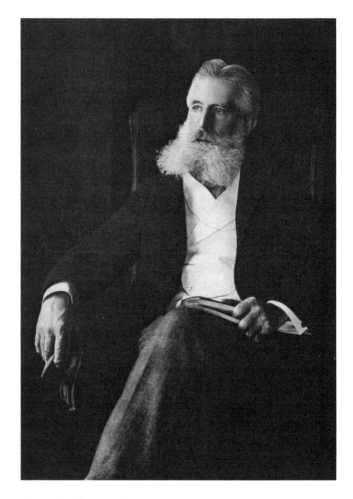

Figure 3. *Edmund Clarence Stedman* (1833-1909) in His Library, photograph by Frederick Stuart Stedman, 1903. Academy-Institute Archives.

the organizations—set to work to design a Venetian Renaissance building that would house administrative offices, a library, and what Huntington planned as a museum containing works of the Institute's and Academy's members [FIG. 6]. With the promise of a building that would provide the necessary storage and exhibition space, Johnson could now realize his hope for a collection that would establish the educational legitimacy of the Academy. Much more than Huntington's $100,000 was required, however, not only to complete the building, but to hire the staff necessary for its maintenance.

In 1915 Johnson formally announced the plan for creating an Academy Archive to the membership in a printed appeal for objects that would contribute to "a collection of unusual value and interest."[12] The Secretary linked the need for a collection with a request for gifts of money to

6

Figure 4. Original manuscript of Edward MacDowell's "From Puritan Days," *New England Idyls*, Opus 62, 1902. Academy-Institute Archives.

an endowment fund. Writing, for instance, to Henry Adams in August 1916 to solicit from him a donation of $100,000 for "administrative purposes," Johnson explained that now that the Academy was promised "a great number of objects of a high class, artistic or literary, for the archives," it required "the momentum of any financial help that can be given inside, or out side, the Academy" [FIG. 7].[13]

Another issue had arisen at this time that made the definition of the Academy as an educational organization of crucial importance. Two years earlier the first constitutional income tax act had been passed by a Progressive Congress under the leadership of President Woodrow Wilson. Although the Underwood-Simmons

Figure 5. *Archer Milton Huntington* (1870-1955), photograph by Anna Hyatt Huntington, undated. Academy-Institute Archives.

Revenue Act of 1913 made no provision for deductions for charitable or educational gifts, it did provide that the tax on corporations would not be applied to associations "organized and operated exclusively for religious, charitable, scientific, or educational purposes." Since income from property acquired by gift or bequest was subject to taxation, it was of great importance to the Academy that its educational function be established.[14] Recognition of the Academy as an educational institution was necessary also if the Academy was to avoid paying to the City of New York a property tax on the lots presented to it by Huntington. In 1915 that tax had amounted to $1,700, a sum that, if continued, would cut into the Academy's fairly meager budget.[15]

Although there were a number of ways in which the Academy could earn its credentials as an educational institution—public lectures, for instance, or the award of prizes or medals for distinction in fields that Academy members believed were important—it was through exhibitions, Johnson believed, that the Academy would make known to the wider public "its plans and purposes." "It must be remembered," he wrote in his annual report for 1916, "that interest in an institution of this sort grows in a geometrical ratio and that the chief difficulty is in the beginning." Collections that were "representative in the highest sense (however restricted in their scope) not only of the work of members of the Academy but of other distinguished achievement by Americans" were essential for exhibitions and, when put on view, would draw to the Academy "the lasting sympathy and pride of the American people."[16]

Johnson's desire to form a collection for the Academy reflected the interests of the period in which he lived, which has come to be recognized as "the Golden Age of Giving."[17] Industrialists and merchants, railroad entrepreneurs and mining barons—all possessing unprecedented amounts of capital and great economic power—sought social and cultural prestige in the accumulation of treasures and masterpieces from past ages. Many of these collections eventually found their way into the numerous museums that these wealthy art patrons and cultural philanthropists were founding throughout the country at the time in a frenzy to bring culture to their communities. Primarily an elitist activity, frequently indulged in by individuals discomfited with what they believed was

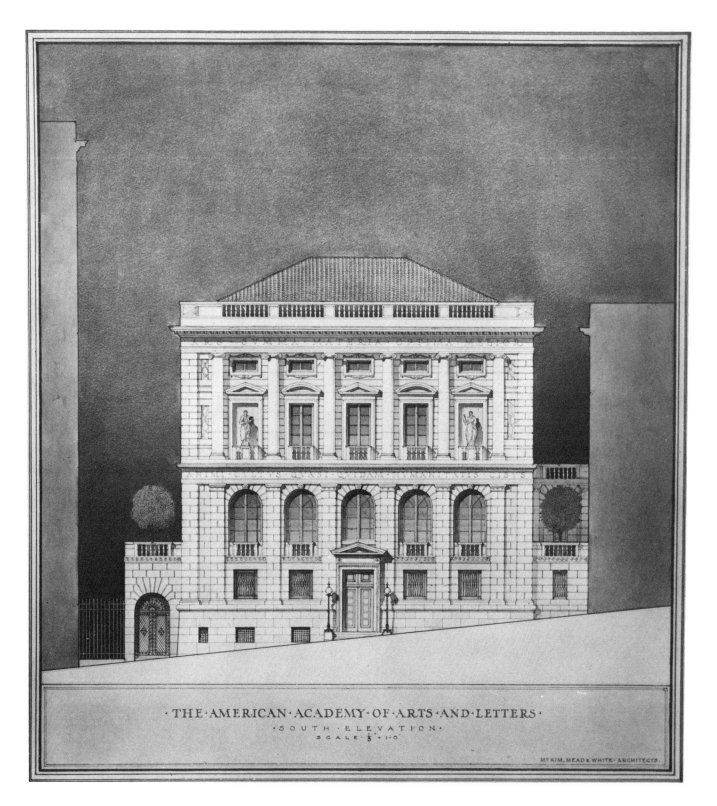

·THE·AMERICAN·ACADEMY·OF·ARTS·AND·LETTERS·
·SOUTH·ELEVATION·
·SCALE·⅛"·1'·0"

Mc KIM, MEAD & WHITE · ARCHITECTS.

Figure 6. Rendering of the south elevation (155th Street facade) of the American Academy building, designed by William Mitchell Kendall (1856–1941), circa 1920, for McKim, Mead and White. Academy-Institute Archives.

18 April. 1915

1603 H STREET

Dear Sir

I fear that you must consider me as quite past service. In any other pursuit than literature, there would be no question about it but even authors grow old and imbecile, and cannot longer serve. I have no manuscripts for one of my weaknesses has always been not to take myself seriously or to believe that my work would ever to be regarded as serious beyond my own day. I have left to my brothers all care for fame, and you can still make my brother Brooks. who is the most capable of us all, take charge of such duties as seem good.

Yrs truly
Henry Adams

Figure 7. Autograph letter signed from Henry Adams to Robert Underwood Johnson, April 18, 1915. Academy-Institute Archives.

the mediocrity of democracy and committed to being stewards of taste, art collecting during these years became a matter of great public interest. Newspapers publicized new acquisitions and extolled their unique qualities as works of art, their significance for the country's civilization, and their material value. The importance that Americans assigned to collecting and to museums was exemplified by one of Johnson's other pet projects—a program to encourage the founding of art museums in states where they did not exist. Although Johnson's plan did not receive support until 1922, when the Academy received a grant from the industrialist Cleveland H. Dodge of Phelps, Dodge & Company for the purpose, the Secretary had first proposed it in 1915, at the same time that he was developing his idea of an Academy collection. Both projects, he believed, "would give [the Academy] unique practical value and public recognition."18

Like so many other American collectors at the time, Johnson and his fellow Academicians were eager to exercise some influence on public taste and values. Excluded from the arena of public decision making, they reluctantly acquiesced to the realization that they would probably not be called upon to serve on projects as influential as those undertaken by their French colleagues, such as compiling a standard national dictionary; nor could they, like the French academicians, influence assignments to governmental positions. Some public role, however, was required if they, and through them the Academy, were to be recognized as the highest authority in questions concerning literature, language, and the arts. A collection that served an educational function, while making more widely known to the American public the achievements of the nation's best artists and writers, not only answered their didactic and aesthetic purposes, but prom-

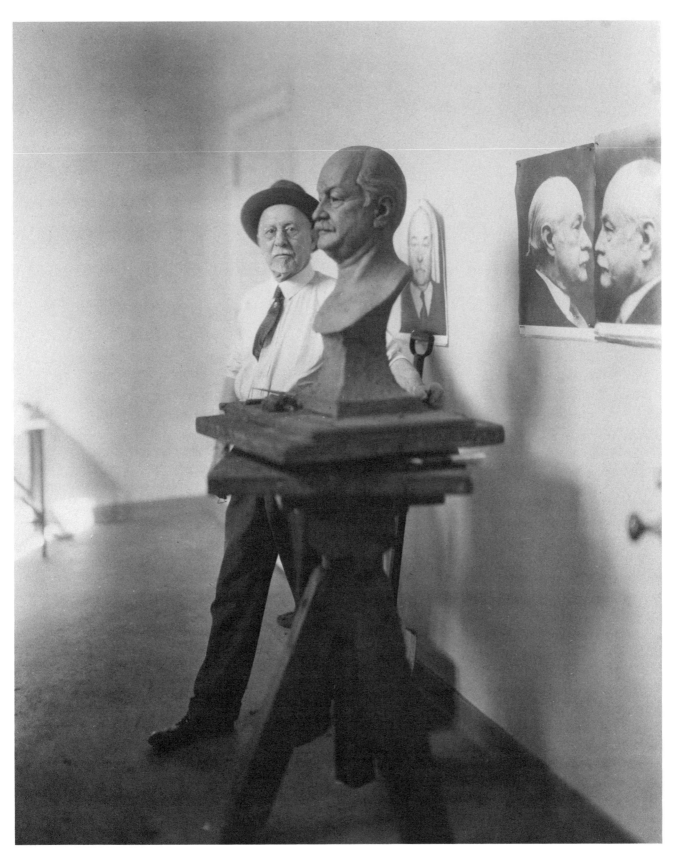

Figure 8. Photograph of F. W. Ruckstull with his bust of Nicholas Murray Butler (1862–1947), circa 1933. Academy-Institute Archives.

ised also to make the Academy an institution of great public utility.

The American Academy was established during what Richard Guy Wilson has defined as the "High" period of the American Renaissance and at the end of that historically disreputable time known as the Gilded Age, a name given to the post-Civil War years by the first president of the National Institute, Charles Dudley Warner, and his coauthor, Samuel Clemens (Mark Twain) [CAT. NO. 6].[19] Its founding, on the eve of the election in his own right of Theodore Roosevelt to the presidency of the United States, coincided with the emergence of Progressivism, with its emphasis on economic, political, and social reform; and it was in the spirit of cultural reform that the members of the Academy entered upon their activities. Too long had the country been managed by machine politicians, industrialists, and the "money trust." It was time, they believed, for men of culture and learning—educators such as Nicholas Murray Butler, president of Columbia University [FIG. 8], or Andrew Dickson White, president of Cornell University; writers such as Owen Wister or William Cary Brownell; novelists such as Thomas Bailey Aldrich or Henry James [CAT. NO. 13], among many others—to assert power in the nation and earn the respect of the American people.

In *The Gilded Age,* Warner and Twain had described an American civilization marked by the ugliness of a new urban industrial culture, the vulgarity of a *nouveau-riche* class, and fraudulent—i.e., imitative—arts. The founders of the Academy largely agreed with this analysis, complaining of an age that seemed to discourage great art and great thoughts. Despite the efforts of a burgeoning community of artists, writers, and musicians, two-hundred-fifty of whom were to make possible the formation of the Institute in 1898, and despite the proliferation of museums, universities, and national cultural, professional, and scholarly associations, America appeared destined for cultural mediocrity to the men who founded the Academy. Charles Eliot Norton, for instance, who resigned from the Academy almost as soon as he was elected, believed that, given "the conditions of literature and the arts in this country, and . . . the character of the country itself, the hope of establishing an institution that should be of real benefit [to American arts and letters] is hardly likely to be fulfilled." Although he was persuaded to withdraw his resignation, he did so with great reluctance, pessimistic that even men of "confidence and en-

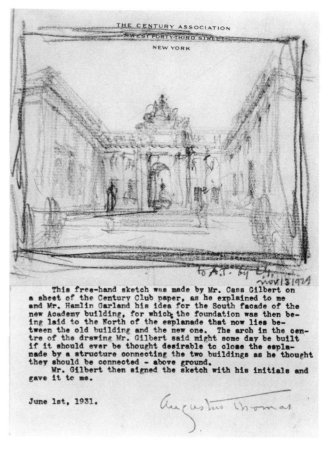

Figure 9. Sketch for south facade of the new American Academy building, pencil on paper by Cass Gilbert, June 1, 1931. Academy-Institute Archives.

thusiasm," as he characterized the founders, could succeed in their patriotic mission.[20] As late as 1914, the Academy's Permanent Secretary issued jeremiads about "the need of maintaining standards of excellence, dignity, style, form and tone," and bemoaned the absence of intellectual leadership. "The magazines have largely abdicated their responsibilities . . . the authority of the church is on the wane, family influence and personal dignity have been greatly lessened, insurgency and puerility are rampant, and the Past has little to teach the rising generation," he wrote. But Johnson was optimistic. Luckily for America, he concluded, the Academy, "a wise and conservative influence in these higher activities, [would help to] counteract deteriorating influences."[21]

Johnson's conviction that the Academy was capable of turning American civilization around and making it worthy of its great material growth and international position was shared by the artists and writers of the American Renaissance. Like Johnson, they sought to establish intel-

lectual leadership through collaborative effort, a recall of the past and affirmation of tradition in artistic practice, and an appeal to Europe as the wellspring of American inspiration. Their watchwords were beauty, dignity, and utility—brave ideals that challenged what they viewed as the ugliness, vulgarity, and meretriciousness of the Gilded Age.[22]

Many of the early members of the Institute and Academy were active participants in the American Renaissance. Architects Charles Follen McKim [CAT. NO. 16], William Rutherford Mead, Stanford White, Thomas Hastings, and Cass Gilbert [FIG. 9] sought to preserve the past in an eclectic architecture that recalled previous Golden Ages. In the spirit of the Renaissance, they worked closely with artists skilled in different media—muralists Edwin Austin Abbey [FIG. 10], Edwin Howland Blashfield [see Frontispiece], Kenyon Cox [FIG. 11], John Singer Sargent [CAT. NO. 19], and sculptors Herbert Adams [FIG. 12], Daniel Chester French [CAT. NO. 8], and Augustus Saint-Gaudens—to create elaborate buildings and city parks modeled on European historical designs that they believed expressed permanent artistic principles. Elihu Vedder [CAT. NO. 23], Abbott H. Thayer, H. Siddons Mowbray, Francis Davis Millet, Will H. Low [FIG. 23], Walter Gay, William Merritt Chase [CAT. NO. 5], John White Alexander [see FIG. 22], and Henry O. Walker saw themselves in the vanguard of a new artistic movement that, despite its emphasis on tradition, was revolutionary in its assertion of the preeminence of style and the decorative nature of art.[23]

Most of the literary men in the initial membership shared the artists' faith in the importance of tradition. The Institute, summarized Charles Warner at the organization's first public meeting in 1900, was designed to "keep alive the traditions of good literature, while . . . [being] hospitable to all discoverers of new worlds." A "safe motto" for the society, he suggested, should be "Tradition and Freedom—Traditio et Libertas."[24] The writers also echoed the artists' interest in Europe, as providing models for their work as well as a congenial environment. Local colorists such as Bret Harte [CAT. NO. 9] or proponents of social realism such as William Dean Howells [FIG. 13] traveled or lived abroad, finding European life and civilization more attractive than the American society that they were committed to portraying.

All of the founding members of the Institute were born before or during the Civil War—the oldest in 1817,

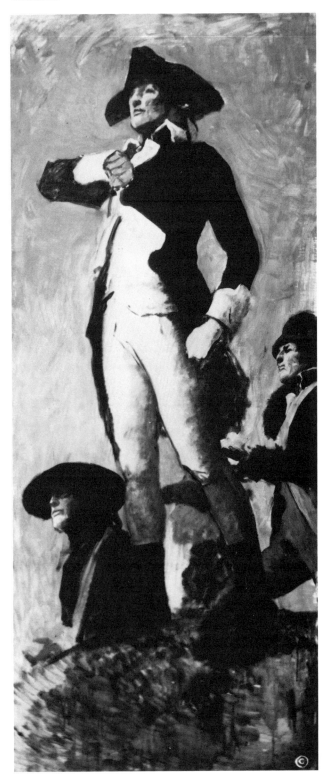

Figure 10. Study for the figure of Anthony Wayne for *The Apotheosis of Pennsylvania*, oil sketch by Edwin A. Abbey, undated, 82.9 x 76.2 cm. (72 x 30 in). Academy-Institute Archives.

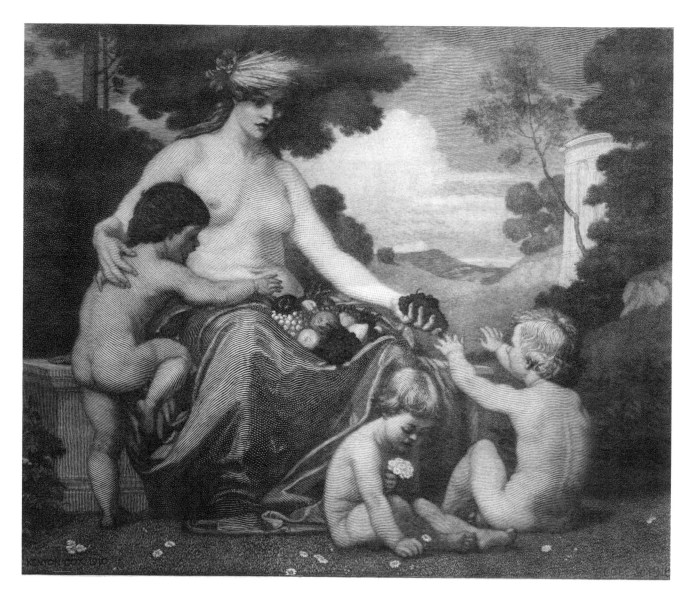

Figure 11. Engraving after *Plenty* (1910) by Kenyon Cox, by Timothy Cole, 1916, 18.1 x 23.2 cm. (7¼ x 9⅛ in.). Collection of the American Academy and Institute of Arts and Letters.

Figure 12. Reverse of Medal for Good Diction on the Stage, gold, designed by Herbert Adams, undated, 8.3 cm. (3¼ in.) diameter. Collection of the American Academy and Institute of Arts and Letters.

the youngest in 1863—and their writings, for the most part (with an exception here and there of such authors as Henry James), were concerned with preserving what George Santayana castigated in 1912 as "the genteel tradition."[25] Many of the literary members were, like Owen Wister, "decided and even angry conservatives."[26] Most had achieved eminence, but they were aging, and the sense that they might soon be displaced surely affected their activities in the organization. In his journals Hamlin Garland described a dinner of the Institute in 1902, with William Dean Howells, then sixty-five, presiding: *He looked old and sad that night, tragically sad it seemed to me . . . [Edmund Clarence] Stedman also looked his age. In truth nearly every man present was gray-haired. [Francis] Hopkinson Smith was almost white—so was [George Washington] Cable; only Brander Matthews remained much the same as when I first saw him. Edward MacDowell and I were the younger men in the room and we were not so very young even by contrast. "I cannot claim to be one of the younger writers any longer," I said to him, and with a chuckle he replied, "Nor I to being a promising young composer."*[27]

A brief examination of the lives and experiences of the Academicians who were most actively involved in forming the Academy's collection illuminates the collection's origins and purposes. Five men were most significant during the period of active collecting: Robert Underwood Johnson [see FIG. 2], editor and poet, for whom the Academy constituted, aside from his poetry, "the chief literary interest of my later life"; Archer Milton Huntington [see FIG. 5], the generous benefactor of the Institute and Academy, who served as chairman of the Museum Committee for most of the twenty-five-year period; and the three members of the first Committee on Art, called at the time the Committee on Art Censorship, who approved gifts to the collection—the painter Kenyon Cox [FIG. 14], the architect Cass Gilbert [FIG. 15], and the sculptor Herbert Adams [FIG. 16].[28]

Most important was Johnson. Born in 1853, the Academy's first Permanent Secretary epitomized the "genteel tradition." The son of a country lawyer and Wayne County judge, Johnson grew to college age in America's Midwest—in the town of Centreville, Indiana. His was a boyhood marked by middle-class and mid-American respectability. His parents were eminent members of their

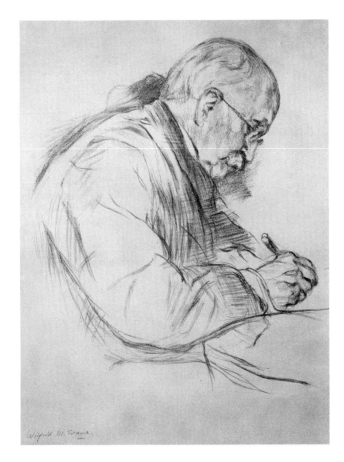

Figure 13. *William Dean Howells* (1837–1920), pencil on paper by Wilford M. Evans, undated, 44.8 x 34.6 cm. (17⅝ x 13⅝ in.). Collection of the American Academy and Institute of Arts and Letters.

community, stalwart supporters of the Presbyterian church, and advocates of such reform causes as abolition and women's suffrage. The father inculcated respect for law and organization, while the mother conveyed to him a sense of the importance of literature and music in personal and community development. Johnson's description of growing up in Indiana, in the chapter of his autobiography called "Records of a Happy Boyhood," could easily have been taken from Edward Eggleston's *The Hoosier School-Master* (1871) or James Whitcomb Riley's *The Old Swimmin' Hole and 'Leven More Poems* (1883).

After "tranquil" days at the Quaker Earlham College in Richmond, Indiana, Johnson was hired as a clerk in the Chicago agency of Scribner Educational Books. At age twenty he joined the New York staff of *Scribner's Monthly,* and for the next forty years devoted his life to editing. *Scribner's* (later called *The Century Magazine*) left

Figure 14. *Kenyon Cox* (1856-1919), photograph by Davis and Sanford, undated. Academy-Institute Archives.

instruction, and tenement-house improvement, and they actively opposed such "pernicious social influences" as the boss system, sectionalism, and the Louisiana lottery [see FIG. 17].[29]

Holland's mantle fell on Richard Watson Gilder, endowed, according to Johnson, with "superb fighting power that he displayed in many good causes."[30] Gilder's broad literary and artistic interests extended Johnson's professional, as well as personal, experiences. At Dr. Holland's receptions, Johnson had met literary men, such as John Hay [CAT. NO. 11], Bret Harte, and poet Edmund Clarence Stedman [FIG. 3]. At the Gilders' "Friday evenings at home" he met musicians such as Clara Louise Kellogg or Ignace Jan Paderewski [CAT. NO. 17], actors such as Joseph Jefferson [CAT. NO. 14], and members of the Society of American Artists, most of whom also became members of the Institute, and some—Chase, Blashfield, Cox, George deForest Brush, J. Alden Weir, Childe Hassam [CAT. NO. 10], Willard Metcalf, and Saint-Gaudens—of the Academy. As a result of his influential editorial position, Johnson became associated with that

a permanent impression on Johnson. The magazine, he was convinced, exercised a "notable influence upon the life of the American people," an influence that continued until "the radical change in its policy in 1913." "No history of the United States from a sociological point of view can be accurate or complete," he wrote in *Remembered Yesterdays* (1923), *that does not take account of the part played in the development of the country after the [Civil] war by this magazine, and, later, by others which it stimulated. It had had admirable predecessors, for instance* Harper's *and the* Atlantic, *but none that aimed directly at leadership in political, religious, artistic, and social opinion.* Under the editorship of Dr. J. G. Holland, *Scribner's Monthly* undertook "to stimulate [Americans] to a sense of their responsibility in working out the difficult problems of democracy." Its editorials advocated such middle-class reforms as an international copyright, the Australian ballot, forest conservation, international arbitration, kindergarten

Figure 15. Three sketches of Cass Gilbert (1859-1934), red crayon on paper by Robert Ingersoll Aitken, undated, 19.7 x 15.2 cm. (7¾ x 6 in.). Collection of the American Academy and Institute of Arts and Letters.

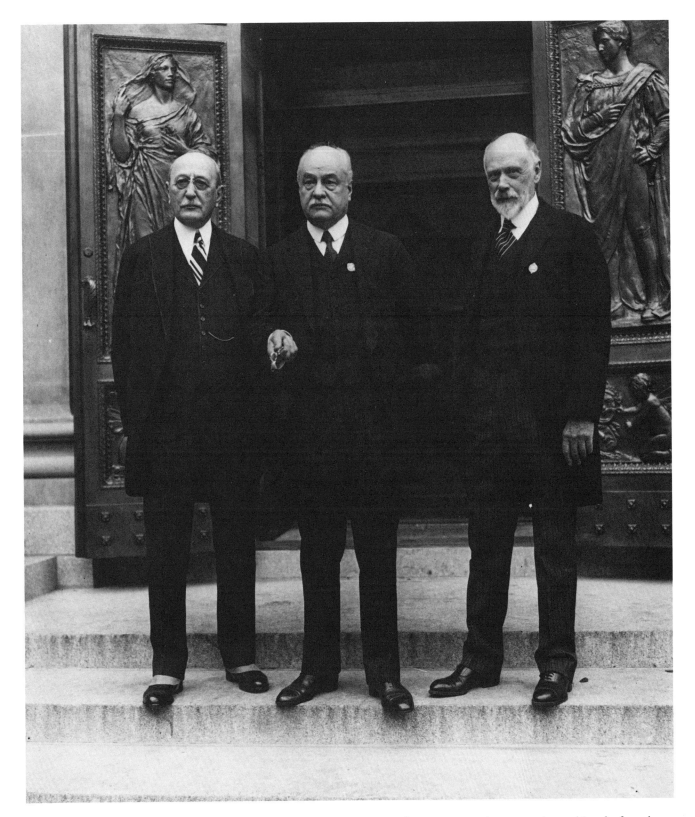

Figure 16. Cass Gilbert, Nicholas Murray Butler, and Herbert Adams, November 13, 1930, at the ceremonies marking the formal opening of the new building of the American Academy, photograph by Acme Newspictures. Academy-Institute Archives.

tightly knit group of American Renaissance artists and writers who were convinced of the importance of art and letters in the nation's cultural life.

One of Dr. Holland's "unformulated principles" was the insistence that every issue of the magazine carry at least one article with "spiritual significance." Gilder maintained this principle, emphasizing also "good taste" and the importance of literature as a harmonizing force in social and political activity. When Johnson took over the reins of *The Century* in November 1909, upon Gilder's death, he insisted upon continuing this "conservative policy, approved by the trustees at the time," despite the magazine's steady decline in circulation. To maintain the tradition of the journal became the "keynote" of his management for the three-and-a-half years that he served as editor; he resigned, or retired, when the magazine's publisher decided to change its policy.[31]

Johnson regarded the Institute as he did his magazine, as "an opportunity . . . to promote the allied interests of literature and the arts."[32] When that opportunity seemed blocked by too large and unwieldy a membership, Johnson urged the formation of an Academy, convinced on the basis of his "long editorial experience and observation" that "such an organization was not only possible [in America] but would have great potential usefulness."[33] With similar energy Johnson advanced the idea of a collection; impressed by the achievement of the men he met at Academy meetings and committed to a belief in the social usefulness of art and literature, Johnson was certain that artifacts representing their work would exercise enormous influence on the American cultural scene.

Archer Milton Huntington (1870-1955) silently encouraged Johnson's quest for a collection. The son of Arabella Duvall (Yarrington) Worsham Huntington (circa 1850-1924), Archer Huntington remained a very private person throughout his life, albeit a generous public benefactor. Perhaps it was the mystery of his birth that made him shun the limelight: Arabella Huntington was born Belle D. Yarrington of Richmond, Virginia, and took the name of Worsham from the man who fathered her child. She became the mistress, probably, and then the second wife of the millionaire railroad baron Collis P. Huntington (1821-1900), who adopted the fourteen-year-old boy at the time of the marriage in 1884, and permitted Archer to assume his surname.

From the time that Arabella began to enjoy an income from Huntington's fortune, she assumed all the attributes of elegant and respectable social life. She bought and transformed houses in New York City that reflected the taste and position of the class that she aspired to enter; she educated her young son in museums throughout Europe and introduced him to art and literature as befitting an heir apparent to a large fortune. He was tutored in languages and sent to the most prestigious universities. He attended, but did not earn degrees from, Yale, Harvard, Columbia, and the University of Madrid (later he received honorary degrees from Yale, Harvard, and Columbia).

After their marriage Arabella and Collis Huntington undertook the formation of an art collection—a necessary appurtenance of wealth and social position. In his will Collis Huntington left the collection to the Metropolitan Museum, subject to its lifetime use by Arabella and Archer. On Arabella's death in 1924, Archer relinquished his claim to the nearly two-hundred works. By this time he had accumulated a collection of his own—a large and important group of Spanish works, which filled the rooms of the Hispanic Society of America at Audubon Terrace.

Archer was left a substantial fortune by Collis P. Huntington, and probably later by his mother and Collis's nephew Henry E. Huntington, who in 1913 married the widowed Arabella and merged the two Huntington fortunes. At Archer's death in 1955, he was eulogized by the *New York Times* as a "multi-millionaire who gave away most of his fortune founding and supporting museums." The *Times* was quite correct: Huntington himself is reported to have said, "Wherever I put my foot down, a Museum springs up."[34]

Apparently Huntington enjoyed his participation in Academy affairs and the camaraderie of artists and literary men. He attended board meetings fairly regularly, and constantly opened his purse to pay for both large and small Academy needs, the final sum of his contributions between 1914 and 1936 amounting to more than three million dollars. He donated lots, the Academy's first home, and, in 1928, funds for a second building to house exhibition galleries and an auditorium, even giving the Academy an organ (which remained largely unused) for the auditorium. Almost every year he defrayed Academy deficits with a donation of $20,000.[35] In 1930 the president of the Academy paid tribute to Huntington's "princely generosity . . . I know of no great literary or aesthetic undertaking in the world that has a Maecenas at all comparable to Mr. Huntington," said the president.

Figure 17. *The Century Group: Robert Underwood Johnson, Alexander Wilson Drake, Clarence Clough Buel, Richard Watson Gilder,* oil on canvas by Orlando Rouland, 259 x 213.2 cm. (102 x 84 in.), 1909. Collection of the American Academy and Institute of Arts and Letters.

Cass Gilbert, a member of the Art Censorship Committee, seconded the president's tribute; Huntington, added the architect, *has the highly practical capacity of understanding every single detail for which he is giving and the high artistic and aesthetic appreciation of every element concerned in the matter. He is not only a Maecenas . . . but he is . . . a Pericles in a sense for he does things by a native instinct, for the love of beauty in the fine arts and in literature.*[36] As chairman of the Museum Committee, Huntington worked closely with Johnson on behalf of the Academy's collection, contributing money to its support, adding to it works of art that he particularly admired—such as three Childe Hassam paintings—and helping to plan exhibitions.[37]

The three artist members of the Committee on Art Censorship, whose job it was to approve gifts of art to the institution (or, as Johnson put it, to "suppress anything that would do [the Academy] discredit"), were close friends of Huntington's and each other. The muralist Kenyon Cox (1856–1919), the sculptor Herbert Adams (1858–1945), and the architect Cass Gilbert (1859–1934) were all prominent participants in the American Renaissance, and expressed its ideals in their work.[38]

Cox was the son of a Republican governor of Ohio and secretary of the interior who as a Liberal Republican had resigned from President Grant's cabinet in protest over his policies. As dean of the University of Cincinnati's law school from 1881 to 1897, and author of books on military history, the elder Cox was a highly regarded member of his midwestern community. His son Kenyon was reared in an academic environment—stable, principled, and respected—and revealed its influence in such phrases as "a sane and vigorous art," "submission to discipline," "the rigor of self-control."[39] Like his father, Kenyon wrote, lectured, and taught, and developed ideas on the laws of art. He studied painting at the Pennsylvania Academy of the Fine Arts in Philadelphia, and from there traveled to Paris to continue his work in Duran's and Gérôme's studios. When he returned to the United States, he found himself in demand as a portraitist but not as an imaginative painter. With Edwin H. Blashfield and other Parisian-trained artists, Cox helped to create a demand for decorative murals where his penchant for classical nudes could find expression. These he painted for the 1893 Chicago Exposition, the New York Appellate Court, the Library of Congress, and the Iowa and Minnesota State Capitols, among others. In these commissions he worked closely with such other future Academicians as

Figure 18. "Genius of Inspiration," bas-relief on the gates of the American Academy by Herbert Adams.

Blashfield, Gilbert, Saint-Gaudens, and Adams. Besides writing critical essays, which he collected in *Old Masters and New* (1905) and *Painters and Sculptors* (1907), Cox contributed essays to August F. Jaccacci's *Noteworthy Paintings in American Private Collections,* research for which took him into some luxurious private homes and surely impressed upon him the social significance of collecting.[40]

Herbert Adams was a decorative sculptor who produced highly refined works reminiscent of the antique and classical. Born in Vermont, he studied at the Massachusetts Normal Art School in Boston, and in Paris. A judicious and fair-minded individual, Adams disliked "experiments" such as those that characterized George Gray Barnard's statute of *Lincoln* (Cincinnati, 1917) and produced an uproar among the Academicians as well as members of the National Academy of Design; but Adams

refused to take a stance against the work, leaving it to the public to judge.[41] His clear integrity made him a popular member of juries as well as an officer in many art organizations. He was president of the National Sculpture Society for three terms; he served two terms as president of the National Academy of Design; he was also president of the Saint-Gaudens Memorial Museum, director of the Hispanic Society of America and of the American Academy in Rome, and a member of the Art Commission of the City of New York and of the National Commission of Fine Arts. Adams believed thoroughly in the importance of craftsmanship, convinced, as the sculptor Adolph Weinman put it in his memorial tribute, "that it is the lack of training in craftsmanship which accounts for so many failures in the field of so-called self expression in art, that futile effort of the untutored to say something without possessing the power of speech."[42]

As a member of the Cornish art colony in New Hampshire, Adams was a close associate of Academicians Saint-Gaudens and Daniel Chester French. He was most noted for his portrait busts of women, some tinted in the manner of Renaissance portraits, but his range was broad and included small bronze statuettes, low reliefs, and portrait statues of a commemorative kind, such as that of William Cullen Bryant in New York City and Joseph Henry in the Library of Congress. "While the tradition of the Renaissance especially asserts itself throughout his work," wrote Weinman, "his own good taste and spirit are the dominant and controlling factors. His own personality seems to be reflected in the quiet serenity and nobility of thought that permeates his work."[43]

The sculptor supported Johnson's plans for a collection and exhibition program wholeheartedly. In 1914 he complained to Johnson that *The plain and disgraceful fact is that there is no suitable place in New York for our exhibition of painting and sculpture. This is just the thing that artists have been up against in New York for years. . . . it really seems to me that unless we could hold* [the exhibition] *in the same building with the rest of our functions, it will do the Institute very little good* [see FIG. 18].[44]

Cass Gilbert, also born in Ohio, was, according to Richard Guy Wilson, "at home in the corporate boardroom, the university trustees' meeting, the club room, the mayor's office, the drafting room, the building site, and the artist's studio," summing up by his presence the significance of architecture as a mark of civilization.[45] He was educated in Boston at the Massachusetts Institute of Tech-

nology; he traveled in England and Europe, worked as a draftsman in the offices of McKim, Mead, and White, and won his first success with the commission for the Minnesota State Capitol. In 1910 he was appointed a member of the National Commission of Fine Arts and secured a number of Washington assignments as a result, the most important of which was the Supreme Court Building. Although his early work showed the influence of the Romanesque, in his later work he, like Cox and other members of the American Renaissance, turned to the Classic, producing designs that were not particularly original or daring, but received the common approval of his contemporaries. In Gilbert's opinion, Greek sculpture was "great art" because of its "calm vitality, it's [*sic*] rich and beautiful 'pattern'. it's mastery of form and line and movement." The task for American artists, he believed, was to produce similar things of "absolute beauty" despite "the vulgarity and materialism" of the present environment. Meaning in art was not important; what Gilbert was concerned with in art was "the composition—the design—the arrangement—the balance"—in other words, the "Art" of the work.[46]

What kind of a collection would such men put together? To a great extent, of course, the Academy had to take whatever came its way voluntarily from members, or from members' families or friends. The collection, therefore, could not reflect a single taste or particular interest such as might inform a private art collection. Moreover, Johnson's main interest in recommending the collecting project was historical: he wished to develop archives consisting of manuscripts and visual images that would convey the history of the institution and its prestigious membership to Americans at the time and in the future; to heighten through memorabilia, manuscripts, painted, drawn, and sculpted works of art, and any other related objects the reputation and importance of individual members, and through these to make the Academy almost by osmosis the institutional reflection of their glory.

Portraits dominated, not only because such historical documents suited the particular requirements of an Academy collection, but also because, as works of art, portraits were valued highly by both the public and the men assembling the collection. Portraits in all media were solicited and received. A *Guide* to the Academy's collec-

tions, published in the 1930s, indicates that the institution at that time owned a preponderance of bronze, marble, and plaster portrait busts of members, together with portraits in oil, watercolor, and black and white, testifying to the continuing popularity of portraiture during the early decades of the twentieth century. A few portraits of nonmembers also appear in the Academy's collection: busts of Ralph Waldo Emerson by Daniel Chester French, a relief portrait of Walt Whitman by John Flanagan, and a preliminary sketch model of Horace Greeley by John Quincy Adams Ward [FIG. 19].

The prominence of small three-dimensional objects in the Academy's collection calls our attention to the popularity at the time of sculpture as decoration for the home as well as for the public square. In the Parisian studios where most of the artist members of the Academy had worked, study of classical or Renaissance art was emphasized. We see this influence in the Academy's portrait reliefs by Saint-Gaudens of William Merritt Chase [CAT. NO. 5], Charles Follen McKim [CAT. NO. 16], and John Singer Sargent [CAT. NO. 19], in all three of which the

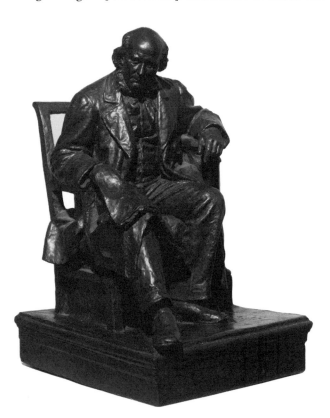

Figure 19. Model in bronze for monument to Horace Greeley at City Hall Park, New York City, by John Quincy Adams Ward, 1883–1890. Collection of the American Academy and Institute of Arts and Letters.

sculptor demonstrates how well he had mastered the particular beauties of Italian Renaissance relief sculpture. The influence of Beaux-Arts training appears in Olin Warner's bronze busts, in particular the highly refined *Daniel Cottier* (1878) and the impressionistic and lively *J. Alden Weir* [FIG. 20].

In Paris, American artists absorbed the concept of "total design" as an aspect of an art that was decorative rather than representational. Literary subjects with general or symbolic allusions, such as Lorado Taft's *The Crusader,* a model for his memorial to Victor Lawson in Gracelands Cemetery, Chicago, or the figures on the Academy's bronze doors designed by Herbert Adams and Adolph A. Weinman [FIG. 21], reflect this concern for art as decoration. Painters also were caught up in the ideal of a decorative art, as in Alexander's *Portrait of a Lady (In the Orchard)* [FIG. 22], Chase's *Lady in Black* (1936), or Frank Vincent Dumond's *The Flowered Shawl* (not dated), all of which illustrate the way in which Paris-trained artists turned portraits into decorative figures more important for their color and design qualities than for their specific representativeness. Similarly, Will H. Low's *Ariadne in Naxos* [FIG. 23], Elihu Vedder's illustrations for the *Rubáiyát of Omar Kháyyám* [FIG. 24], and the work of Kenyon Cox illustrate the interest of the artists of the American Renaissance in the figure and, in particular, the nude, an interest derived from their Parisian training. It is not surprising, given the education and interests of the artist members of the Academy, that Modern art would be eschewed and traditional approaches to painting emphasized. Most of the artists represented in the collection strove for Cox's "classic spirit," which Cox defined as "the love of clearness and reasonableness and self-control. . . . It asks of a work of art, not that it shall be novel or effective, but that it shall be fine and noble."[47]

Old Masters could not, of course, play an important part in the Academy's collection, based as it was on the work of its members, but the interest of the times in such works was expressed in the gift made in 1927 by Archer Huntington of sixty-seven wood engravings by Timothy Cole, after Masters' paintings in such large museums as the Uffizi, the Louvre, the National Gallery of London, the Edinburgh Museum, the Metropolitan, and the Frick.[48]

Works on paper—etchings, lithographs, drawings, and engravings—by Academy members and nonmembers also figured largely in the Academy collections, as did photographs, manuscripts of published works, and vari-

ous memorabilia. Johnson pursued these kinds of items vigorously—possibly because their relatively low economic value made them more available. Members were still warm in their graves when he approached widows and family members seeking commemorative gifts. That such donations were forthcoming, despite the occasional bad taste of his unrelenting solicitations, suggests that most Academy members and their families during the 1920s and 1930s believed in the validity of his project and the importance of the collection. Of course, many of the donors contributed in order to honor an individual artist or writer, to ensure him or her a place on Parnassus; but many, also, were convinced, as was Kenyon Cox, that museums were important for "the 'diffusion of culture,'" and that therefore such institutions should possess along with pictures in frames an "enormous number and variety of objects . . . [of] a genuinely artistic nature."[49] The kind of heterogeneous collection the Academy was creating met Cox's definition of the model museum.

With the death of Robert Underwood Johnson in 1937, active collecting for the Academy/Institute diminished. It ceased almost entirely by 1941, when a new regime took control. The change spelled an end to the policies of the Old Guard, who had managed the operations of the Academy almost since its founding: Nicholas Murray Butler, chancellor of the Academy from 1924 to 1928 and president from 1928 to 1941 [FIG. 25]; William Milligan Sloane, chancellor from 1908 to 1920, treasurer from 1912 to 1917, and president from 1920 to 1928 [FIG. 26]; Wilbur L. Cross, treasurer and chancellor from 1931 to 1941 [FIG. 27]; and Archer M. Huntington. Accustomed to assuming control and making decisions, these men regarded the Academy not only as a haven for an educated elite, but as a center where the energy of scholars and artists could be marshaled for the exercise of public influence. Butler had risen from professor of history to the presidency of Columbia University, where he fostered the development of graduate faculties and used the strength of his position to participate actively in public affairs and to encourage his faculty to do likewise. Sloane, his predecessor in the presidency of the Academy, had resigned his professorship at Princeton University in order to accept the Seth Low Professorship of History at Columbia, where he remained close in thought and behavior to the

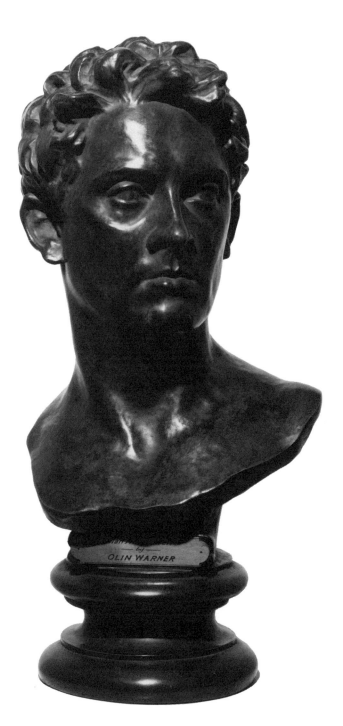

Figure 20. *J. Alden Weir* (1852–1919), bronze bust by Olin Warner, 1880, 43.1 x 29.2 x 25.4 cm. without base (17 x 11½ x 10 in.). Collection of the American Academy and Institute of Arts and Letters.

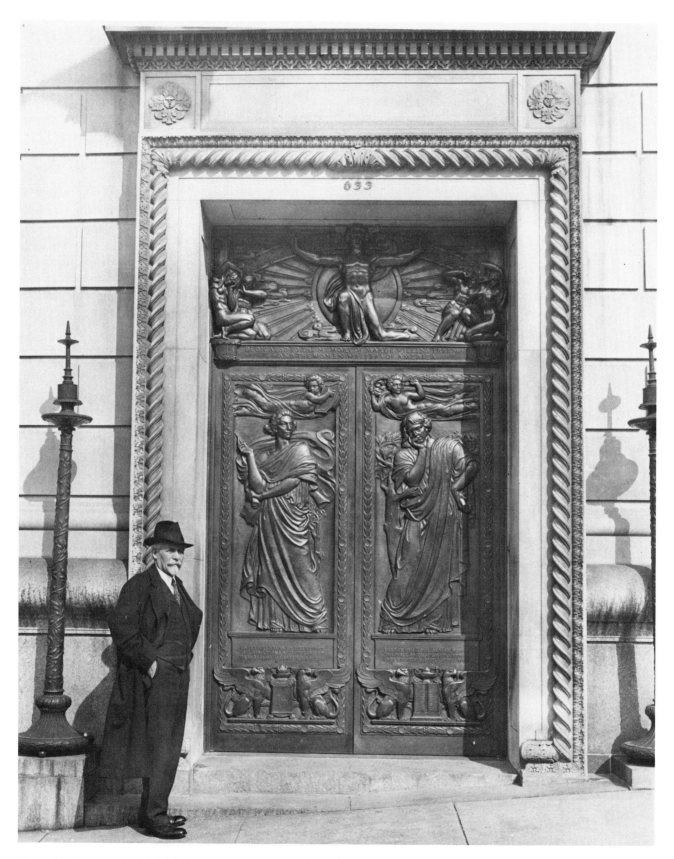

Figure 21. Photograph of Adolph A. Weinman (1870–1952), standing before his bronze doors, commissioned by Archer Huntington for the 155th Street entrance of the American Academy building, 1938. Academy-Institute Archives.

university's president. Wilbur L. Cross was also a scholar who engaged in public life. Professor of English and dean of Yale University's Graduate School, Cross left Yale to serve four terms as governor of Connecticut. Immersed in history, these men understood the importance of archives for historical scholarship, and as educators and active public servants, they had encouraged Johnson's efforts to create an Academy collection. When they departed from office, they took with them, also, the collecting spirit.

Ironically, their departure and the Academy's subsequent change of policy from collecting to patronage of living artists were precipitated by the same kind of dissatisfaction with the quality of the Institute's membership that had given birth to the Academy originally in 1904. The change of policy also reflected the unique economic and sociological circumstances of the Great Depression.

Dissatisfaction with the writers and artists being elected to the Institute had been festering among the Academy's leaders since at least 1924, when Johnson railed against the idea of admitting Carl Sandburg (whom he insisted upon calling "Sandborg") into the larger organization and thereby making him eligible for the more elite Academy. Sandburg's election to the Institute was staved off until 1933, but in that year he and such other "undistinguished" and "radical" poets as T. S. Eliot, Robinson Jeffers, and Archibald MacLeish were being proposed for the Literature section, along with Rachel Crothers, Helen Keller, Edward Kennard Rand, Frederick J. E. Woodbridge, Samuel Eliot Morison, and Carl Becker, all of whom were elected. "It is easier," wrote the irate secretary, "to get into the Institute than into the Roasted Peanut Dealers Association." Johnson was particularly worried that the new candidates might not be "in sympathy with our traditions," and that "the radicals will soon have control."[50]

Johnson died in 1937, unhappy to the last with the directions the Institute and Academy seemed to be taking. Two years later, his aging but still very active former colleagues confronted the same problem and decided to effect a constitutional change that would separate the Academy from its parent organization, the National Institute. By proposing to change the bylaw that limited election to the Academy to members of the National Institute, the directors hoped "to leave the Academy free in its choice of members, as the Institute of Arts and

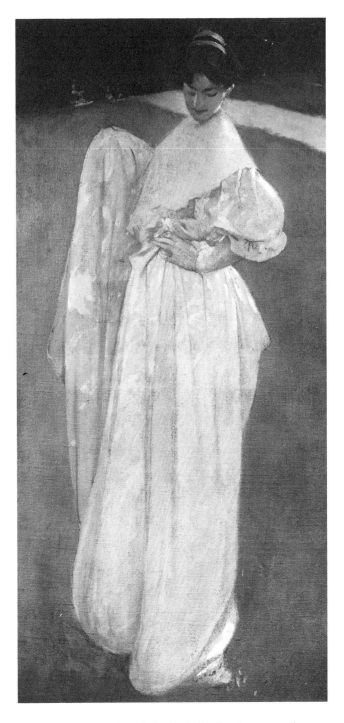

Figure 22. *Portrait of a Lady (In the Orchard)*, oil on canvas by John White Alexander, 1894, 191.8 x 89.5 cm. (75½ x 35¼ in.). Collection of the American Academy and Institute of Arts and Letters.

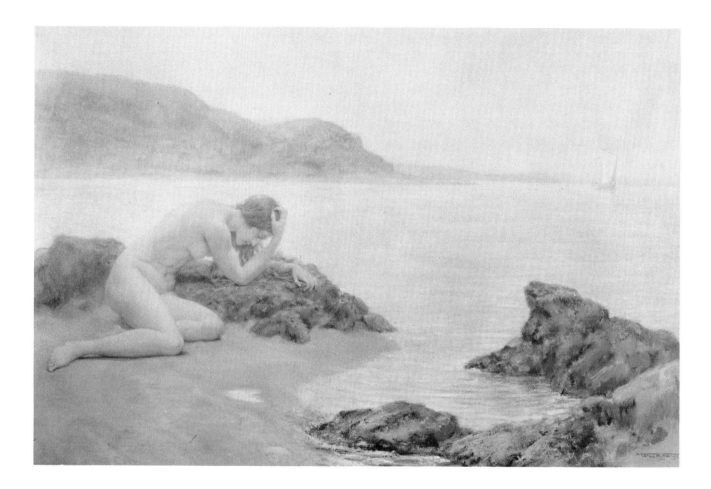

Figure 23. *Ariadne in Naxos*, oil on canvas by Will H. Low, 1920, 97.8 x 148.3 cm. (38½ x 58⅜ in.). Collection of the American Academy and Institute of Arts and Letters.

Letters now is, without in any way altering the relationship which now exists between the Academy and the Institute."[51]

It has been suggested that the force behind the proposed amendment to the bylaws was Nicholas Murray Butler, who was eager to advance General John J. Pershing into the Academy along with some Columbia University faculty members. The onus, however, was placed by the members at the time on Archer Huntington, whose determination to make the Academy independent of the Institute seemed to exert a powerful influence on the decision of the other board members. Huntington had promised the Academy to tear down the two apartment houses that blocked the view of the Hudson River from its present buildings, a plan that was to be accompanied by an increased endowment. News of Huntington's involvement infuriated most of the membership; the Amendment seemed to be an expression of the will of the

Academy's rich benefactor, and the directors seemed to be merely his tools, more interested, as Nicholas Murray Butler himself admitted, in obtaining Huntington's contributions than in abiding by ethical or constitutional considerations. Idealism, then, and artistic freedom versus control of the institution by monied patrons became important issues in the conflict.[52]

A few members of the Academy approved the amendment, including Cecilia Beaux, Thornton Wilder, and Sinclair Lewis, who felt that its passage would "give flexibility and naturalness to the election of Academy members, and these are qualities more important than even reasoned tradition."[53] But these were minority views. Most of the Academy members—more than thirty of them—disapproved the change. Eugene O'Neill, for instance, believed that "if the Academy Board remains obdurate, all those in the Academy opposed to the amendment should resign and leave Mr. Huntington's Academy to

26

Mr. Huntington and his little group of obedient respecters of 'enormous wealth.'"[54]

Joining forces with Walter Damrosch (1862–1950), president of the National Institute and popular orchestra conductor, a group of dissidents—Stephen Vincent Benét, Van Wyck Brooks, Frank Jewett Mather, Jr., Deems Taylor, William Adams Delano, and Chauncey Brewster Tinker—set in motion a movement of opposition that thwarted the ploy of the Academy's directors to separate the two organizations.

In the autumn of 1940, Damrosch circulated memoranda and letters to the membership, urging attendance at the forthcoming November meeting that would "determine whether the Academy should lose its idealistic purpose and shall be turned over completely to become the toy of a very rich man."[55] Damrosch's memoranda brought results. At that meeting, a new Board of Directors was elected containing six dissidents and three members of the old group—Huntington, Butler, and Cross. At the board meeting that followed on November 29, Damrosch presented an amendment to the amended by-laws that reinstated the old relationship. With its passage, Huntington, Butler, and Cross immediately resigned. By the next meeting of the board in January, with only former dissidents present, the offices were filled by the opposition, and a new era for the Academy was launched.

The controversy brought into the open the unhappiness of some members over the way the Academy had been controlled, in the extreme words of Ezra Pound, by "these fossilized old jossers."[56] The members were also particularly resentful of Huntington's gifts, a discontent hitherto suppressed except in private conversation. Huntington, said Damrosch, "in return for his election as an Academician has already burdened us with an entirely useless building which is used by less than one-half of our members only once a year. Its grandeur is oppressive and its location is too far away to be of any real service."[57] "The Academy should live in comparative poverty, or at least in decent simplicity," agreed James Truslow Adams, *instead of bowing to the will of one man who happened to inherit many millions as the adopted son of a railroad magnate of a not very savory period of American finance. If he who has never done anything himself of note in the Arts, is to tell the fifty members who are supposed at least to have done something, exactly what they shall do or he will stop his contributions, I would personally be inclined to sell the confounded building and thumb my nose at it.* Some members found the

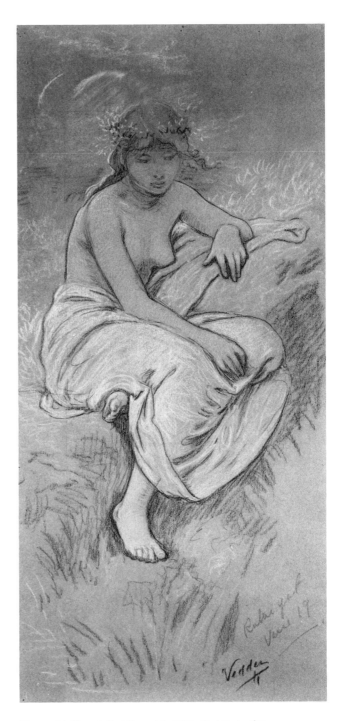

Figure 24. Sketch for Verse 19 of *The Rubáiyát of Omar Khayyám*, chalk on paper by Elihu Vedder, undated, 43.8 x 20.6 cm. (17¼ x 8⅛ in.). Collection of the American Academy and Institute of Arts and Letters.

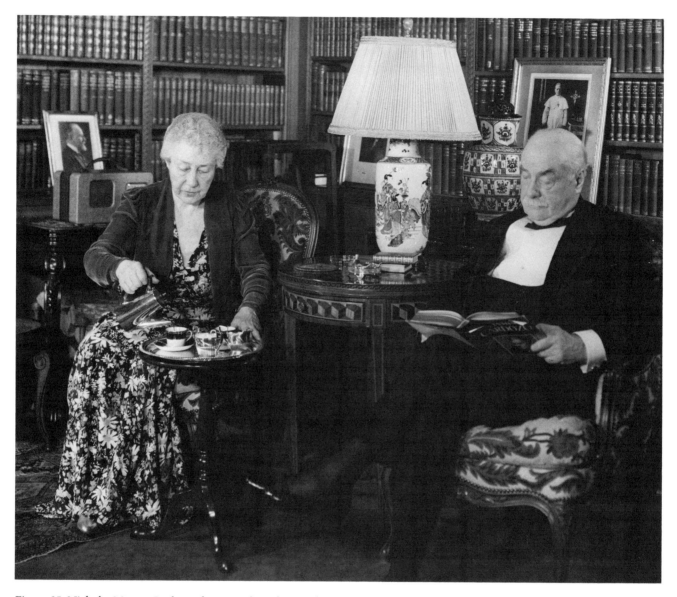

Figure 25. Nicholas Murray Butler and Mrs. Butler at home, photograph by Dmitri Kessel, undated. Academy-Institute Archives.

Academy's collection also a subject for criticism. It was, said one member, a collection of "trivia."[58]

Once in power, then, the new board went about resolving their old grievances. They stopped holding their board meetings at the inconvenient building on 155th Street, dispensed with the expensive luncheons that occurred at these times, and reduced the office staff. "Now that we have saved an average of $35,000 a year," the board asked itself, "to what use could this money be put as a permanent cultural contribution to the arts?" The answer was ambiguous, but the sense of the group was clear: with the resignation of Archer Huntington from the board, the Academy could not count upon his pro-

gram of private philanthropy to needy artists and writers. It was up to the organization to make that program an organizational policy, and "to continue using our funds directly for creative work."[59]

Accordingly, the new board of the Academy established "a sinking fund for the burial of members" whose families were in need of financial assistance in the hope that "a decent burial will relieve the public authorities of some possible expense, and may encourage men to follow an unprofitable but socially desirable calling in the Arts beyond the point where they would be willing to do so other wise." The board also decided to make available to the Artists' and Writers' Relief Fund of the Insti-

tute the sum of $2,500 "to help distinguished artists in distress." Later it was agreed to "give financial assistance by 'loans' to genuine artists in need (through the Artists' and Writers' Relief Fund) irrespective of membership in the Institute (such aid to be given because the artist is in need, and not as a recognition of his artistic achievement)." And a fund was established for grants to "younger artists of demonstrated achievement, for whom adequate recognition will prove a stimulus and encouragement for future production."[60]

Conforming to its new policy of patronage rather than collecting, the board decided to accept the plan suggested in Childe Hassam's will (1935) and begin selling the paintings he had bequeathed to the Academy in order to establish a fund for the purchase of works of art for distribution to the nation's museums—a policy that continued until the 1970s. Perhaps the feeling that the collections were trivial also hastened the decision to distribute the works in the Vedder bequest (1954), retaining a few drawings as the "best" examples of Vedder's art.

Donations to the collection would continue to come to the Academy from members influenced by the old policy, which had now become something of a tradition. But the active solicitation of gifts ceased, and not until the 1960s was any further effort made to develop the Academy's museum and archives.[61]

The directors who ran the Academy after 1940 consisted primarily of active participants in the arts rather than educators. More willing to accept new artistic departures and styles than were their predecessors, they reflected—whatever their age—the spirit of the generation that came to maturity after the Armory Show of 1913 and after Modernism had been assimilated into American taste. Thus they were more interested in encouraging the new than in collecting the old.

In contrast, the men who were responsible for the Academy's collection were responding to the original purpose of the institution to conserve traditions and standards by retaining the past as a model for the present, by educating through reference to the past, and by memorializing writers and artists whose work might otherwise be disregarded by new generations already competing for reputation.

The collection of the Academy-Institute also grew out of the need of the two organizations to define themselves. Their membership seriously wished to serve some social and cultural purpose, but the question of how such purposes could best be served by individuals whose primary work was not community-oriented but private, insofar as it was creative, eluded answer. It was obvious that an American academy could not expect to model itself after aristocratic European institutions, but no other models were available. Neither the university, the museum, nor the professional organization offered programmatic models appropriate to the needs of the multidisciplined and varied Academy and Institute. How to find a program that would recognize the elitism of artistic achievement while taking into account the democratic values of the community—that would serve the organization's membership while at the same time making a

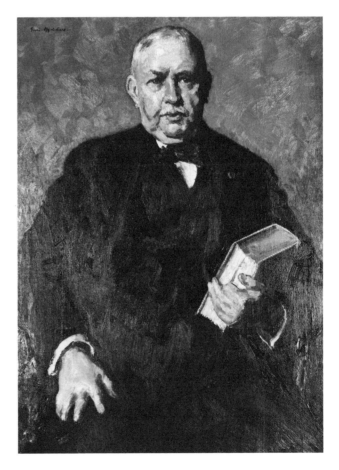

Figure 26. *William Milligan Sloane* (1850–1928), oil on canvas by Gari Melchers, 1923, 107.2 x 77.5 cm. (42¼ x 30½ in.). Collection of the American Academy and Institute of Arts and Letters.

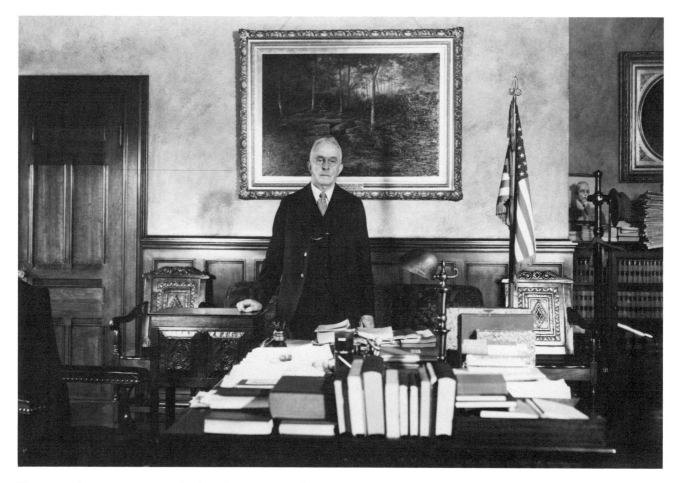

Figure 27. "A serious moment in the day of Gov. Cross in the Executive Chambers of the Capitol, Hartford, Conn.," photograph, circa 1931–1939. Academy-Institute Archives.

"contribution to the intellectual and artistic life of the public at large" —was the problem that the membership had faced from the beginning.[62] The creation of a collection of works representing their own achievement and a public-exhibition program related to it, was one response to their dilemma.

This response was not unrealistic. The American interest in exhibitions of works of art was a continuing one. In 1931, for instance, during the nadir of the Depression, more than forty-eight thousand visitors viewed the organizations' exhibition of works of living artist members, and its closing date had to be extended to accommodate members of the American Federation of Arts, which was holding its convention that year in Brooklyn.[63] Other exhibitions throughout the 1930s set comparable attendance records. Obviously, neither the

uptown address nor the Depression deterred New Yorkers and visitors to the city from coming to Audubon Terrace.

The Academy's collecting efforts did not produce "trivia." As a result of Johnson's urgings and the interest of the organization's members and their families, the Academy-Institute became the recipient of valuable historical and archival documents relating to some of the most eminent artists, writers, composers, and philosophers in the country's history. Its collection of portraits of these men and women constitutes both a social and artistic record of their times. The entire collection, together with the buildings that house them—like the museums, libraries, and public art collections founded at the same time throughout the country—contributes to the cumulative enrichment of American civilization.

1. The most important and thorough evaluation of the American Renaissance movement is the Brooklyn Museum's *The American Renaissance, 1876–1917* (Brooklyn, N.Y., 1979).

2. Charles A. Fenton, "The Founding of the National Institute of Arts and Letters in 1898," *The New England Quarterly* 32, no. 4 (December 1959): 436.

3. H. Holbrook Curtis to William M. Sloane, April 17, 1908, Academy-Institute Archives. As early as 1901, members feared that the Institute would "die of inanition" unless it engaged in "some active work." Many of the founding members resigned that year, because they believed that "the institution is of no value." See James Breck Perkins to Hamilton W. Mabie, January 23, 1901, Academy-Institute Archives.

4. Robert Underwood Johnson, *Remembered Yesterdays* (Boston, 1923), p. 441. There were only a few dissenters to the idea of an endowment; one was the Institute's president, William Dean Howells, who wrote to the treasurer, Hamilton Mabie, on October 9, 1902: *I am very sorry to differ with you and Mr. Johnson in regard to the endowment of the Inst. I think the Inst. should remain poor, and free from every tie of gratitude for money benefactions, which as yet it has done nothing to deserve. For us to show a material appearance to the public before we have made any intellectual impression would be a grotesque mistake. I feel very strongly about the matter, and yet I should be so unwilling to oppose a majority that it is a serious question with one whether I ought not at once to resign from the Inst., and not take any part in a controversy which would not change my feeling.* Another dissenter was Henry James (see Cat. no. 13).

5. At a meeting of the Institute on April 25, 1902, Johnson moved the appointment of a Permanent Committee on Endowment. The Committee's minutes of its meeting on January 5, 1904, notes the significance of its membership list for "any one inclined to contribute to an endowment" and records the decision to arrange the membership of the Institute in two classes, "the smaller body [of] which should compose a 'National Academy of Arts and Letters'" (Academy-Institute Archives). The decision is given almost verbatim in Johnson's *Remember Yesterdays*, p. 442. Also see Laura Stedman and George M. Gould, *Life and Letters of Edmund Clarence Stedman*, vol. 2 (New York, 1910), p. 446.

6. Fenton, "Founding of the National Institute," p. 442.

7. Because it was difficult to assemble a quorum at meetings, the members of the Academy expanded their number to fifty in 1907–8. See Minutes of the Annual Meeting of the American Academy, May 1908, Academy-Institute Archives.

8. Executive Committee of the Academy, printed draft of a "Proposed Constitution" (1907). Also see Minutes of the Annual Meeting of the American Academy, May 1908, Academy-Institute Archives.

9. Robert Underwood Johnson to William Milligan Sloane, January 26, 1915, Academy-Institute Archives.

10. See Secretary's Report, November 18, 1915, Academy-Institute Archives. Actively opposing the charter of the Academy was California's congressman William Kent, whose "pet project"—the Hetch-Hetchy aqueduct and reservoir—had been strenuously opposed by Johnson as detrimental to the environment. Later, Kent is said to

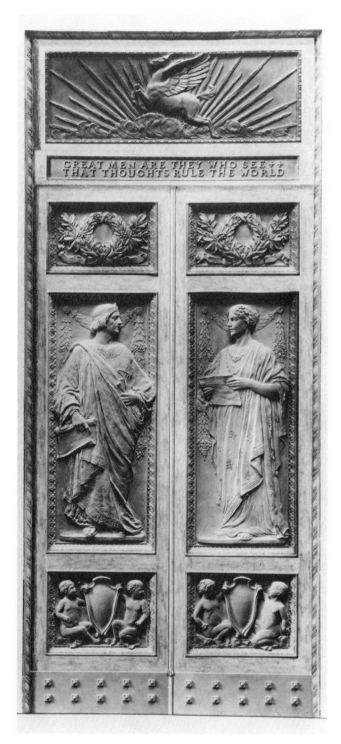

Figure 28. Bronze Doors of the Administration Building of the American Academy, designed by Herbert Adams. Photograph by Dewitt Ward, 1929. Academy-Institute Archives.

have apologized for his "cantankerousness." On April 13, 1916, the bill incorporating the Academy was passed, and was signed by President Wilson on April 17. See Richard Crowder, "The First Years of the American Academy of Arts and Letters and the National Institute of Arts and Letters," unpublished manuscript dated September 29, 1978, Academy-Institute Archives.

11. Secretary's Report, November 18, 1915, Academy-Institute Archives.

12. Broadside, "Archives of the American Academy of Arts and Letters," signed Robert Underwood Johnson, n.d., Academy-Institute Archives.

13. Robert Underwood Johnson to Henry Adams, August 26, 1916, Academy-Institute Archives. Johnson had earlier sought from Adams the manuscript of his *Mont St.-Michel and Chartres* or, if that were not possible, "an inscribed copy of the book for the Archives." He also wanted Henry to send something from the writings of his late brother, Charles Francis Adams; and when Henry "modestly" declined contributing anything of his own, Johnson asked him for memorabilia for Hay and LaFarge to honor the memory of such good men. "A canvas of LaFarge's and a ms. of Hay's," he suggested, "would add to the interest of the collection." Johnson to Henry Adams, April 14, 1915, April 26, 1915, Academy-Institute Archives.

14. U.S. Statutes, 63rd Cong., 1st sess., vol. 38-1, ch. 16, pp. 167, 172.

15. See Treasurer's Report, January 1, 1915, linking a collection relating to literature and the fine arts in America to an educational program and the need for tax exemption. The property tax was reported in the Minutes of the Meeting of the Board of Directors of the American Academy, April 22, 1915. At this meeting the Board expressed the hope that "before the close of the year we shall establish an educational status . . . which will result in exemption from this tax." At this juncture, the secretary, R. U. Johnson, "reported very encouraging progress in the collection of memorabilia for public exhibition as part of the Archives of the Academy. . . ." In February 1916 a tax-exempt status was granted to the Academy. See C. Rockland Tyng, Secretary, City of New York Department of Taxes and Assessments, to John B. Pine, Esq., February 15, 1916, Academy Minutes, 2: 58, Academy-Institute Archives.

16. R. U. Johnson, Annual Report of the Secretary, November 15, 1916, Academy-Institute Archives.

17. Leo Lerman, *The Museum: 100 Years and the Metropolitan Museum of Art* (New York, 1969), p. 121. Also see Nathaniel Burt, *Palaces for the People. A Social History of the American Art Museum* (Boston, 1977), pp. 233–348.

18. Minutes of the Board of Directors, February 18, 1915; R. U. Johnson to Cleveland H. Dodge, n.d., and Dodge to R. U. Johnson, n.d., in Minutes of the Board of Directors, May 13, 1927. In 1927 the program ceased, and the Art Museum Fund, as it was called, was converted to a Music Fund. Its cessation resulted from the fact that the Carnegie Foundation had also undertaken a program "for the promotion and establishment of Art Museums calling for an annual expenditure of at least $350,000." See Minutes of the Spring Meeting, April 21, 1927, Academy-Institute Archives.

19. Richard Guy Wilson, "The Great Civilization," in *American Renaissance,* pp. 63–68; Charles Dudley Warner and Samuel L. Clemens, *The Gilded Age* (New York, 1873).

20. Charles Eliot Norton to American Academy of Arts and Letters, December 29, 1905, Academy-Institute Archives.

21. Robert Underwood Johnson to Harrison S. Morris, April 20, 1914, Academy-Institute Archives.

22. Wilson, "The Great Civilization," p. 12.

23. See *American Renaissance* for illustrations of the work of these men.

24. Charles Dudley Warner, Address at First Public Meeting of the National Institute of Arts and Letters, Mendelssohn Hall, January 30, 1900. Published in part in *National Institute of Arts and Letters: Aims and Purposes of the Institute as Expressed by Past and Present Members* ([New York], May 15, 1941).

25. "The genteel tradition" was first defined by George Santayana in 1912 in a speech before a California group of philosophers. According to Santayana, the "genteel tradition," which represented "a survival of the beliefs and standards of the fathers," characterized a basic conservatism that he believed bound Americans to traditional tastes, ideas, and methods, and inhibited them from adjusting to new social realities. See *Winds of Doctrine* (New York, 1912), pp. 187–88.

26. *Dictionary of American Biography, s.v.* Wister.

27. Hamlin Garland, quoted in Malcolm Cowley, "Sir: I Have the Honor," *The Southern Review* 8, n.s. 1 (winter 1972): 4–5.

28. Johnson, *Remembered Yesterdays,* p. 439.

29. *Ibid.,* pp. 82, 87.

30. *Ibid.,* p. 88. For the Gilders' "evenings at home," see p. 91.

31. *Ibid.,* p. 134. The timing of Johnson's "retirement" from *The Century* in June 1913, and his call for items to form a collection in 1915 is interesting to speculate about. It is possible that, given his disappointment with the direction taken by the trustees of his magazine, he transferred his expectations and energies to the project of an Academy collection.

32. *Ibid.,* p. 440.

33. *Ibid.,* p. 439.

34. Beatrice Gilman Proske, *Archer Milton Huntington* (New York, 1963), p. 1. Also see James T. Maher, *The Twilight of Splendor, Chronicles of the Age of American Palaces* (Boston, 1975), pp. 215–309. Archer was acquainted with the artists involved with the Academy long before the institution was organized, Vedder, Blashfield, Mowbray, and Francis M. Lathrop all having executed murals for his mother's home in the 1880s. He also met them at the Gilders' Friday nights (see Proske, *Huntington,* pp. 4–5; Maher, *Twilight of Splendor,* p. 281). For Archer M. Huntington's obituary and list of organizations he supported, see *The New York Times,* December 12, 1955.

35. See "Chronological List of Gifts of Money and Property to the American Academy of Arts and Letters by Archer M. Huntington, Anna H. Huntington, and Arabella D. Huntington," May 19, 1936, Academy-Institute Archives. The directors were constantly seeking ways to use the auditorium and its organ consistent with the organization's tax-exempt status. See Minutes of the Board of Directors, January 9, 1931; Minutes of Spring Meeting of the Academy, April 23, 1931; entries for November 8 and 19, 1928, and November 1930, in "Chronological List," for fund for organ and its upkeep up to 1936, Academy-Institute Archives.

36. Minutes of the Spring Meeting of the American Academy, April 21, 1927, Academy-Institute Archives.

37. In 1927 Huntington gave the Academy $100,000 to establish a fund for Art Exhibitions, now known as the Huntington Exhibition Fund. See entry in "Chronological List of Gifts . . . by Archer M. Huntington . . .," for February 1927. Also see "Report of the

Art Committee April 1927," signed by Grace Vanamee and Frank P. Crasto, Jr., in Minutes of the Spring Meeting, April 21, 1927, Academy-Institute Archives.

38. Robert Underwood Johnson's secretary to Herbert Adams, August 13, 1917, Academy-Institute Archives.

39. Kenyon Cox, *The Classic Point of View* (1911; reprint ed., Freeport, N.Y., 1968), pp. 21, 22.

40. Issued in three volumes, 1909, New York, N.Y.

41. Herbert Adams to F. W. Ruckstull, August 29, 1917, Academy-Institute Archives.

42. Adolph Weinman, "Memorial Tribute to Herbert Adams," unpublished manuscript, p. 35, Academy-Institute Archives.

43. *Ibid.,* p. 37.

44. Herbert Adams to Robert Underwood Johnson, July 14, 1914, Academy-Institute Archives.

45. Richard Guy Wilson, "Architecture, Landscape, and City Planning," in *American Renaissance,* p. 75.

46. Cass Gilbert to Robert Aitken, July 19, 1932, Academy-Institute Archives.

47. Kenyon Cox, "The Classic Spirit," in *The Classic Point of View,* pp. 3–4.

48. See "Chronological List of Gifts . . . by Archer M. Huntington . . .," Academy-Institute Archives.

49. Kenyon Cox, "Museums of Art and Teachers of Art," in *Art Museums and Schools. Four Lectures by G. Stanley Hall, Kenyon Cox, Stockton Axson, and Oliver S. Tonks* (New York, 1913), p. 56.

50. Robert Underwood Johnson to Harrison Morris, October 4, 1933. See also Harrison S. Morris to Nicholas Murray Butler, April 8, 1940, in which Morris comments that Johnson "(with me) sensed the change from dignified devotion to Beauty and Taste fast coming, and he despaired of stemming the tide" (Academy-Institute Archives). For a lengthy discussion concerning the Institute's "dissatisfaction . . . resulting from the distinction which has been drawn between the Academy and the Institute," see Minutes of the Meeting of the Board of Directors of the American Academy, June 10, 1921, Academy-Institute Archives.

51. Minutes of Meeting of Board of Directors of the American Academy, October 13, 1939, Academy-Institute Archives. Formal notice of the proposed change in the bylaws was sent to the membership on October 26, 1939.

52. See file in Academy-Institute Archives containing memoranda, letters, and responses from the membership concerning the controversy over the Academy-Institute relationship, 1939–1940.

53. Sinclair Lewis to Nicholas Murray Butler, [1939], Academy-Institute Archives.

54. Eugene O'Neill to Walter Damrosch, May 4, 1940, Academy-Institute Archives.

55. Walter Damrosch to William Lyon Phelps, Secretary of the American Academy, [1940], Academy-Institute Archives. Copies of this letter were sent to the Academy's membership.

56. Ezra Pound to Walter Damrosch, April 7, [1940], Academy-Institute Archives.

57. Walter Damrosch to Walter Lippmann, October 20, 1940, Academy-Institute Archives.

58. James Truslow Adams to Walter Damrosch, May 8, 1940, Academy-Institute Archives.

59. Minutes of Annual Meeting of the American Academy of Arts and Letters, October 22, 1943, Academy-Institute Archives.

60. Minutes of Meeting of Board of Directors of the American Academy, January 22, 1941, March 12, 1941, October 20, 1942, Academy-Institute Archives. Also see the Minutes of the Meeting of the Members of the Committee on Grants of the American Academy of Arts and Letters and the National Institute of Arts and Letters, January 26, 1944, Academy-Institute Archives.

61. In 1966–1967 the Academy-Institute resumed active collecting, and acquired more than fifty drawings and other works of art either by purchase or gift. The passage of the Tax Reform Act of 1969 discouraged donations by limiting deductions for gifts of art works to the cost of materials. See Leon Kroll, chairman of the Art Committee of the Academy to members of the Art Department of the Institute, April 3, 1967, Academy-Institute Archives.

62. Mark A. DeWolfe Howe to "The Directors of the American Academy," quoted by Van Wyck Brooks in Minutes of Meeting of Board of Directors of the American Academy, November 24, 1941, Academy-Institute Archives.

63. Minutes of Spring Meeting of the American Academy of Arts and Letters, April 23, 1931, Academy-Institute Archives.

THE PORTRAITS
CATALOGUE OF THE EXHIBITION

1.

Maude Adams 1872-1953

By Rudolph Evans 1878-1960
INSTITUTE, 1926

Plaster bust; 33.9 x 23.2 x 26 cm. (13⅜ x 9⅙ x 10¼ in.); circa 1906; Inscription: *For Dr. Edlich Jr / R Evans Sc*;
Gift of Theodore J. Edlich, Jr., 1963[1]

Rudolph Evans began his career as a sculptor in the studio of U.S.J. Dunbar in his native Washington, D.C. At nineteen, he went to Paris and studied at the Académie Julian before gaining entrance to the prestigious École des Beaux-Arts, where he was the only American student to be admitted in 1898. While in Paris, he visited Rodin, whose emotionally charged work presented an appealing alternative to the cool academicism of the École. Evans returned home in 1900, and two years later began a portrait of the celebrated actress Maude Adams. Like thousands of Americans, the twenty-six-year-old sculptor had admired the beautiful star of the New York stage from afar. When he received the portrait commission, he reported, he "came from Washington to New York like a bird."[2]

At the turn of the century, Miss Adams was at the height of her career. Born in Salt Lake City in 1872, she made her first stage appearance as a baby in her mother's arms. As a child she worked regularly, moving as a matter of course into ingenue roles when she came of age. By the 1890s her reputation was growing steadily, and when the enormously popular John Drew joined Frohman's Theater in 1892, Maude Adams starred opposite him. She became known for her roles in the plays of her friend J. M. Barrie, and on November 5, 1905, she first played the part that had been written with her in mind: Peter Pan. From that day on, she was always identified with Barrie's most-loved character. Evans saw her in this role in an early Washington, D.C., production.[3]

To help Maude Adams appear convincingly as Peter Pan, the painter John White Alexander and his wife, Elizabeth, agreed to design the costumes for the play, John designing and drawing, and Elizabeth cutting, sew-

ing, and adjusting. It was the beginning of a continuing collaboration; later, Alexander would assist Adams with scenery and lighting effects as well.

The portrait of Adams caused some fiscal problems for the sculptor. In 1902, he had given the first of his portrait busts to the actress.[4] In response, Adams indicated her willingness to pay for his work and suggested that at some future date he do another bust for a fee.[5] Following Evans's return from a second trip to Europe, Adams sat again for the sculptor for this portrait, which was finished probably by mid-1906. When Evans sent Maude Adams a bill, she protested, maintaining that she had never actually commissioned a second portrait. In the end Adams bought a copy of the head in plaster and another in bronze, which she hoped Mr. Frohman would place in the lobby of his theater.[6]

Evans's portrait of Maude Adams is one of his most powerful and least conventional busts. The sitter's windswept hair gives animation to the work, as does the artist's decision to cut the bust off irregularly, as if it were a mask, and to leave the back of the piece concave. The asymmetrical and fragmentary planes of the hair, which give the portrait its striking movement and life, suggest the innovations of Rodin, while the classically rendered features betray the idealizing tendencies of a student of the École des Beaux-Arts. Especially when compared with his later work, the Maude Adams portrait seems strikingly progressive, or perhaps unfinished. Evans executed the commissions that followed in a more restrained manner. These included portraits of such noted figures as William Jennings Bryan, Robert E. Lee, and Bernard Baruch, as well as classically inspired nude and draped figures. Ignoring contemporary trends, Evans maintained

a traditional style, considering modernism a travesty of proper aesthetic goals. The work of Picasso, for instance, he called an "abomination."[7]

Evans was proposed for membership in the Institute in 1926 by fellow sculptors Lorado Taft, Hermon A. MacNeil, and John Flanagan. In 1956 he declined Institute President Douglas Moore's invitation to attend a meeting, reporting that he had been suffering with "an extremely *painful spinal illness* during the past thirteen years." The sculptor wrote his letter in the end pages of a booklet which described Washington, D.C.'s newest monument. "My breakdown came at the completion of the heroic Memorial Statue of Jefferson in wartime conditions," he explained.[8] Today Rudolph Evans is most often remembered for this colossal statue of our third President, executed for the Jefferson Memorial, and dedicated by President Franklin D. Roosevelt in 1947.

1. Theodore J. Edlich, Jr., had been the sculptor's physician for many years. He presented the bust, a gift to him from Evans, to the Academy-Institute "in his [Evans's] memory." Theodore J. Edlich, Jr., M.D., to the National Institute of Arts and Letters, September 22, 1963, Academy-Institute Archives.

2. Tescia Ann Yonkers, "Rudolph Evans: An American Sculptor (1878–1960)" (Ph.D. diss., The George Washington University, 1984), vol. 2, p. 340.

3. *Ibid.,* vol. 2, p. 361.

4. *Ibid.,* vol. 2, p. 340. The portrait is unlocated.

5. *Ibid.,* vol. 2, p. 361.

6. See *Ibid.,* vol. 2, pp. 361–65, 340–41 for an inconclusive account of the details surrounding these portraits, based upon Yonkers's examination of Evans's papers.

7. *Ibid.,* vol. 1, p. 21.

8. Rudolph Evans to Douglas Moore, May 15, 1956, Academy-Institute Archives.

2.

George Arliss 1868–1946
By Cecilia Beaux 1855–1942

INSTITUTE, 1930; ACADEMY, 1933

Crayon on paper; 47.5 x 34.8 cm. (18¹¹⁄₁₆ x 13¹¹⁄₁₆ in.); October 26, 1913;
Inscription: *To George Arliss/Cecilia Beaux*; Gift of Miss Beaux

"When Cecilia Beaux recently appeared before the American Academy of Arts and Letters to receive its gold medal," Preston Wright reported for the Republic Syndicate in 1926, *public recognition was only being given to a fact which for many years has been universally conceded—that she is the foremost woman artist of her country. . . . It is not proper to define Miss Beaux* [in this way]. *. . . Art knows no sex. Her place is fixed among the truly great of our American painters.*[1]

Mr. Wright was correct on one account: Miss Beaux's talents had been recognized for decades, and as early as 1905 she was mentioned as a candidate for membership in the Institute. But the rules of the Institute had not caught up with Mr. Wright's thinking about gender. After the rather perfunctory election of Julia Ward Howe in 1907, a debate over the election of women raged within the organization for almost twenty years. Members with feminist sympathies had to be content with giving prizes to women, which was particularly convenient since the gold medal was designated for nonmembers. It was not until 1926, seven months after Miss Beaux received her award, that Margaret Deland, Edith Wharton, Agnes Repplier, and Mary E. Wilkins Freeman were elected to the Literature Department of the Institute. In 1930 Miss Beaux became the first woman painter to be so honored. She was elevated to the Academy three years later, given a retrospective exhibition in the Academy's galleries in 1935–1936, and was voted another gold medal, this time from the Institute, just before her death in 1942.

Primarily a portraitist, Cecilia Beaux painted many notables, friends, and relatives, but, as Arthur Train noted when presenting the Institute's medal, she "never accepted a commission unless the subject appealed to her artistic

sense. Indeed, I know of one case where a man of vast wealth offered her whatever sum she might name if she would paint his daughter, but she refused."[2]

Occasionally the artist approached her own subjects. Miss Beaux wrote to George Arliss in the fall of 1913, telling him that she would be pleased to draw his portrait. Arliss had been a star on the American stage since he had come to New York from his native London in 1902, and at the time of Miss Beaux's request, he was in Boston for a six-month run of his successful play *Disraeli*.

Arliss arranged to see the artist between performances on October 26.[3] In her diary, Beaux noted that although the day was dreary, pouring rain and stormy, Arliss had come to her home, Green Alley, in Gloucester by train and she was able to draw all afternoon. Her portrait records the middle-aged actor in mid-career wearing his trademark monocle, suave and confident but with a touch of humor. Miss Beaux told her diary that Arliss was very pleased with his portrait but, although she signed it "To George Arliss," she retained it and sent the actor a replica.[4]

In 1930 George Arliss was selected as the fifth recipient of the Academy's Medal for Good Diction on the Stage. The medal had been conferred for the first time in 1924, but as early as 1915 Permanent Secretary Robert Underwood Johnson had begun soliciting funds from "ladies of means" for an award that, as he explained to Mrs. August Belmont, would "do something to promote a conservatory on the French lines so that diction may not be left to the chance of criticism of a stage manager, but may embody the very best traditions."[5] Mrs. Belmont was not convinced. She called the idea "an extravagant beginning for a plan, the efficacy of which in this country remains to be proved."[6] As always, Johnson perse-

vered, and in 1922 he persuaded the industrialist Cleveland H. Dodge to allow $5,000 of his $25,000 gift to the Academy to be used as an endowment for a medal that would, in Johnson's words, "not only be a stimulus to better elocution and address upon the stage but would also commend the Academy to public favor by its activity in a matter of such close relationship to the life of the play-going classes."[7]

Early in his campaign to establish the diction prize, Johnson insisted that it was imperative that the Academy "promote drama of the best type in the face of the ruinous commercial competition of the moving picture."[8] However, by the time Arliss received the medal, he was renowned for his work on the screen as well as on stage, having just received an Oscar for the 1929 re-creation of his stage role in *Disraeli*.

In presenting the award to Arliss in 1930, the Academy's spokesman, Harvard Professor of Playwriting George Pierce Baker, aware of the new role of the movies in American culture and of Arliss's recent entry into the field, stated that the medal was being given *not only for the speech which we have long recognized on the stage for its precision, its clearness, and its beauty, but above all for the way in which recently—duplicating your successes on the stage—you have given us and your fellow workers a standard for speech in that new form of theatrical art—the talking picture.*[9]

Arliss, too, was aware of the power of this new medium in influencing "the diction of the masses." "America," he noted in his acceptance speech, *has frequently maintained the purity of the language which in course of years has become vitiated in England. . . . The chief fault in speech in America I should describe as sloppiness, and the outstanding defect in England, snippiness. . . . The American is never guilty of this straining after superiority. But in my opinion he errs on the other side. He is so afraid of being meticulous in his speech that he allows himself to become careless.*[10] Because of its contrast between American English and British English, Arliss's speech was quoted in newspapers across the country. But no one in the Academy or general public seems to have been concerned that a medal from the American Academy was presented to an Englishman. Of the eighteen recipients of this medal since George Arliss, one-third were born in Great Britain.

1. Preston Wright, "Fellow Student Saw Greatness of Talent of Cecilia Beaux, Who Soon Was Honored by Paris Salon," Norfolk, Virginia, *Pilot,* July 25, 1926.

2. "Presentation to Cecilia Beaux of the Gold Medal of the Institute by Arthur Train, President of the National Institute of Arts and Letters," n.d. [May 1942], p. 2, Academy-Institute Archives.

3. George Arliss to Cecilia Beaux, October 14, 1913, Archives of American Art, Smithsonian Institution.

4. Cecilia Beaux, manuscript diary, Archives of American Art, Smithsonian Institution.

5. [Robert Underwood Johnson] to Mrs. August Belmont, June 4, 1915, Academy-Institute Archives.

6. Eleanor R. Belmont to Robert Underwood Johnson, April 12, 1916, Academy-Institute Archives.

7. Report of the Secretary [Robert Underwood Johnson], Minutes of the American Academy of Arts and Letters, November 18, 1915, Academy-Institute Archives.

8. *Ibid.*

9. "Mr. George Pierce Baker, Member of the American Academy of Arts and Letters, Presents the Medal for Good Diction on the Stage to Mr. George Arliss," *Proceedings to Mark the Formal Opening of the New Building of the American Academy of Arts and Letters* (New York, 1931), p. 340.

10. "Mr. Frank Gillmore, President of the Actor's Equity League, Reads an Address by Mr. George Arliss Accepting the Medal for Good Diction on the Stage," *Proceedings to Mark the Opening of the New Building,* pp. 347, 348, 351.

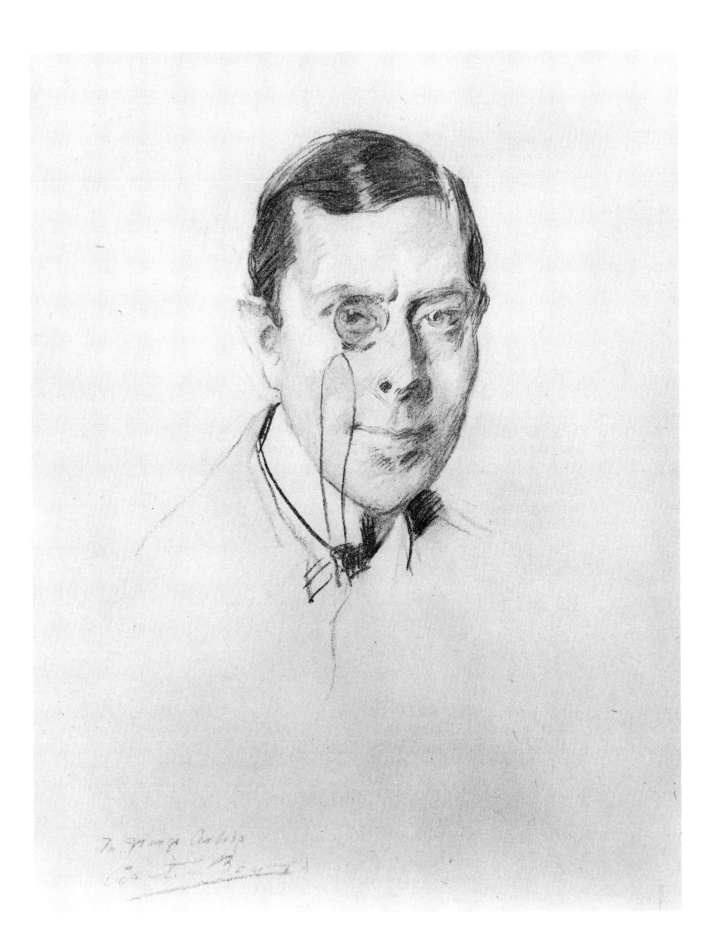

To George Cukor

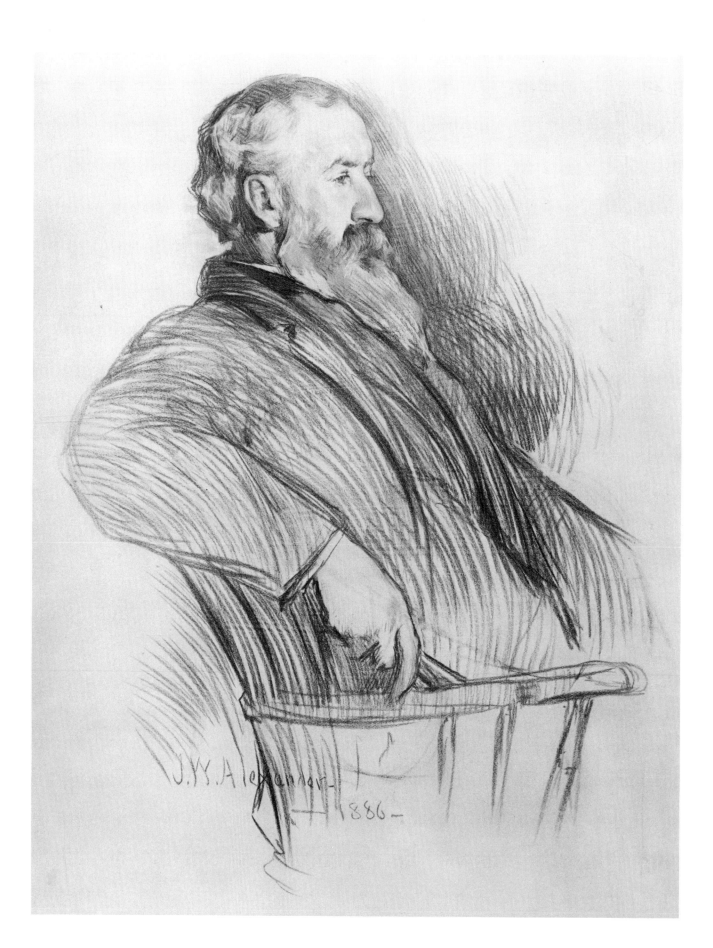

42

3.

John Burroughs 1837–1921

INSTITUTE, 1898; ACADEMY, 1905

By John White Alexander 1856–1915

INSTITUTE, 1898; ACADEMY, 1910

Crayon drawing, signed; 97.5 x 72.7 cm. (38⅜ x 28⅝ in.); 1886;
Gift of Mrs. John White Alexander, 1916

John Burroughs's lifelong interest in nature began during his childhood in New York's Catskill Mountains, where he could readily explore the untamed countryside. After brief schooling in his native Roxbury, Burroughs decided to become a teacher, taking time off in 1856 for a short period of study at the Cooperstown Seminary. There he was introduced to the writings of Ralph Waldo Emerson, whose work so influenced him that Burroughs's essay "Expression," published anonymously when he was twenty-three, was entered in *Poole's Index* as Emerson's work.

In October 1863 Burroughs became a clerk in the Currency Bureau of the Treasury Department, a position he held until 1872. During his stay in Washington, D.C., he befriended Walt Whitman, whose work he had admired for several years. Burroughs's first book, *Notes on Walt Whitman as Poet and Person,* published in 1867, was in many ways a collaboration—Whitman suggested the title and some of the chapter heads, and wrote portions of the text itself. "I owe more to him than to any other man in the world," Burroughs said of Whitman. "He brooded me; he gave me things to think of; he taught me generosity, breadth, and an all-embracing charity."[1]

Burroughs's first nature essay, "With the Birds," appeared in the *Atlantic* in 1865, and six years later, *Wake-Robin,* a book on birds so named by Whitman, was published to favorable reviews. During an 1871 trip to England on behalf of the Treasury Department, Burroughs gathered material for four essays, published as *Winter Sunshine* in 1875. Henry James, who reviewed the volume in the January 27, 1876, issue of the *Nation,* described Burroughs as "a sort of reduced, but also more humorous, more available, and more sociable Thoreau."

By this time Burroughs was firmly launched on a literary career and would publish at regular intervals for the rest of his life. Recalling Burroughs's work in 1922, Bliss Perry remarked: *He remained the friendly familiar essayist of the eighteen-sixties, with the same keen eye and delicate ear, and with a tireless, ever-increasing curiosity about the physical universe and the ultimate causes of things. If he watched birds somewhat less as he grew older, he thought more constantly about geology and astronomy, biology and physics, and the origin and destiny of man. . . . He wrote with simplicity and dignity about the vast, the insoluble problems raised by contemporary science and philosophy. He even ventured upon the field of theology.*[2]

Burroughs contributed essays to many periodicals, including the *Century Magazine,* for which John White Alexander made this portrait of him in 1886. The artist filled the large sheet of paper with muscular, energetic strokes, blocking in the composition rapidly. Concentrating on the pensive look in his sitter's eyes, Alexander used small, bright points of light to define Burroughs's profile, outlining it with dark, cross-hatched shadows. In his journal the sitter called the drawing "a good picture . . . but not a good likeness."[3] Burroughs was generally critical of his portraits, always complaining that the artist never saw him as he saw himself.

Burroughs's friends came from all walks of life, and included Theodore Roosevelt, William Dean Howells, Thomas Edison, and Henry Ford. Robert Underwood Johnson, never one to let a good contact go unused, approached Burroughs in 1914 about soliciting a donation from Ford for the Academy's endowment. A year earlier Ford had introduced the assembly-line system into his factories, and the Model T, the first automobile de-

signed for a mass market, was achieving success nationwide. Although Johnson was hopeful of tapping into Ford's profits, Burroughs was skeptical. "I hope Mr. Ford will be moved by your pleading, but I am doubtful," he reported to Johnson. "He is shy of colleges & academies & of college men—will not employ a college graduate if he can avoid it."[4] Ford, described repeatedly by Burroughs as a "big hearted" man who "likes to help the poor & the laboring classes," gave his money elsewhere.[5]

In 1916, when the Institute's Department of Literature was asked to nominate candidates for a Gold Medal for Essays or Belles-Lettres, Burroughs tied for first place with William Crary Brownell, and, by vote of those present at the annual members' meeting, the medal was awarded to Burroughs. In his journal Burroughs recorded that it was "a great surprise, but, near eighty, it means little to me."[6] His biographer reports that he commented, *They should have given it to some one else—Brownell, Paul Elmer More* [who placed ninth in the voting], *or some of those academic chaps—instead of to a rustic like me. I can imagine those men who have really earned it wondering why I should have it. "It doesn't belong to him," I can hear them say, "—an old fellow who writes about birds and chipmunks."*[7]

Burroughs, however, took a different tone in a letter to Institute Secretary Ripley Hitchcock: *The box containing the precious medal came safely. Not since I was a boy have I received so big & valuable a penny. The old copper cents I used to get as a boy for the cakes of maple sugar I used to make & sell, filled my eye about as completely as does this big disk of gold with its personal inscription. Still I guess it has a value to me that the old coppers did not possess. Needless to say that I feel greatly honored by its bestowal & hope my descendants will never be so pressed for their bread & butter that they will be tempted to convert it into cash. Please convey my hearty thanks to the members of the Institute.*[8]

The members of the Academy and Institute returned Burroughs's thanks with a memorial meeting after his death in 1921. In a speech on this occasion, Hamlin Garland remarked that "There was something in him, in his books, which tallied with the character and experiences of thousands of his readers. As he grew in years he gathered to himself an immense audience of students and nature lovers who were able to follow his footsteps and verify his discoveries."[9] He had no more devoted follower than Clara Barrus, who made a Boswellian record of her friend's life and published several biographical volumes. As a result of Dr. Barrus's friendship with Grace D. Vanamee, the Academy's first paid nonmember administrator whose husband had introduced Barrus to Burroughs, much of Barrus's research material, including photographs, scrapbooks, and correspondence, now rests in the Archives of the Academy-Institute.

1. Clara Barrus, *The Life and Letters of John Burroughs,* vol. 1 (Boston and New York, 1925), p. 113.

2. Bliss Perry, "Burroughs the Man of Letters," *Public Meeting of the American Academy and the National Institute of Arts and Letters in Honor of John Burroughs* (New York, 1922), pp. 32–33.

3. Barrus, *Burroughs,* vol. 1, p. 277.

4. John Burroughs to Robert Underwood Johnson, May 29, [1915], Academy-Institute Archives.

5. John Burroughs to Robert Underwood Johnson, March 29, [1914]; June 29, [1914], Academy-Institute Archives.

6. Barrus, *Burroughs,* vol. 2, p. 240.

7. *Ibid.,* vol. 2, p. 297.

8. John Burroughs to Ripley Hitchcock, December 7, [1916], Academy-Institute Archives.

9. Hamlin Garland, "Burroughs the Man," *Public Meeting . . . in Honor of John Burroughs,* p. 53.

4.

George Washington Cable 1844–1925

INSTITUTE, 1898; ACADEMY, 1908

By Abbott Handerson Thayer 1849–1921

INSTITUTE, 1898; ACADEMY, 1909

Oil on canvas, signed; 34.4 x 25.7 cm. (13⁹⁄₁₆ x 10⅛ in.); June 1881;
Gift of Daniel Chester French, circa 1918

Replying to a request for his 1905 dues, Abbott Thayer wrote to Hamilton Wright Mabie, "I have decided to drop out of the Inst. of Arts and Letters. I need all my five dollarses for too many very vital things."[1] Thayer's resignation was never acted upon, but the treasurer's dunning continued, and again in 1913 Thayer was forced to explain, "When I was first elected I was assured that men, if they were wanted, were wanted whether or no they could pay dues."[2] Undaunted, or perhaps unwittingly, Robert Underwood Johnson approached Thayer during the summer of 1916 about making a donation to the Academy's archives, suggesting that he buy back from the Century Company a portrait of fellow member George Washington Cable that he had painted in 1881. Had Johnson consulted the Academy's files before making this request, he would not have been surprised at the artist's reply: "even at $25.00," the purchase was out of the question. "I am dead broke," Thayer confessed. "My wife & I are mortgaging real estate to get on."[3]

Two years later Johnson found a buyer for the portrait. "You will be pleased to know," he wrote Thayer, "that Dan French has bought your portrait of Cable and has presented it to the archives of the Academy. He tells me that he was present when you were making it, which is an interesting circumstance."[4] Indeed Thayer was pleased, and he quickly acknowledged Johnson's letter, thanking him for a reminder of his "*precious* past"—a time thirty-seven years earlier when he was sharing a studio with Daniel Chester French in the YMCA building on 23rd Street in New York.[5]

Born in Boston in 1849, Abbott Handerson Thayer grew up in New Hampshire, studied at the National Academy of Design, and then traveled to Paris in 1875, where he worked in the atelier of Gérôme. Not long after his return to New York in 1879, he received a commission from *The Century Magazine* for a group of six portraits, including this image of Cable and those of Mark Twain [CAT. NO. 6] and Henry James [CAT. NO. 13].[6]

At thirty-seven, Cable was enjoying the first fruits of his success as a writer of socially observant local-color stories. In photographs from this period, the writer appears sharply intelligent, lighthearted, and even a bit mischievous. However, by casting a shadow across the lower portion of the canvas, Thayer accentuated Cable's eyes, giving him a soft and sympathetic expression that suggests the writer's sensitive insight into his literary subjects. Years later, Thayer explained his approach to portraiture to the critic Royal Cortissoz: "Let the painter once look upon a person who has . . . *one dominant greatness* . . . and in his own heart the image of such a personality wakes into brilliant ringing clearness, and *takes the helm.*"[7]

Thayer worked steadily throughout his life, painting poetic views of the New Hampshire landscape dominated by Mount Monadnock, and introspective allegorical portraits of women and children. A lifelong interest in wildlife led him to give intensive study to animal coloration, and during World War I he unsuccessfully tried to persuade the Allies of the military utility of camouflage. Despite steady commissions and public interest in his work, financial stability eluded the artist.

As a writer of local-color fiction, George Washington Cable was in the right place at the right time. After the Civil War northern magazines clamored for pieces dealing with exotic domestic places, particularly the South, which had been a taboo subject during the slavery controversy and war. Cable's work was exactly what was

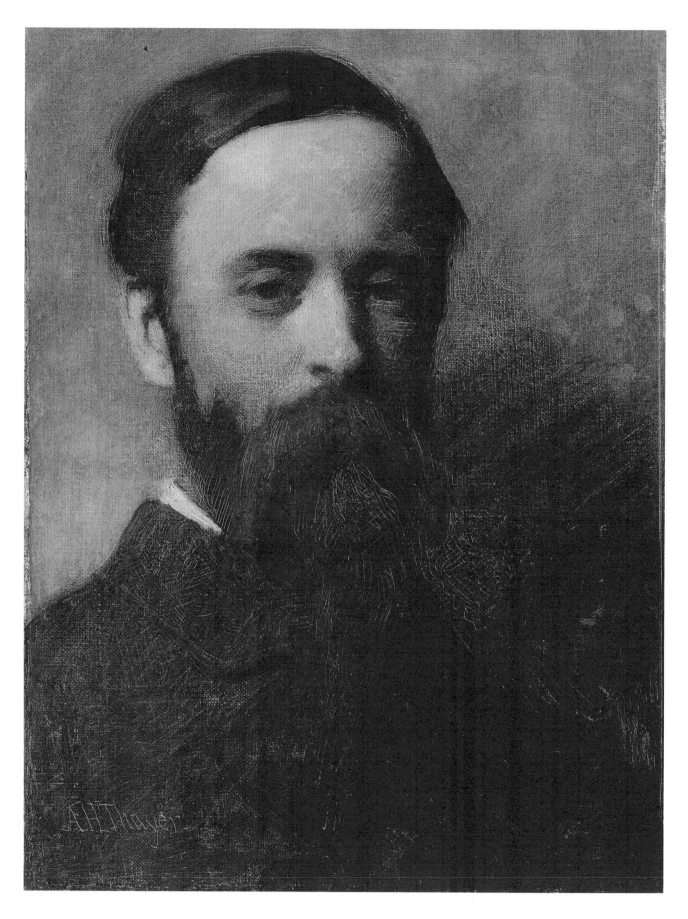

required. He brought a new realism to southern fiction in tales dealing with class and caste, race relations, the clash of the past with the present, and the picturesque idiosyncracies of his native New Orleans.

By 1881 Cable had been connected with *The Century* and its progenitor, *Scribner's Monthly,* for a number of years. His first story was published in *Scribner's* in 1873, and in 1879 Charles Scribner's Sons issued *Old Creole Days,* a collection of previously published stories. The volume was an immediate and unanimous success, turning Cable into a literary celebrity. When the author visited New York in June 1881 to meet with his publishers and to sit for Thayer, he wrote home to his wife and mother in disbelief that he had met John Hay and Augustus Saint-Gaudens. A week later he met Mark Twain for the first time; later, the two men would make reading tours together, and during the height of Cable's fame his work was often compared to that of his friend.

Cable's fiction during this period was characterized by his willingness to address controversial issues—a quality lacking in his later efforts. His northern editors encouraged him to avoid disturbing questions and concentrate, instead, on the picturesqueness of southern life. Unfortunately, his editors prevailed, and by the time he died in 1925, Cable was all but forgotten in literary circles. In a commemorative tribute to Cable, Robert Underwood Johnson recognized his eclipse, but encouraged his associates in the Academy to "Reweigh the jewel and retaste the wine," to discover a man of genius. "I believe the final verdict of criticism will be that *The Grandissimes* is not only the greatest American novel to date," Johnson declared, "but that it stands in the front rank of the fiction of the world."[8] Cable's ambitious 1880 historical romance is almost as obscure today as Johnson's own reputation, and it is interesting to note that it was the young Mr. Johnson who had edited the novel. "You must remember that my reputation as an editor is involved as well as yours as a writer," he had earlier warned Cable.[9]

As Permanent Secretary of the Academy, Johnson often consulted the novelist on matters relating to the organization, and Cable's responses were frank and pointed. In a long letter in 1908, for example, Cable considered the Academy's influences in public matters, among them the selection of a national hymn. If "our action prove in any way unfortunate we might incur something very much like ridicule," he conceded. "But if the fear of making a mistake or of incurring ridicule is going to rule us we shall never do anything, and shall make the radical mistake of remaining a mere shadow when our duty to our national appointment is that we be a genuine substance." He insisted that by taking a stand on issues the Academy would become more than "a shadow, and should it make us no more tha[n] a voice the voice would be one of power, dignity and public service."[10] Perhaps Cable recognized the repressive influence of the genteel Mr. Johnson, whose aversion to conflict had helped to make Cable's own work a mere shadow.

1. Abbott H. Thayer to Hamilton Wright Mabie, June 8, 1905, Academy-Institute Archives.

2. Abbott H. Thayer to Samuel Isham, February 24, 1913, Academy-Institute Archives.

3. Abbott H. Thayer to Robert Underwood Johnson, July 29, 1916, Academy-Institute Archives.

4. Robert Underwood Johnson to Abbott H. Thayer, April 16, 1918, Academy-Institute Archives.

5. Abbott H. Thayer to Robert Underwood Johnson, April 24, 1918, Academy-Institute Archives.

6. Thayer's portrait of Cable was rendered into a wood engraving for the frontispiece of the February 1882 issue of *The Century Magazine.*

7. Abbott H. Thayer to Royal Cortissoz, April 14, 1915, Thayer Papers, Archives of American Art, Smithsonian Institution.

8. Robert Underwood Johnson, "George Washington Cable," in *Commemorative Tributes of the American Academy of Arts and Letters, 1905–41* (New York, 1942), pp. 179, 180.

9. Arlin Turner, *George W. Cable: A Biography* (Durham, N.C., 1956), p. 95.

10. George Washington Cable to Robert Underwood Johnson, November 3, 1908, Academy-Institute Archives.

William Merritt Chase 1849-1916

INSTITUTE, 1898; ACADEMY, 1908

By Augustus Saint-Gaudens 1849-1907

INSTITUTE, 1898; ACADEMY, 1904

Bronze bas-relief, 74.9 x 55.9 x 5.2 cm. (29½ x 22 x 2¹⁄₁₆ in.); 1888;
Inscription: WILLIAM MERRITT CHASE IN HIS FORTIETH YEAR FROM HIS FRIEND/AVGVSTVS SAINT-GAVDENS NEW-YORK AVGVST
M D C C C LXXXVIII; Gift of Mrs. William Merritt Chase, 1918

Illustrated in color on the front cover

When William Merritt Chase was elected to the Academy in 1908, he wrote to Robert Underwood Johnson that he felt "highly complimented to be elected a second time to the Academy of Arts and Letters." He went on to assure Johnson that "You will find that I was one of the first of the artists to become a member of this distinguished society of distinguished men."[1] Johnson wrote back to tell Chase that he had earlier been elected to the National Institute of Arts and Letters, and that the current honor was indeed more prestigious.

Chase's confusion is understandable, not only because of the unusual structure of the new organization, but also because of the number of societies to which he belonged. His name was included on the roster of members of the American Art Club, American Watercolor Society, Brooklyn Art Association, Salmagundi Club, New York Etching Club, Tile Club, and the Society of Painters in Pastel. He had been elected an Academician of the National Academy of Design in 1890, and had served for many years as president of the Society of American Artists, which he had joined in 1878. That same year, Chase began teaching at the newly formed Art Students League in New York. When Augustus Saint-Gaudens joined the League faculty in 1888, he and Chase were already old friends, having met at sessions of the Society of American Artists, which Saint-Gaudens had helped to found.

During the summer of 1888 Chase and Saint-Gaudens took portraits of one another in the sculptor's New York studio, and while they worked, Kenyon Cox painted Saint-Gaudens in action. Although the painting was destroyed (along with Chase's portrait of the sculptor) in the fire at Saint-Gaudens's studio in 1904, Cox made a copy of it from a photograph for a Saint-Gaudens memorial exhibition at the Metropolitan Museum of Art in 1908. The sculptor's pose in Cox's portrait mirrors Chase's in the bronze relief, and with his reddish hair, intense concentration, and robust stance, Saint-Gaudens appears a very vital forty. Chase, who was the same age, seems equally assured and energetic. Dressed in his painting clothes—a smock, bow-tie, and tam-o-shanter—Chase reaches across the panel toward the easel on which he is painting Saint-Gaudens. The sculptor placed Chase's canvas just beyond the edge of the plaque, and with its high relief and diagonal composition, the portrait has an exuberance and immediacy not present in many of Saint-Gaudens's earlier efforts. The small Pegasus medallion at the lower left foreshadows the Academy's insignia, which would be designed almost three decades later by James Earle Fraser, who had been Saint-Gaudens's assistant.

Chase's sister-in-law, Virginia Gerson, has stated that Chase treasured his sculpted portrait and had it built into the entryway of his home at Shinnecock Hills on Long Island.[2] Following Chase's death in 1916, his widow gave the portrait to the Academy, and in 1934 Miss Gerson added to the Chase archive a small, gilt-edge tintype of Chase, James Abbott McNeill Whistler, and two others taken in a London street. "The particular interest is that it *proves something!*" she explained to Grace Vanamee, the Academy's administrator. "One summer in Paris Mr. Chase had a *straight brimmed* silk hat made. The *next year* Whistler began wearing a straight brim, and after that *never went back to the curley brim* top hat again,—but always said that Chase had copied his." She added that "Mr. Chase always kept the little tintype for the fun of it."[3] Whistler's stance in the tintype is strikingly similar to his pose in the portrait Chase painted of him in 1885. Although

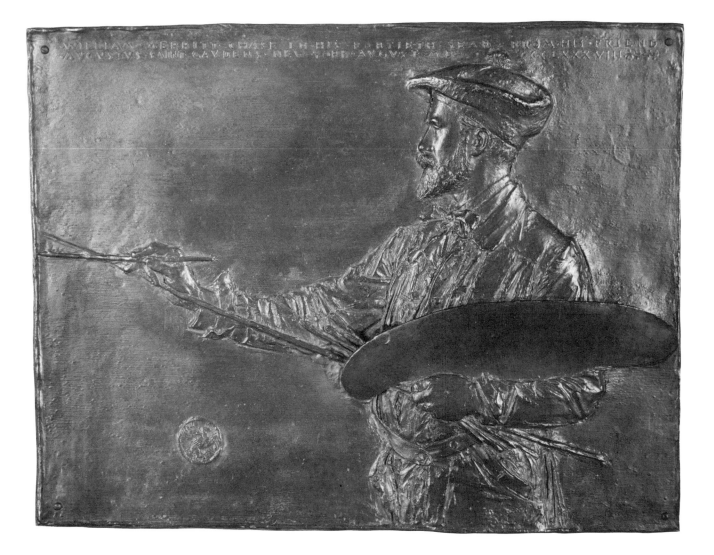

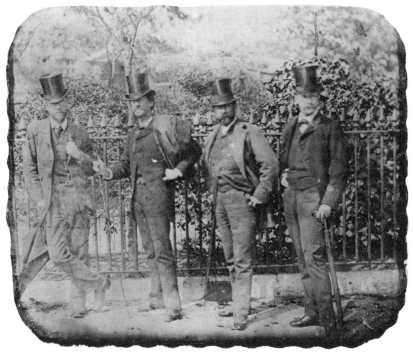

Figure 1.
Charles Miller, James Abbott McNeill Whistler, William Merritt Chase, and Mortimer Menpes on a London street, tintype by an unidentified photographer, circa 1885, 7.2 x 8.6 cm. (2⅞ x 3⅜ in.). Academy-Institute Archives, gift of Virginia Gerson, 1934.

Chase and Whistler had agreed to paint each other's portrait, Whistler never finished his of Chase. Chase's portrait of Whistler, on the other hand, engendered an extraordinary amount of controversy when it was exhibited in the United States, eventually resulting in the crumbling of his friendship with Whistler. In the press Chase was accused of producing a foppish caricature of his former friend. It is tempting to speculate that Chase kept the tintype on hand to prove something else—that his view of the great Whistler had a firm basis in fact [see Fig. 1].

In 1928 the Academy held an exhibition of Chase's work, "continuing its policy of bringing to the attention of the American public the achievements of great native artists."[4] Chase, who was born in Indiana, studied with Barton S. Hayes in Indianapolis before going to New York, where he enrolled at the National Academy of Design. In 1872 he went to Munich and studied at the Royal Academy, producing dark, dramatic paintings in the style of the Old Masters. Chase returned to New York in 1878, began his long tenure as an instructor at the Art Students League, and continued to paint a variety of subjects, including portraits, nudes, genre scenes, landscapes, and still-lifes. By the late 1880s his dark Munich palette had grown lighter and fresher, influenced by the Impressionists and plein-air painters. In 1891 Chase founded the Shinnecock Summer School of Art on Long Island, where he taught and painted sparkling landscapes. An influential teacher, Chase continued to give classes at various locactions until shortly before his death in 1916, often taking groups to Europe for the summer. In his introduction to the catalogue which accompanied the Academy's exhibition of Chase's work, Royal Cortissoz noted that the painter "is remembered both for what he did and for what he taught others to do. He was a constructive figure in his generation. The whole generous force of the man was spent in fostering the growth of good painting in American art."[5]

1. William Merritt Chase to Robert Underwood Johnson, February 5, 1908, Academy-Institute Archives.

2. Burke Wilkinson, *Uncommon Clay: The Life and Works of Augustus Saint Gaudens* (San Diego, New York, London, 1985), p. 194.

3. Virginia Gerson to Grace D. Vanamee, November 4, 1934, Academy-Institute Archives.

4. "William Merritt Chase." Press release prepared by the American Academy of Arts and Letters for the Chase exhibition, 1928, Academy-Institute Archives.

5. Royal Cortissoz, "Foreword," *A Catalogue of an Exhibition of the Works of William Merritt Chase,* April 26–July 15, 1928 (New York, 1928), p. 10.

6.

Samuel Langhorne Clemens (Mark Twain) 1835-1910

INSTITUTE, 1898; ACADEMY, 1904

By Abbott Handerson Thayer 1849-1921

INSTITUTE, 1898; ACADEMY, 1909

Oil on canvas, signed; 33.9 x 29.2 cm. (13⅜ x 11½ in.); 1882; Academy-Institute purchase, 1942[1]

On March 5, 1898, William Dean Howells wrote to Samuel Langhorne Clemens to tell him that *We organized the Institute the other night, with C.D.W. [Charles Dudley Warner], as President; I had positively refused. I think it will be a good thing; there is a button, or ribbon, which comes with it, and is alone worth the money. Of course you know that you belong; and so does every important American author.*[2] A willing member but a reluctant participant, Clemens, popularly known as Mark Twain, did not take an active role in the newly formed National Institute of Arts and Letters, but when he was chosen to be among the first seven members of the new American Academy of Arts and Letters in 1904, his interest was aroused.

With his six colleagues Twain was charged with the responsibility of selecting others to complete the roster. On April 28, 1905, he sent a list of nine nominations.[3] When Johnson requested more names, Twain demurred. "No, I've named enough," he began. *It ought to be a rule, & a rigid one, that whenever a man offers a name, he must get up & state his reasons for his choice. Without it, men vote their affections instead of their cold judgment. I wish you would propose it; if I were going to be there I would do it. Without this rule the Academy milk is bound to be watered. We all know this, by experience. Judas & Peter & some of the others would not have gotten in, if the Disciples had had this same ordinance.*[4]

Mark Twain was not able to attend the meeting on May 6, 1905, when only four of his nominees succeeded in being elected, because he had gone to Dublin, New Hampshire, curiously enough on the recommendation of Abbott Thayer.[5] "Any place that is good for an artist in paint is good for an artist in morals and ink," he wrote of his mountain retreat.[6] In another letter written from

Dublin that summer, Twain explained his reacquaintance with the artist. "I know the Thayers of old. . . . Mrs. Thayer and I were shipmates in a wild excursion perilously near 40 years ago."[7] Mrs. Thayer was the seventeen-year-old Emmeline ("Emma") Beach when she met Mark Twain aboard the *Quaker City* in 1867. It was this cruise that provided the writer with material for *The Innocents Abroad,* which made Mark Twain a national celebrity when it was published in 1869. Thayer and his first wife, Kate, had taken an immediate liking to Miss Beach when they met in 1881, and she soon was managing their household affairs. Following Kate's death in 1891, Emma and Abbott were married, and ten years later they moved permanently to Dublin, where they had been spending their summers since the early years of their marriage.

Abbott Thayer's own acquaintance with Mark Twain began in 1882, when he went to Hartford for two days to paint this portrait. Thayer's freely painted image shows Twain with his glance averted and his eyes in shadow, giving him an inaccessible and even idealized look that conveys more about the artist's admiration for the author than it does about the sitter's personality. Several years later Thayer's portraiture underwent change. His idealized paintings of female family members and friends dressed in classical drapery and bearing such titles as *The Angel* (circa 1888; National Museum of American Art), *Virgin Enthroned* (1881; National Museum of American Art), and *Caritas* (1893-1897; Museum of Fine Arts, Boston), were invested with a personal and spiritual symbolism that transcended mere representation.

Thayer's monochromatic oil sketch of Twain was engraved by Timothy Cole for the September 1882 issue of *The Century Magazine,* where it accompanied an arti-

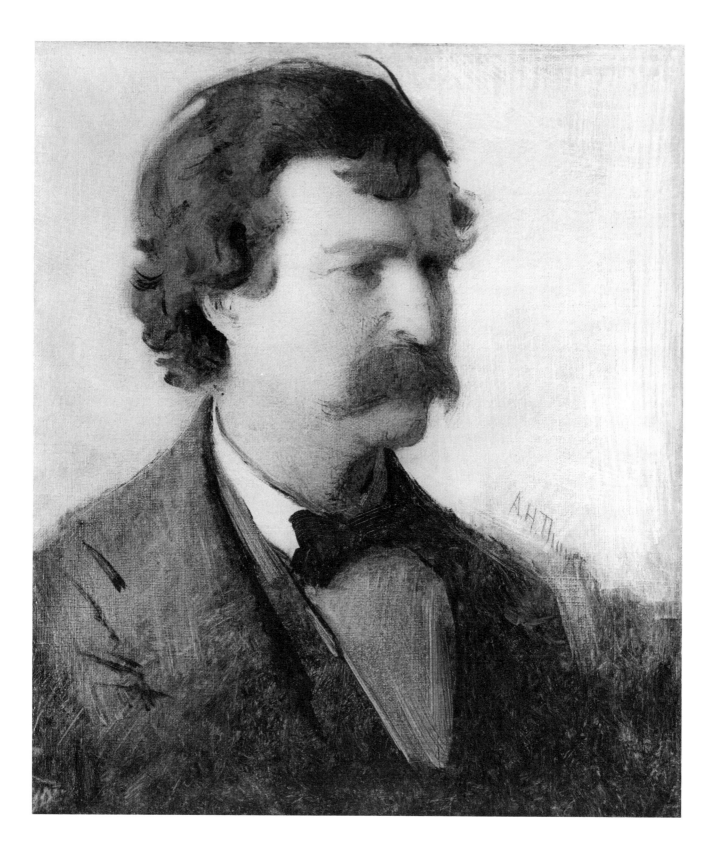

cle on the writer by William Dean Howells. Howells sent the manuscript to Twain before submitting it for publication. Mark Twain, who had recently published *A Tramp Abroad* (1880) and would release his masterpiece, *The Adventures of Huckleberry Finn,* in 1884, was enthusiastic and grateful to have his friend's praise.

Twenty-eight years later, at a public meeting of the Academy held in Carnegie Hall in New York on November 30, 1910, entitled "In Memory of Mark Twain," Howells again paid tribute to Samuel Langhorne Clemens. As president of the Academy and Clemens's closest friend among the members, Howells opened the ceremonies by putting words into the mouth of his departed friend: "Why, of course, you mustn't make a solemnity of it; you mustn't have it that sort of obsequy. I should want you to be serious about me—that is, sincere; but not too serious, for fear you should not be sincere enough."[8]

At the meeting George Washington Cable, who had met Twain in Hartford in June 1881, just a week after he had sat for Thayer, recalled a time during his lecture tour with Twain in 1884-1885 when in a Rochester, New York, bookstore, Twain came across an unfamiliar volume. With Cable's encouragement Twain bought the book and read it quickly, and Cable noted that *when I saw come upon his cheekbones those two vivid pink spots which every one who knew him intimately and closely knew meant that his mind was working with its energies, I said to myself: "Ah, I think Sir Thomas Mallory's* Mort d'Arthur *is going to bear fruit in the brain of Mark Twain."* When Twain visited Cable a year or two later and described his plans for *A Connecticut Yankee in King Arthur's Court* (1889), Cable exclaimed, "If that be so, then I claim for myself the godfathership of that book." Twain agreed.[9]

The Academy's memorial meeting was brought to a close by Henry Van Dyke, who called his departed colleague "dear Yorick of the West."[10] Mr. Howells's closing words were less lofty, but more reasonable to the modern ear: "Here ends our part in the memorial to Mark Twain: it is for the ages to take up the task and carry it on. You may trust them."[11]

1. This portrait, along with Timothy Cole's woodblock and a proof pulled by Thomas Nason, were purchased from Winfield Scott Clime of Old Lyme, Connecticut. Mr. Clime first suggested the purchase to the Academy in a letter to Walter Damrosch dated May 18, 1941. The Art Committee Chairman, Charles Dana Gibson, approved the purchase, and Mr. Clime was paid on January 8, 1942.

2. Henry Nash Smith, William M. Gibson, and Frederick Anderson, eds., *Mark Twain-Howells Letters: The Correspondence of Samuel L. Clemens and William D. Howells, 1872–1910,* vol. 2 (Cambridge, Mass., 1960), p. 688.

3. Clemens wrote to Robert Underwood Johnson nominating Francis Marion Crawford, William Gillette, Edward Everett Hale, Joel Chandler Harris, Bronson Howard, Thomas Nelson Page, Carl Schurz (who, he commented, "should have been elected at the *recent* meeting—and *should not fail this time*"), Augustus Thomas, and Alfred Thayer Mahan ("if he is the naval historian"). Clemens went on to say that the choice of art and music members should properly be left to "the gentlemen of those guilds," but nonetheless indicated his approval of Edwin Austin Abbey and John White Alexander. Samuel Langhorne Clemens to Robert Underwood Johnson, April 28, 1905, Academy-Institute Archives.

4. Samuel Langhorne Clemens to Robert Underwood Johnson, n.d. [May 3, 1905], Academy-Institute Archives.

5. Without Clemens at the next meeting to defend his candidates, only Harris, Schurz, Mahan, and Abbey were elected.

6. Albert Bigelow Paine, comp., *Mark Twain's Letters* (New York and London, 1917), vol. 2, p. 782.

7. *Ibid,* vol. 2, p. 772.

8. William Dean Howells, "In Memory of Mark Twain" (November 30, 1910), *Proceedings of the American Academy of Arts and Letters and the National Institute of Arts and Letters* (New York, 1911), vol. 1, no. 3, p. 5.

9. Comments by George Washington Cable, *ibid.,* p. 24.

10. Henry Van Dyke, "Mark Twain," poem read during meeting, *ibid.,* p. 29.

11. Closing comment by William Dean Howells, *ibid,* p. 29.

7.

Royal Cortissoz 1869-1948

INSTITUTE, 1908; ACADEMY, 1924

By Oswald Hornby Joseph Birley 1880-1952

Oil on canvas; 90.2 x 71.6 cm. (35½ x 28³⁄₁₆ in.); 1925;
Inscription: *To Royal Cortissoz/from Oswald Birley 1925*; Gift of Mr. Cortissoz, 1934

At the age of fourteen Royal Cortissoz was apprenticed to the architectural firm of McKim, Mead and White, where he worked for six years, acquiring a lifelong taste for the classical and a profound respect for the masters of the past. In 1891, moving on to what would be his lifework, he joined the staff of the *New York Herald Tribune* and began his career as an art critic. Cortissoz held his position at the *Tribune* for fifty years, covering more than one-hundred exhibitions each season. The critic also lectured widely and published many books, including monographs on Augustus Saint-Gaudens (1907), John LaFarge (1911), Arthur B. Davies (1932), and Edwin Howland Blashfield (1937), and several volumes of general art criticism.

Cortissoz's tastes in art were conservative, and even in his later years he preferred such American artists as John LaFarge, Winslow Homer, and George Inness to Matisse, Picasso, and Gauguin. In 1913 Cortissoz stated his position in *Art and Common Sense,* a volume of related essays that included a review of the recent Armory show. The critic praised much of the work he saw at that historic exhibition, but stopped short when he came to the French Post-Impressionists. Cortissoz called Cézanne "a second-rate Impressionist" who lacked the technical skills to produce lasting works of art, and complained that Van Gogh had "little if any sense of beauty and spoiled a lot of canvas with crude, quite unimportant pictures."[1] His resistance to the work of these artists was based on his classical canon. The architect William Adams Delano recalled discussions with Cortissoz: "When I championed the virtues of some contemporary artist, his invariable question was: 'Does he know the fundamentals of his

art?' Beauty," Delano emphasized, "played the major part in his thought and talks."[2]

The British artist Oswald Birley painted this portrait of Cortissoz in 1925, when the critic was fifty-six. Born in New Zealand while his parents were on a world tour, Birley was educated at Harrow, then taken by his father to Dresden, Munich, and Florence. In 1897 he attended Trinity College, Cambridge; in 1901 he studied in Paris with Marcel Baschet and at the Académie Julian. Returning to London, he established a reputation as a portrait painter, and exhibited at the Royal Academy and at the Modern Society of Portrait Painters. A renowned conversationalist and a man of many interests, Birley studied Indian philosophies and religions, was an amateur architect, and a patron of music and the Russian ballet. However, like his subject Cortissoz, Birley's eclectic tastes did not include a liking for modernist developments in art. In approaching his sitter, the artist used restrained color, sound drawing, and a rapid method of paint application to achieve a good likeness. Concentrating on the face, the artist contrasted dark strokes and broad highlights to indicate Cortissoz's discerning, almost squinting expression. The sitter's suit, the chair, and background are rendered in a more painterly fashion using subdued tones that further emphasize the face. In reviewing an exhibition of Birley's paintings, Cortissoz admired his "habit of clean-cut, efficient but never hard draftsmanship and expressive modeling."[3]

Not long after he painted this portrait of Cortissoz, Birley received his first royal commission for a portrait of King George V. Later he would paint almost every member of the royal family. During the Second World

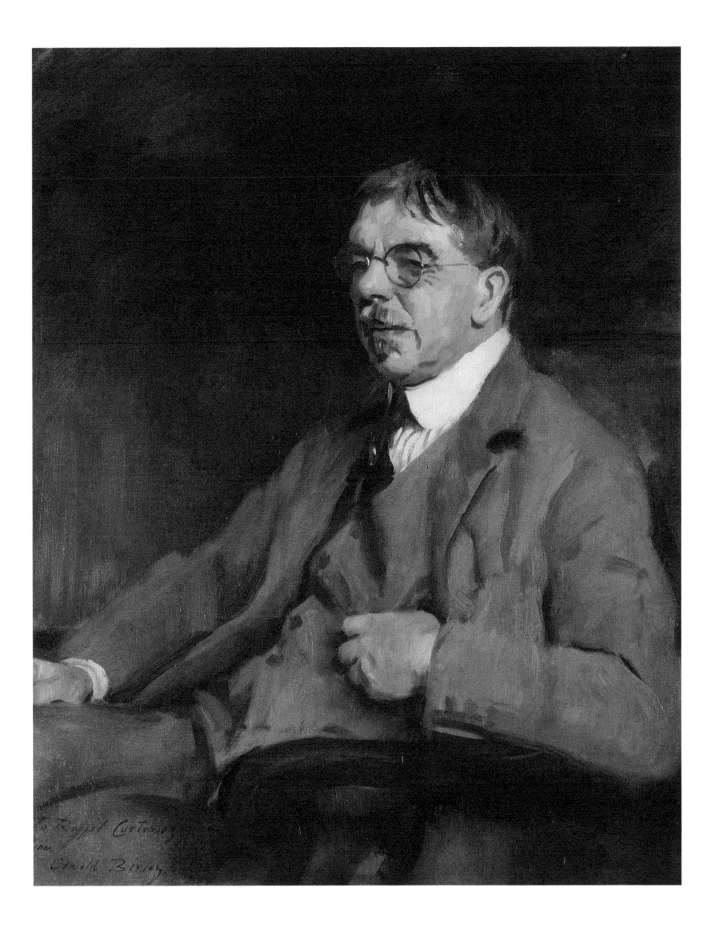

War, although he lost an eye while serving with the Sussex Home Guard, Birley continued to work, painting many statesmen and military leaders, including Dwight D. Eisenhower. He was knighted in 1949, and died three years later at his London home.

Cortissoz presented this portrait to the Academy in 1934, and in his will bequeathed a collection of his books to the library. An active member of the organization, he served ten years on the Academy's Board of Directors and was often called upon to write commemorative tributes or forewords for Academy-Institute exhibition catalogues.[4] Of himself, Cortissoz said, *As an art critic I have been a "square shooter," knowing neither friend nor enemy. My belief, as an art critic, has been, briefly stated, this: That a work of art should embody an idea, that it should be beautiful, and that it should show sound craftsmanship. I have been a traditionalist, steadfastly opposed to the inadequacies and bizarre eccentricities of modernism.*[5]

1. Royal Cortissoz, *Art and Common Sense* (London, 1914), pp. 152, 153.

2. William Adams Delano, "Royal Cortissoz," *Commemorative Tributes of the American Academy of Arts and Letters, 1942–51* (New York, 1952), p. 98.

3. Royal Cortissoz, "A Loan Exhibition of Various Examples: Portraits by Oswald Birley and Pictures by Quinquela Martin," *New York Herald Tribune,* March 18, 1928, in scrapbook of clippings, Academy-Institute Archives.

4. Cortissoz's tributes to Paul Wayland Bartlett, Edwin Howland Blashfield, George deForest Brush, Daniel Chester French, Walter Gay, Cass Gilbert, Childe Hassam, William Mitchell Kendall, Jonas Lie, William Rutherford Mead, and Willard Leroy Metcalf were published in *Commemorative Tributes 1905–41.* His forewords appear in the Academy's catalogues for exhibitions of the work of Paul Wayland Bartlett (1931, publication no. 76), Gari Melchers (1932, no. 78), George deForest Brush (1933, no. 81), Cecilia Beaux (1935, no. 87), Anna Hyatt Huntington (1936, no. 89), and Charles Adams Platt (1938, no. 94).

5. Obituary, "Royal Cortissoz Art Critic, 79, Dies," *The New York Times,* October 18, 1948.

8.

Daniel Chester French 1850–1931

INSTITUTE, 1898; ACADEMY, 1905

By Robert William Vonnoh 1858–1933

Oil on canvas, signed; 150.9 x 125.4 cm. (59⁷⁄₁₆ x 49³⁄₈ in.); 1913;
Gift of Bessie Potter Vonnoh Keyes (Institute, 1931), 1934

When a young boy living at his family home in Concord, Massachusetts, Daniel Chester French began to model with clay and carve comical figures in turnips. Although no school for sculptors existed in Boston at the time, French learned sculpture technique and methods of building on armatures from Abigail May Alcott, who had studied in Paris. Later he attended the Massachusetts Institute of Technology, where he learned to draw accurately, and during a visit to New York he spent a month with sculptor John Quincy Adams Ward. In 1873 the residents of Lexington and Concord decided to commission a monument to commemorate the hundredth anniversary of the first battles of the Revolution; in response, the twenty-three-year-old French made a model of a young militia man that was accepted enthusiastically at a meeting presided over by Ralph Waldo Emerson. French's name became known nationwide, and decades later his *Minute Man* would be placed on war bonds as an image of America's commitment to freedom.

French was in Italy when his Concord monument was unveiled in 1875. Returning home after two years, he worked on commissions for statues for new buildings, including the St. Louis Custom House (1877), the Philadelphia Court House (1883), and the Boston Post Office (1885). His later projects included the *Milmore Memorial* (1889–1893; Forest Hills Cemetery, Jamaica Plain, Massachusetts), *Richard Morris Hunt Memorial* (1896–1901; Central Park, New York City), *Alma Mater* (1900–1903; Columbia University, New York City), *Francis Parkman Memorial* (1897–1906; Jamaica Plain, Massachusetts), *The Continents* (1903–1907; United States Custom House, New York City), and *Abraham Lincoln* (1909–1912; Lincoln, Nebraska).

In July 1911 the newly appointed Commission on Fine Arts, of which French was chairman, voted to endorse a site in Washington for a long-contemplated memorial to Abraham Lincoln, and asked the architect Henry Bacon to prepare a design. Bacon's plan for a rectangular neoclassical temple included a statue of President Lincoln, and his choice for a collaborator was his friend Dan French. Although initially French had reservations about his working on a project commissioned by the group of which he was chairman, he eventually accepted; but, because the law mandated that the design had to be approved by his commission, he resigned as chairman. The seated figure of the President—one of the sculptor's proudest accomplishments—has become an American icon.

In 1917, while French was working on his *Lincoln,* a controversy arose over sending another portrait of the President to London and Paris. George Gray Barnard's *Lincoln* was less realistic than French's, the sculptor having exaggerated form to achieve an expressionistic effect. Many of the more traditional American sculptors, led by F. Wellington Ruckstull [CAT. NO. 18], organized a campaign against Barnard's *Lincoln,* calling it an unsuitable depiction of a great man that would reflect poorly on the state of American sculpture. French admitted not liking Barnard's statue, which seemed to him "a failure as a portrait in face and figure and as a study of character and to be utterly wanting in dignity." French was fair, however. "He very likely thinks the same of my efforts in the same direction," he wrote, "which may have biased my judgment of his."[1]

Robert Vonnoh's portrait of French shows the sculptor in his studio a year before he received the *Lincoln* commission, sitting on a set of movable stairs that he

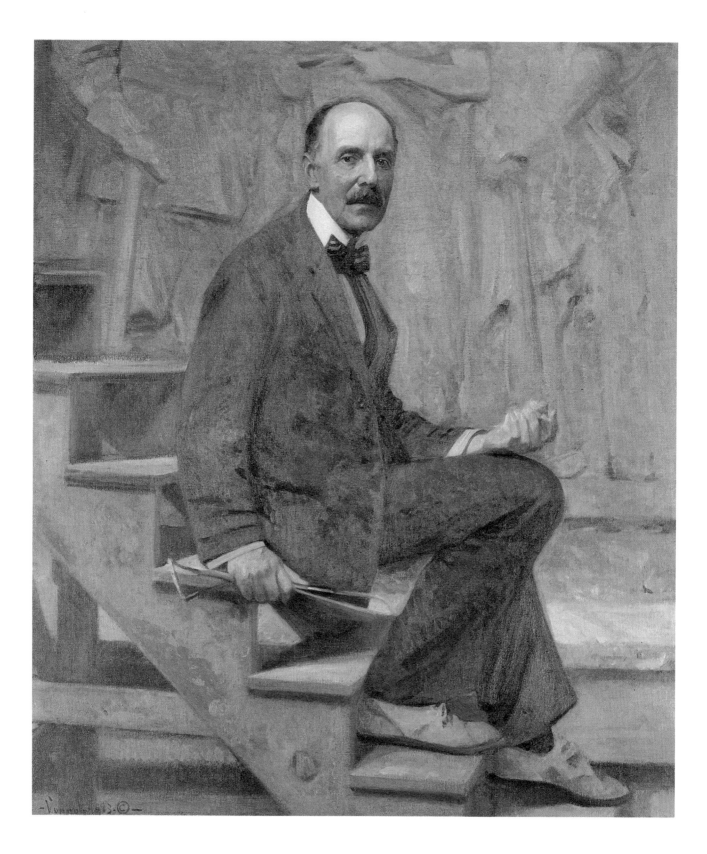

58

used to reach the upper portions of his larger works. The work behind him, a relief panel for French's *Longfellow Memorial,* was erected in Cambridge, Massachusetts, in 1914, a year after this portrait was taken. Dressed in a sport coat rather than an artist's smock, the sixty-three-year-old sculptor holds clay in his left hand and modeling tools in his right, as if pausing in his work. Vonnoh's painting technique is academic, but his informal composition shows modernist influences. By placing the steps at the edge of the picture plane, the artist flattens the space in which French sits, giving the portrait a sense of immediacy and candor. Against a monochromatic background relief, Vonnoh uses strong diagonals and passages of rich color in his sitter's face and clothing to give the portrait energy and provide visual interest. A portrait painter of considerable reputation, Vonnoh had studied at the Académie Julian in Paris. He taught for many years at the Cowles Art School in Boston, the school of the Boston Museum of Fine Arts, and the Pennsylvania Academy of the Fine Arts in Philadelphia, counting among his students Edward W. Redfield, Robert Henri, W. Elmer Schofield, and Maxfield Parrish.

Vonnoh was never elected to the Institute, but his wife, the noted sculptor Bessie Potter (1872–1955), became a member in 1931. Following her husband's death in 1932, she gave this portrait and several pieces of her own work to the organization. Mrs. Vonnoh also remembered the Institute in her will, bequeathing to it cash and stock valued at more than $17,000.

Several years after sitting for this portrait, French was enlisted to serve on a committee charged with commissioning the design for an Academy seal. James Earl Fraser (Institute, 1915; Academy, 1927) was selected to carry out the project. His drawings of a Pegasus received universal approval, but the motto presented a problem. Fraser had initially been told that only two words would appear—"Opportunity" and "Inspiration." By June 1916, when the design was completed, Robert Underwood Johnson and fellow members of the Board decided that three words would form a better inscription. In his inimitable fashion, Johnson conducted a mail survey of the Directors and members of the Academy to determine what that additional word should be. In a letter to French, he suggested "Cooperation, Sympathy, Comradeship (or Fellowship), Vision, Standards (or Principles) or Ideals, and something expressing Conservative Progress."[2] French's polite reply noted, "I am sorry on Fraser's account that the suggestion of another word did not come up earlier. I do not believe that you appreciate how much extra labor this makes for the sculptor."[3] The debate continued until early autumn of 1916. "I hope Fraser will not go daft entirely," French told Johnson.[4] Finally, the Academy settled on "Achievement" as the third word for the motto, and the seal was completed. Fraser received belated appreciation from the organization more than three decades later, when he won its Gold Medal for Sculpture.

1. Daniel Chester French to Robert Underwood Johnson, August 29, 1917, Academy-Institute Archives.

2. Robert Underwood Johnson to Daniel Chester French, June 30, 1916, Academy-Institute Archives.

3. Daniel Chester French to Robert Underwood Johnson, July 3, 1916, Academy-Institute Archives.

4. Daniel Chester French to Robert Underwood Johnson, August 2, 1916, Academy-Institute Archives.

9.

Bret Harte 1836-1902

INSTITUTE, 1898

By Robert Ingersoll Aitken 1878-1949

INSTITUTE, 1915

Bronze bust on marble base; 45.4 x 30 x 22.5 cm. (17⅞ x 11¹³⁄₁₆ x 8⅞ in.); circa 1902;
Gift of Mrs. Aitken, 1962

Bret Harte was born in Albany, New York, in 1836 and moved to California when he was eighteen. Shortly after his arrival in the West, he decided on a literary career, and obtained a job on a newspaper in Arcata. There he contributed poems to the publication and soaked in the local color, gathering material for his later stories. In 1860 he went to San Francisco and began to contribute pieces to the *Golden Era,* but his most creative period began after he was appointed editor of the *Overland Monthly.* In the first issue of the new magazine in 1868, he published "The Luck of Roaring Camp," followed in the next issue by "The Outcasts of Poker Flat." These two stories, which remain among his best, evoked tremendous response. Easterners were fascinated by his characters, which included miners, gamblers, stage-drivers, and other western types. He scored another triumph with the dialect poem, "The Heathen Chinee," in 1870.

Encouraged by his success, Harte journeyed east in 1871 and was offered a contract with the *Atlantic Monthly.* When the stories he produced failed to meet the quality of his earlier efforts, Harte's reputation in the publishing industry declined. In 1878, accepting a diplomatic post in Rhenish Prussia, he left for Europe, never to return to the United States. Although he continued to write until his death in 1902, his later work never fulfilled the promise of his early stories.

This bust of Harte was designed as part of a monument to the writer commissioned by the Bohemian Club of San Francisco early in the century.[1] The portrait shows Harte with his arms crossed, a pen poised in his right hand, his look discerning. When Harte arrived in the East after his early success, his readers were surprised to find that the author of such earthy stories was rather a dashing figure, well dressed, well mannered, and well spoken. In his bust portrait, Aitken invested Harte with the dignity and authority that the author sought in vain in his later life.

Robert Aitken, who was born in San Francisco, was a member of the Bohemian Club and exhibited there on his return from Paris in 1895. During his career he undertook monumental works, many of which included portraiture. For the West Pediment of the United States Supreme Court Building in Washington he executed portraits of Chief Justices John Marshall, Charles Evans Hughes, and William Howard Taft, as well as depictions of himself and the building's architect, Cass Gilbert. One of his most ambitious projects, an immense frieze for the Columbus (Ohio) Gallery of Fine Arts (1930-1937), includes full-length figures representing the history of western art beginning with Phidias and Praxiteles, and ending with Saint-Gaudens and Sargent. Aitken was elected to the Institute in 1915, and the same year received the New York Architectural League's Medal of Honor for Sculpture and a Silver Medal from the Panama-Pacific International Exhibition.

Following Aitken's death in 1949, his widow was asked by the Academy's librarian to assemble a collection of photographs that would document her husband's work. Mrs. Aitken agreed, and offered to add sketchbooks, drawings, and memorabilia to complete her husband's archive at the Academy. "Fortunately she understands that we are only interested in material in some way connected with the Institute," the Librarian told the Art Committee, "and for this reason she offers us a . . . fairly small bust of Bret Harte . . . [which] has a certain roman-

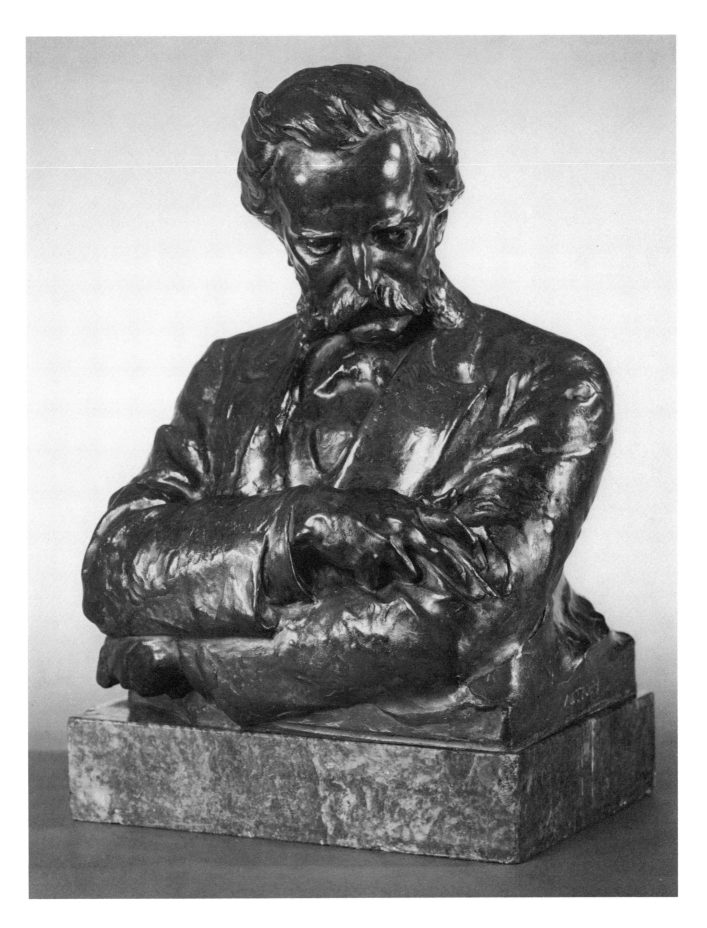

tic charm."[2] Recommending that the bust be accepted, Leon Kroll, painter member of the committee, noted that it "may be very good because some of Aitken's work is."[3] The committeemen were also interested in Aitken's sketchbooks and drawings, provided that they pertained to members, but since it was summertime and everyone was in the country, they postponed their decision until the fall.

Six years passed before the first of the Aitken material joined the Academy-Institute's collections. Donated were 140 photographs; 105 sketches, including sketches for the reliefs on the National Archives Building in Washington and for the Columbus Gallery of Fine Arts; newspaper and magazine clippings; and a page of small drawings of Aitken's friend Cass Gilbert. It was another five years before the Harte bust came to Audubon Terrace.

1. Elizabeth Anna Semple, "Art of Robert Aitken, Sculptor," *Overland Monthly* 61 (March 1913): 3. Semple noted that Aitken had sculpted reliefs picturing scenes from Harte's "The Luck of Roaring Camp" and "The Death of Old Kentucky"; one of these panels was lost in the 1906 earthquake and fire.

2. Hannah Josephson to Barry Faulkner, July 18, 1951, Academy-Institute Archives.

3. Leon Kroll to Hannah Josephson, August 3, 1951, Academy-Institute Archives.

Self-Portrait

By Childe Hassam 1859–1935

INSTITUTE, 1898; ACADEMY, 1920

Oil on canvas; signed; 83.3 x 52.7 cm. (32¹³⁄₁₆ x 20¾ in.); 1914;
Inscription: *Cos Cob, June 7, 1914*; Bequest of Mr. Hassam

Frederick Childe Hassam left high school at sixteen, bound for a career in the accounting offices of the Boston publishing firm of Little, Brown and Company. It was not long before his supervisor noticed that he was not suited for the job. "Instead of adding a column of figures correctly," he was told, "your mind is on something else—and as you are too young to think much of the girls I am sure your mind is wholly adapted to something entirely different."[1] Hassam's perceptive boss suggested he pursue his interests in drawing, and the aspiring artist, happily taking the advice, became apprenticed in the shop of a local lithographer. During this time he did freelance illustrations, signing his earliest work "F. Childe Hassam." The poet Celia Thaxter suggested that he drop his first initial. "You should not with an unusual name like yours fail to take advantage of its unique character," she told him, adding that, "There is a young Englishman who has just written some remarkably good stories of India . . . his name is Joseph Rudyard Kipling—but he has the literary sense to drop the Joseph." From then on the young artist became Childe Hassam.[2]

During his apprenticeship Hassam studied at the Boston Arts Club and at the Lowell Institute. He made his first trip to Europe in 1883 and returned to Europe in 1886, settling in Paris with his new wife. For more than a decade the Impressionists had dominated the Parisian art scene, and Hassam undoubtedly was interested in their activities. Still, his style changed little during his first year there. By the spring of 1887, however, his palette was becoming brighter, his brushwork more painterly, his concentration on atmospheric effects more pronounced. Hassam routinely denied that he was an Impressionist: "I have to de-bunk the idea that I use dots of color,

so called, or what is known as impressionism," he insisted; "(everybody who paints and sees is probably an impressionist.)"[3]

Returning to New York in 1889, Hassam applied his European training to outdoor scenes, bringing his exuberant color to views of New York streets and squares and the rocky New England coast at Appledore. By the late 1890s Hassam was well established in the New York art world, but impatient and frustrated with its politics. In reaction to the practices of the Society of American Artists, whose exhibitions were poorly hung and not well attended, Hassam and nine other artists met on December 17, 1897, and signed their names to two documents. With the first, they resigned from the Society, and with the second, they established their own new organization.[4] The group (all of whom became members of the Institute) came to be called "The Ten," and included J. Alden Weir, John H. Twachtman, Willard L. Metcalf, Thomas W. Dewing, Edward E. Simmons, Frank W. Benson, Edmund C. Tarbell, Robert Reid, and Joseph R. De Camp. Their association arose more from friendship than from adherence to an aesthetic canon, but they would exhibit together for twenty years.

Although Hassam was invited by the Association of American Painters and Sculptors to participate in the 1913 Armory show, he was not impressed with much of what he saw at the exhibition, and throughout his life remained skeptical of many modernist developments. "The business of the good painter," he wrote, *is to carry on tradition as every one of the good painters have done always and without deviation from the well beaten path. Not to self-consciously attempt to be original and startling. Where that has been attempted it is always a failure and the canvas is soon*

unnoticed, forgotten—it may have a temporary notice from a space writer as silly as the painter who painted it.[5]

This self-portrait, which was painted a year after the Armory show, demonstrates Hassam's continuing allegiance to Impressionist technique. Sunshine enters from a window behind, defining the robust form of the fifty-five-year-old artist. Hassam breaks up areas of color with thickly painted vertical strokes that juxtapose contrasting colors and create sparkling light and shadow. The shadow across his face, for instance, is achieved when the blue and flesh-tone strokes on the canvas mix in the eye of the viewer. Hassam applied this same technique to his *Flag Series*, paintings of New York's Fifth Avenue draped in flags of all nations during the first World War.[6]

Childe Hassam was elected to the Academy in 1920, a distinction he considered "the highest honor that any American in the arts can attain."[7] Shortly after his death on August 27, 1935, the Academy was notified of impending good fortune. The artist had bequeathed to the organization the contents of his studio—326 paintings in oil, 19 decorative panels, 89 watercolors, and 33 pastels. In stipulating what was to be done with this bounty, Hassam described an innovative program. He instructed the Academy to sell his work "from time to time in its discretion at private sale and not at auction," and use the proceeds to establish "The Hassam Fund."[8] From this Fund, the Academy should then buy paintings, watercolors, pastels, or graphic works of living artists and present these works of art to museums throughout the country. Royal Cortissoz called Hassam's gift "characteristic of his large and generous nature."[9]

The Academy accepted Hassam's bequest enthusiasti-cally, and began preparations. Archer Huntington suggested the publication of "a definitive catalogue deluxe of all the Hassam items."[10] As a way of encouraging interest in the artist's work, Huntington offered to underwrite the expenses involved in the catalogue's preparation, and Adeline Adams, wife of Art Committee Chairman Herbert Adams, was engaged to write a text for the volume. Although the idea began as a descriptive catalogue of the Hassam work in the Academy's custody, it materialized into a 144-page, illustrated, limited-edition monograph, published in 1938. The book, bound in Academy purple with the Pegasus seal embossed on its cover, was distributed without charge, reaching public libraries, museums, foreign academies, and members of the art department of the Academy and Institute.

By 1946 a great many of Hassam's paintings had been sold, and the Fund had accumulated enough capital to carry out the artist's plan. That year the first distribution was made and, in four decades since, the Academy-Institute has spent $1.2 million for more than 750 paintings, drawings, and graphic works by living artists, which are now in the permanent collection of more than five-hundred museums nationwide. A similar bequest was made by noted portrait painter Eugene Speicher, who died in 1962.

Although Speicher's work is still being sold to add to the capital of the Fund, the Academy-Institute has placed a moratorium on the sale of Hassam's work, maintaining a sizable group in its permanent collection. The *Self-Portrait*, which came to the Academy as part of the bequest, was never offered for sale but was retained as a tribute to the organization's most creative benefactor.

1. Childe Hassam to Miss Farmer, February 22, 1933, Academy-Institute Archives.

2. *Ibid.*

3. Childe Hassam to Ellery Sedgwick, December 3, 1934, Academy-Institute Archives.

4. These original agreements, signed by all ten members, are in the Academy-Institute Archives.

5. Autobiographical notes, fragment "H," Academy-Institute Archives.

6. Two paintings in this series, *The Italian Block* (1918) and *Vic-tory Day, May 1919* (1919), are in the Academy-Institute's permanent collection.

7. Autobiographical notes, p.1, Academy-Institute Archives.

8. "Last Will and Testament of Frederick Childe Hassam," December 20, 1934, Academy-Institute Archives.

9. Royal Cortissoz, "Childe Hassam," in *Commemorative Tributes, 1905–41*, p. 336.

10. Minutes of a meeting of the Board of Directors of the American Academy of Arts and Letters, April 23, 1936, Academy-Institute Archives.

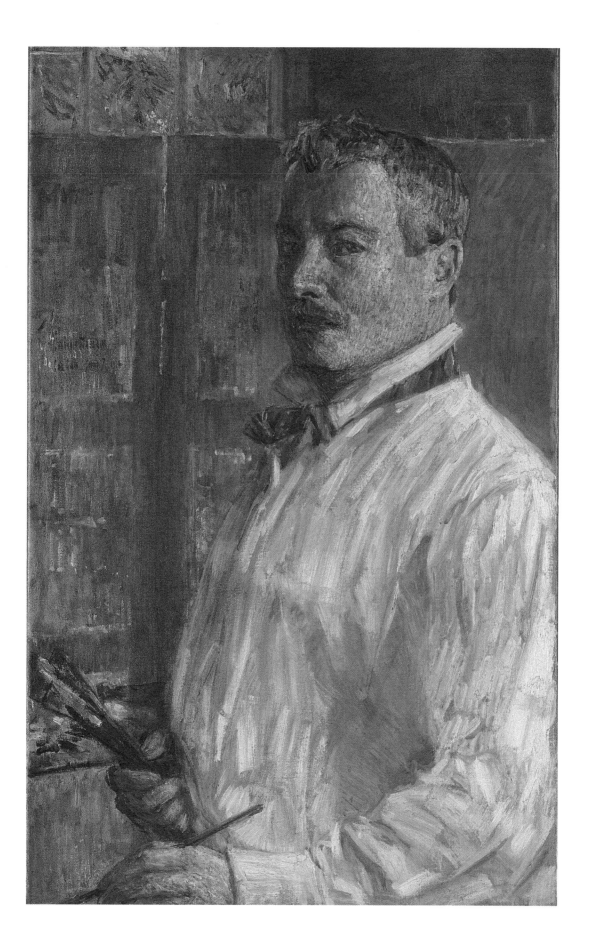

65

11.

John Milton Hay 1838–1905

INSTITUTE, 1898; ACADEMY, 1904

By John White Alexander 1856–1915

INSTITUTE, 1898; ACADEMY, 1910

Crayon drawing, signed; 97.9 x 72.5 cm. (38⁹⁄₁₆ x 28⁹⁄₁₆ in.); March 1886;
Gift of Mrs. John White Alexander, 1916

After graduating from Brown University in 1858, John Milton Hay studied law in Springfield, Illinois, in an office next door to Abraham Lincoln's. This coincidence gave Hay the opportunity of a lifetime. When Lincoln was elected President of the United States, Hay and his friend John George Nicolay went to Washington as the President's assistant private secretaries. Following Lincoln's assassination in 1865, Hay was dispatched to Paris as secretary to the United States legation where the American minister, John Bigelow, encouraged him to write. After a brief stay in Paris, he moved to Vienna and then to Madrid, returning home in 1870 to a position on the staff of the *New York Tribune*. Although his editorials were anonymous, Hay's name soon became known to thousands of readers as a result of the publication in the *Tribune* of such verses as "Little Breeches" and "Jim Bludso." These pieces were included in his *Pike County Ballads* (1871), published several weeks before *Castilian Days*, a book based on his experiences in Spain. The *Ballads* stand today as his most important contribution to American literature, but Hay himself preferred his more conventional poems.

Since their days with Lincoln, Hay and Nicolay had toyed with the idea of writing a biography of the President with whom they had been so closely associated. Eventually they agreed on a cooperative plan, divided the work, and exchanged chapters for revision. Ten years later, in 1885, they signed a contract for serial publication of the work in *The Century Magazine* for an unprecedented fifty thousand dollars, and in March 1886 John White Alexander took this portrait of Hay for publication in the magazine. Concentrating on his sitter's face and folded hands, Alexander rubbed out highlights around

the head and on the face, giving Hay a penetratingly serious expression appropriate to his monumental task. The ten-volume biography, *Abraham Lincoln: A History*, was published in 1890 and remains an indispensable first-hand account of a historic life.

Hay had returned briefly to government service as an assistant secretary of state in 1878, and in March of 1897 he was appointed ambassador to Great Britain by the newly elected President McKinley. After the outbreak of the Spanish-American War in 1898, the President urged him to accept the post of secretary of state, and he acquiesced. In Washington he helped negotiate the peace with Spain and later championed the "Open Door" policy in China, a doctrine largely formulated by William Woodville Rockhill, whom Hay proposed for Institute membership in 1904.[1]

Following McKinley's assassination in 1901, Hay maintained his position as secretary of state, assisting President Theodore Roosevelt in diplomacy that eventually led to the independence of Panama and the construction of the canal. When the Academy was founded, just as Roosevelt was elected in his own right to a second term, Hay was the sixth man chosen for membership. He wrote to Edmund Clarence Stedman that he regarded his "choice as one of the 'planet seven' as the greatest distinction I have ever received."[2] A year later, his health failing, Hay took leave from his Cabinet post and went abroad for medical treatment. Although he seemed improved when he returned in June, he died on July 1, 1905.

Robert Underwood Johnson took Hay's place in the Academy, and it was he who found Alexander's portrait of the statesman in 1915. The artist had just suffered a stroke. Johnson took advantage of the occasion by send-

ing the stricken artist flowers and enclosing a note to Alexander's wife, which read in part, "If he [Alexander] is well enough to have things said to him, you may tell him that I have rescued from the Century collections a lot of original drawings by him of literary men and others . . . all of which can be had at small expense."[3] The artist died on May 31, but Johnson patiently waited until December, when he suggested to Mrs. Alexander that she purchase four drawings, including those of Hay and John Burroughs [CAT. NO. 3], for twenty-five dollars each and present them to the Academy. Mrs. Alexander had already donated her husband's drawing of Walt Whitman, on which she noted, "John considered [this] the best drawing he ever made."[4] Mrs. Alexander agreed to buy the portraits and, at Johnson's further prodding, had them framed before forwarding them to the Academy.

John White Alexander began his career as an illustrator for Harper Brothers and then spent several years studying in Munich, Florence, and Venice. After his return from Europe in 1881, he received the large portrait commission from the Century Company that included the drawings in this exhibition. As a painter, Alexander came into his own in the 1890s in Paris, where he was influenced by a group of artists and writers known as the Symbolists. His talent for insightful portraiture found further expression during this period in ethereal depictions of women painted in the Grand Manner, which are among his best paintings. Alexander moved back to New York in 1901 and in 1905 received a commission to paint a series of murals at the Carnegie Institute in his native Pittsburgh. Ten years earlier he had executed another mural cycle, *The Evolution of the Book*, for the new Library of Congress building in Washington, D.C.

In a commemorative tribute to Alexander, the muralist Edwin Howland Blashfield remarked, "In John White Alexander a frail body lodged a tireless, eager spirit . . . eager not only in seach for beauty but in service to his fellows."[5] In addition to his artistic activities, Alexander served as President of the Institute in 1911-1912, and was president of the National Academy of Design from 1909 until his death in 1915.

1. Hay's nomination of Rockhill, signed by Theodore Roosevelt and Henry Adams and dated December 13, 1904, cited "his honorable and eminent position as a Diplomatist" and his contributions to Oriental scholarship (Academy-Institute Archives).

2. John Hay to Edmund Clarence Stedman, December 15, 1904, Academy-Institute Archives.

3. Robert Underwood Johnson to Mrs. John White Alexander, May 27, 1915, Academy-Institute Archives.

4. Elizabeth A. Alexander to Robert Underwood Johnson, June 8, 1916, Academy-Institute Archives.

5. Edwin Howland Blashfield, "John White Alexander," in *Commemorative Tributes 1905–41*, p. 82.

12.

Julia Ward Howe 1819–1910

INSTITUTE, 1907; ACADEMY, 1908

By José Villegas Cordero 1848–1921

Oil on canvas; 46.1 x 34.9 cm. (17¹⁵⁄₁₆ x 13¾ in.); 1898;
Inscription: *A mi buena amiga Sra. de Elliot recuerda de la estima de ma querido madre en Roma José Villegas*;
Gift of Maud Howe Elliott, 1934

Although he was asked to become a charter member of the National Institute of Arts and Letters in 1898, Thomas Wentworth Higginson declined, saying that he was "prevented by one fatal objection, that it comprises one sex only. However rational this limitation might have seemed half a century ago," he continued, "it now seems to me altogether outgrown & reactionary, at least in this country."[1] An early campaigner for women's rights, Higginson accepted membership in 1905 only after being assured that the bylaws had been changed to accommodate the election of women. One of the first things he did as a new member of the Institute was to nominate his friend Julia Ward Howe, the "Foremost Woman in America," as she was generally known in the press. Samuel Langhorne Clemens agreed to serve as seconder, writing to Higginson to say that "I agree with you that it is eminently proper that she should be the first woman member. It is her earned and rightful place."[2] Also seconding the nomination was Richard Watson Gilder, editor of the influential *Century Magazine* from 1881 to 1909 and an advocate of the feminist cause within the Institute. Early in 1907 Mrs. Howe became the Institute's first female member, and a year later, at age eighty-nine, she was invited to join the ranks of the Academy. No other women would be elected until 1926.

Born into a distinguished New York family, Julia Ward was well educated, well read, and well traveled. While other young women in her situation aspired to the allure of society and fashion, she turned her energies to literature and scholarship, publishing her first poems before age twenty. At twenty-four, Julia Ward married Dr. Samuel Gridley Howe, a man almost twenty years her senior who was continually preoccupied with matters of social reform. The marriage and "her quick responsiveness to ethical impulses," according to Bliss Perry, "brought her into intimate relations with that restless, aspiring movement of reform which characterized New England for a score of years before and after the Civil War."[3]

Despite his liberal political views, Dr. Howe's ideas about a wife's appropriate role were quite traditional, and limited Mrs. Howe's literary activity. Yet she continued to write, publishing her first volume of poetry, *Passion Flowers*, in 1854 and, during the following decade-and-a-half, another volume of poems, two travel sketches, and a play. With Dr. Howe she edited *The Commonwealth*, an antislavery publication, and became active in the abolitionist movement. In 1861 their efforts in behalf of emancipation brought her to an army camp near Washington, D.C., where she composed a poem to the tune of "John Brown's Body" that made her a national treasure. "The Battle Hymn of the Republic," with its patriotic, religious, and moral overtones, ignited the imagination of a nation divided by war. In a memorial tribute to Mrs. Howe almost half a century later, Bliss Perry explained that "It interpreted, as no other lyric of the war quite succeeded in interpreting, the mystical glory of sacrifice for freedom."[4]

After the war, with the slavery question settled and her children grown, Mrs. Howe concentrated her attention on public service. Perry recalled that she "flung herself with girlish enthusiasm into a dozen 'causes,' the education of the blind, the relief of the poor, the Americanization of foreigners, the liberalizing of religion, the emancipation of women, the movement for international peace."[5] Mrs. Howe founded or presided over many women's organizations, including the New England Women's

Club, the American Woman's Suffrage Association, and the Association for the Advancement of Women. She continued to write poetry, but later in life she turned increasingly to essays as a means of literary expression. Reflecting on her work, she told Higginson that she felt her writings were like "a pair of tongs that could not quite reach the fire."[6] Although her mediocre book sales would seem to confirm Mrs. Howe's self-assessment, she was a very effective and popular public speaker. She lectured widely, even into her old age, and was always received enthusiastically.

In late November 1897 Julia Ward Howe went to Rome to spend the winter with her daughter Maud and son-in-law John Elliott. Although seventy-eight, Mrs. Howe kept busy, writing her *Reminiscences* (1899), organizing clubs, and making speeches. A journal entry for December 14 records that she went with her son-in-law to visit the Spanish painter José Villegas at his Moorish villa, where they "found a splendid house with absolutely no fire— the cold of the studio was tomb-like. A fire was lighted in a stove and cakes were served, with some excellent Amontillado wine, which I think saved my life."[7] The following spring, on May 12, Mrs. Howe sat for this portrait. The artist, who at the time directed the Spanish Academy in Rome, later became the director of the Prado Museum in Madrid and court painter to King Alfonso.

In Mrs. Howe's portrait, Villegas applied his brush energetically over the canvas, leaving it raw at the upper and lower edges. He quickly sketched in the lace collar and cap of the sort Mrs. Howe had worn since middle age. The artist used more finely applied strokes of flesh tones with strongly contrasted highlights to define the contours of his sitter's seventy-nine-year-old face. At the center, Mrs. Howe's dark eyes hold the viewer's attention.

The portrait is inscribed to Mrs. Elliot, who gave it to the Academy in 1934. Mrs. Howe's daughter noted that it "is a magnificent piece of painting," but complained that it did not convey her mother's "beauty nor sweetness of expression."[8] If Villegas's portrait lacks this personal insight, it does convey a view more representative of the public Mrs. Howe, who was said to have the "look of a prophetess and seer—of one who had felt the weight of the burdens of humanity and had suffered in sympathy."[9]

In concluding his tribute to Mrs. Howe, Bliss Perry wrote, "A very human woman, a very feminine and wise woman, Mrs. Howe had a place all her own in the affectionate admiration of her contemporaries."[10] She also had a place all her own in the Institute and Academy for two decades. There is a certain irony in the fact that Julia Ward Howe held such a singular honor, since it was her work, and that of other women like her, that made the notion of *not* electing women seem anachronistic. Perhaps, as Malcolm Cowley speculated, she was elected because, to the less enlightened members, she was "not so much a woman as a national institution."[11]

1. Thomas Wentworth Higginson to Hamilton Wright Mabie, August 16, 1899, pp. 1–2, Academy-Institute Archives.

2. Mary Thacher Higginson, ed., *Letters and Journals of Thomas Wentworth Higginson, 1846–1906* (Boston and New York, 1912), p. 235.

3. Bliss Perry, "Thomas Wentworth Higginson, Julia Ward Howe, Francis Marion Crawford, William Vaughn Moody," in *Commemorative Tributes 1905–41,* p. 34.

4. *Ibid.*

5. *Ibid.*

6. Deborah Pickman Clifford, *Mine Eyes Have Seen the Glory: A Biography of Julia Ward Howe* (Boston, 1979), p. 260.

7. Laura E. Richards and Maud Howe Elliott, *Julia Ward Howe, 1819–1910*, vol. 2 (Boston, 1915), p. 240.

8. Maud Howe Elliott to Grace D. Vanamee, October 30, 1934, Academy-Institute Archives.

9. "Julia Ward Howe, Author of 'Battle Hymn,' Dead," obituary, *Detroit Journal,* October 17, 1910.

10. Perry, "Howe," p. 35.

11. Malcolm Cowley, "Sir: I Have the Honor," *Southern Review,* n.s., 8, no. 1 (winter 1972): 3.

13.

Henry James 1843–1916

INSTITUTE, 1898; ACADEMY, 1905

By Abbott Handerson Thayer 1849–1921

INSTITUTE, 1898; ACADEMY, 1909

Crayon on paper, signed; 32.3 x 24.4 cm. (12¾ x 9⅝ in.); circa 1881;
Gift of Robert Underwood Johnson, 1923

When Henry James sat for his boyhood friend Abbott Thayer, he was not yet forty but had already established a considerable literary reputation as a result of the publication of *Daisy Miller* (1879), *The Portrait of a Lady* (1881), and other fictional works. By the time the Academy was formed two decades later, James had completed his "masterpieces": *The Wings of the Dove* (1902), *The Ambassadors* (1903), and *The Golden Bowl* (1904). Still, when the balloting for the first seven Academicians was completed, James was not among those chosen. Elected before him, in the order of votes received, were William Dean Howells, Augustus Saint-Gaudens, Edmund Clarence Stedman, John LaFarge, Samuel Langhorne Clemens, John Hay, and Edward MacDowell. The first duty of these seven men was to elevate eight more Institute members to their company, and Henry James was their first choice.

Three months later, on the fourth round of balloting, Henry's brother William was tapped for the Academy. In response to the usual ceremonious letter from the ever-present Robert Underwood Johnson, the older James declined the honor, stating that he preferred not to belong to an organization whose purpose seemed only that of "distinguishing certain individuals (with their own connivance) and enabling them to say to the world at large 'we are in and you are out.' Ought a preacher against vanities to succumb to such a lure at the very first call?" William asked rhetorically. "Ought he not rather to 're-frain, renounce, abstain' even tho it seem a sour and ungenial act?" William went on to claim that his inclinations were confirmed "by the fact that my younger and shallower and vainer brother is already in the Academy, and that if I were there too, the other families repre-

sented might think the James influence too rank and strong."

William's plea to "'release me and restore me to the ground'" has become central to a debate over the relationship between the James brothers.[1] Henry's biographer, Leon Edel, cites William's letter as a petulant expression of sibling rivalry. Jacques Barzun, an Institute member since 1952, who himself recently refused elevation to the Academy, takes an opposing view. Barzun interprets William's "mock insults" as an expression of affection couched in ironic playfulness.[2] Henry was visiting with his brother in Cambridge at the time this letter was written, and Barzun suspects that William discussed with him his decision to decline the somewhat suspect and seemingly meaningless title of Academician.

Although Henry remained a member, he could not always contain his frustrations with the organization or its spokesman, the high-minded Johnson. Henry shared William's distaste for an institution that served no apparent purpose, and when Johnson wrote to Henry in 1914 with glowing reports of his successful fund-raising efforts, the novelist could no longer contain himself: *The Academy should to my sense have largely made good a promise & abounded in a performance before complacently accepting large money gifts (in recognition of what benefits conferred on our intellectual civilization?) The civilising force that our huge undirected general community most cries aloud for, & most suffers & wastes itself for the want of, is, to my apprehension, educated and educating Criticism; & what sort of a machinery our incongruous association (incongruous for unity of action) represents for the promotion of that interest I wholly fail to see.*[3]

As always, Johnson was resolute, and his reply to James

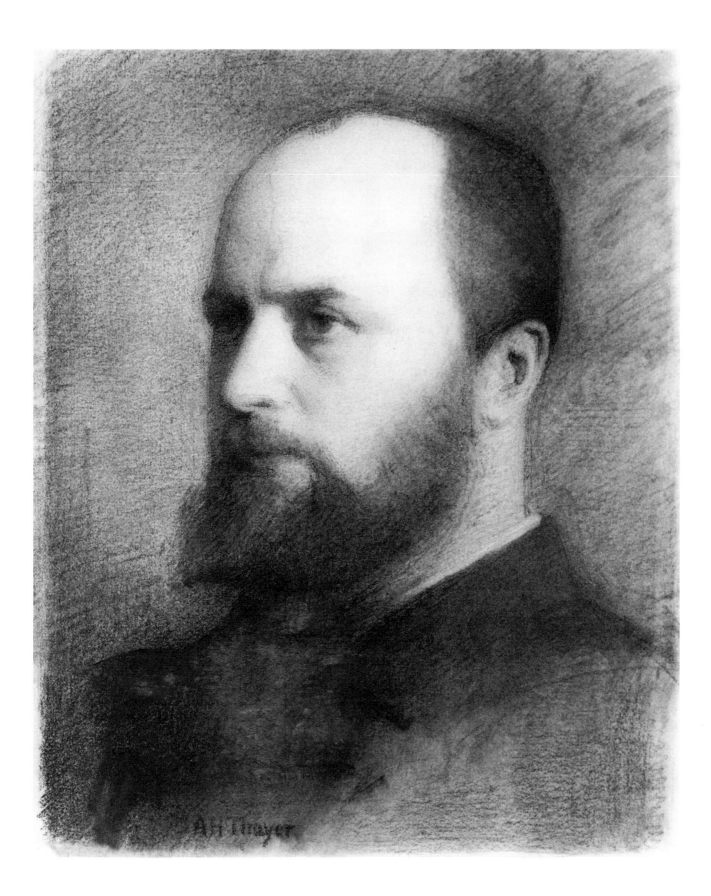

avoided the issue of "purpose" entirely. Completely devoted to the Academy, the Secretary was content to think, as he had explained to James in a letter written a year earlier, that "this solidarity of literary men [is] one of the conservative influences of our time, and if the Institute and the Academy did nothing else but conserve this generous loyalty of writers and artists to one another, they would have abundantly justified their existence."[4] To insure the continuation of the Academy's existence, Johnson succeeded in raising a considerable endowment and began the process of soliciting for the organization art works and archival material. He made several important contributions to the Academy himself, among them this portrait of James by Abbott Thayer, which he "drew in the annual lottery."[5]

Abbott Thayer knew the James family throughout his life, and was especially close to William James's son, William, Jr., and his grandson, Alexander. Today Alexander's son lives on Thayer's property in Dublin, New Hampshire, surrounded by Thayer memorabilia and some of his works.

According to Thayer's friend, critic and fellow Academician Royal Cortissoz, it was not until the 1880s, when this crayon portrait of Henry James was taken, that the artist "found himself." Although Thayer's most successful portraits were primarily of women and children, this sketch of his friend bears out James's comment that Thayer was among those painters who "desire to be simply and nakedly pictorial, and very fairly succeed."[6]

1. William James to Robert Underwood Johnson, June 17, 1905, Academy-Institute Archives.

2. Leon Edel, *Henry James. The Master, 1901–1916* (Philadelphia and New York, 1972), pp. 298–99; Jacques Barzun, *A Stroll with William James* (New York, 1983), pp. 225–26.

3. Henry James to Robert Underwood Johnson, June 13, 1914, Academy-Institute Archives.

4. Robert Underwood Johnson to Henry James, November 20, 1913, Academy-Institute Archives.

5. Robert Underwood Johnson to Miss Lindsay *(The Century Magazine)*, April 16, 1915, Academy-Institute Archives.

6. Henry James, "On Some Pictures Lately Exhibited," originally published in *Galaxy*, July 1875; reprinted in John L. Sweeney, ed., *The Painter's Eye: Notes and Essays on the Pictorial Arts* (Cambridge, Mass., 1956), p. 91.

14.

Joseph Jefferson 1829–1905

INSTITUTE, 1898; ACADEMY, 1905

By Charles Henry Niehaus 1855–1935

INSTITUTE, 1916

Plaster bust; 64.2 x 33.9 x 30.4 cm. (25¼ x 13⅜ x 12 in.); circa 1900; Gift of Mr. Niehaus, 1935

Joseph Jefferson was born into a family of actors in 1829, and made his stage debut at age four, mimicking "Jim Crow" Rice, a popular blackface songster. When young Joe was eight, his family moved west and traveled throughout the countryside, acting in barns, halls, and even log cabins, leaving no time for the boy to attend school. By 1849 Joseph had made his way to New York, where he successfully played Dr. Pangloss in George Coleman's *The Heir at Law;* at age twenty-nine he achieved fame as Asa Trenchard in *Our American Cousin.*

During a trip to London in 1865, Jefferson realized a dream he had cherished for some time. Although there had been several stage versions of Washington Irving's *Rip Van Winkle,* including one by the actor's half-brother Charles Burke, none quite satisfied Jefferson. He engaged his friend Dion Boucicault to prepare a revision based on Burke's attempt, and contributed a scene, involving ghosts and a soliloquy by the title character, which would become legendary. The play opened in London on September 4, 1865, and was immediately hailed as a phenomenon. Jefferson took the production to New York in 1866, where again it enjoyed great success. His very likeable personality and charismatic charm made Jefferson one of the best-loved Americans of his generation, and a trip to see *Rip Van Winkle* became an essential part of every child's education. Touring annually with *Rip,* Joe Jefferson, as he was lovingly called, became a national hero, and played few other roles for the rest of his career. In addition to his popularity on the stage, Jefferson was instrumental in bringing a more naturalistic style of characterization to acting, preparing the way for twentieth-century developments. In 1901 Jefferson was invited to speak before his fellow members at a dinner meeting of the Institute, and after-

ward entertained questions, most of which were about Rip. "I felt that it was a character that I seemed to sympathize with," he said, "from the fact of its weirdness and from its impossibility."[1]

A charter member of the Institute, Jefferson was elected to the Department of Literature in 1898 on the strength of his *Autobiography,* serialized first in *The Century Magazine* and then printed in book form in 1890. In April 1905 Joseph Jefferson was reported gravely ill, and some members of the Institute informed the board that they would like to see him elected to the newly formed Academy before it was too late. Four of the Academy's fifteen members could not be reached, but the other eleven favored the proposal wholeheartedly. A telegram was dispatched to Jefferson the day before he died, and the revered actor was entered into the record as the Academy's sixteenth member.

Charles Henry Niehaus's gift of his bust of Joseph Jefferson was an especially welcome addition to the Academy-Institute's collection, for it represented not only the sculptor but an early and cherished member as well. This portrait is one of his best works. Niehaus endowed the actor with a personality that matched his well-known face. The undraped bust shows Jefferson at an advanced age, and was probably modeled not long before his death, but Jefferson's characteristic warmth and humor emerge in the kindness and depth of expression in his eyes.

Niehaus was born in Cincinnati in 1855, and attended the McMicken School of Art in that city before sailing to Munich, where he won high honors at the Royal Academy. The assassination of James A. Garfield in 1881 brought Niehaus his first important commission. The sculptor poured his skill and youthful enthusiasm into his statue

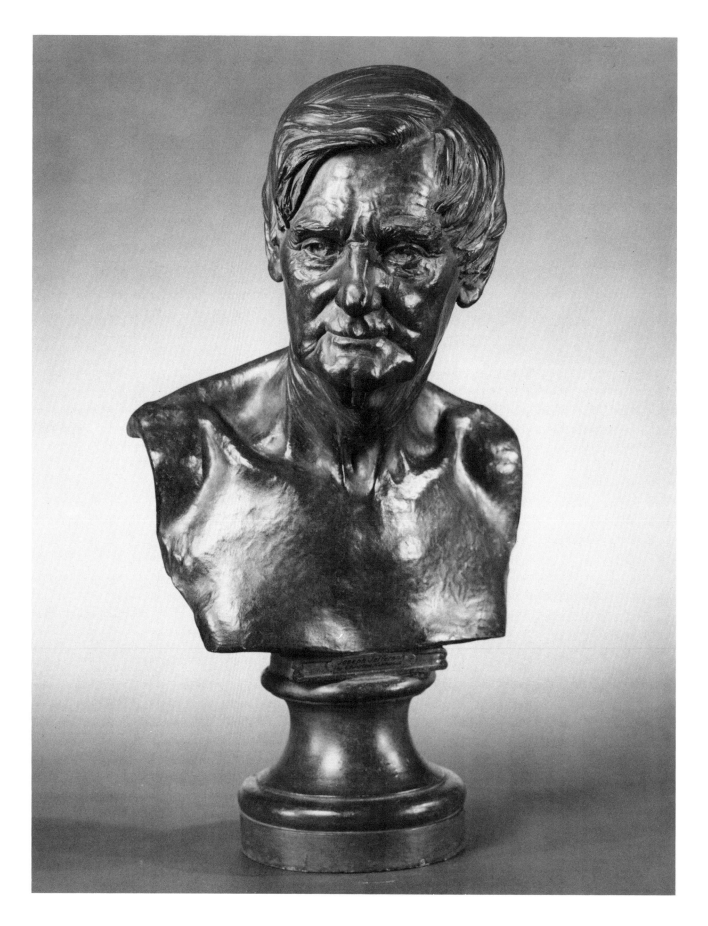

of the fallen President, which was to be placed in the Capitol in Washington, and produced an eloquent oratorical portrait. Later Niehaus returned to Europe to continue his studies, settling in Rome. There he executed several classically inspired works, including *Caestus* and the *Athlete,* both purchased by the Metropolitan Museum of Art. He returned to the States in 1885 and settled in New York. Niehaus considered his monuments to Dr. Samuel C. F. Hahnemann, homeopathic physician, and John Paul Jones in Washington his most important works.[2] His commissions also included statues of Presidents McKinley, Harrison, and Lincoln, and an equestrian portrait of General Nathan B. Forrest.

Several months after Niehaus's eightieth birthday in January 1935, the Academy's assistant to the president, Mrs. Vanamee, visited the sculptor at his home in New Jersey, and found him "in a pitiful condition physically and financially."[3] To assist Niehaus and his daughter in their distress, she attempted to find buyers for some of the pieces in Niehaus's studio and organized a campaign to seek approval of House of Representatives Bill 7977, which would authorize the purchase of his bust of Lincoln for the Capitol building. Wilbur Cross, then governor of Connecticut and president of the Institute, also wrote to the senators and congressmen from his state, urging the bill's passage. Niehaus died on June 19, 1935, but Mrs. Vanamee and Governor Cross maintained their campaign with the hope of helping his daughter Marie settle her father's debts. During a trip to Washington the following spring, F. Wellington Ruckstull made an effort to urge the passage of the bill, but came away with the impression that no action would be taken. His apprehensions proved to be correct and, despite many good intentions, the Lincoln bust was never purchased.

1. "Report of a Discussion Following Joseph Jefferson's Address on Dramatic Art, September 27, 1901," p. 3, Academy-Institute Archives.

2. Artist members of the Institute were asked to complete a form listing the names and locations of their most important works. A note at the bottom of the form asked that they "number the items in what you consider the order of their importance." Niehaus listed *Hahnemann* first and *Jones* second (Academy-Institute Archives).

3. Grace D. Vanamee to Dr. Walter Crump, May 15, 1935, Academy-Institute Archives.

15.

Sinclair Lewis 1885-1951

INSTITUTE, 1935; ACADEMY, 1937

By Leonebel Jacobs 1884-1967

Pastel on paper, signed; 49.5 x 38.2 cm. (19½ x 15¹⁄₁₆ in.); circa 1935;
Gift of Mr. Lewis, 1938

Despite considerable opposition from within the membership, and to the amazement of many, Sinclair Lewis was elected to the Institute in 1922. The writer was not yet forty; *Main Street* had been published two years earlier, and *Babbitt* was about to go to press. No doubt there were more than a few genteel traditionalists in the Institute's ranks who were relieved when Lewis declined election. Four years later he turned down a Pulitzer Prize for *Arrowsmith,* citing his rejection of Institute membership and his dislike of "amateur boards of censorship."[1] He continued his attack on academies in 1930 when he accepted the Nobel Prize, becoming the first American to receive the coveted award. Speaking before the Academy-Institute's sister organization in Sweden, Lewis began his address with a warning: "however indiscreet—it will be necessary for me to be a little impolite regarding certain institutions and persons of my own greatly beloved land."[2] Citing America's lack of artistic standards, Lewis declared that there were no institutions in the United States to inspire the artist—just the American Academy of Arts and Letters.

His attack begun, the Nobel laureate cited the few Academy members whose work he approved, and then launched into his list of neglected writers.[3] In all, he named twenty-one possible candidates, enough to fill almost half the Academy chairs. In an oft-quoted quip, Lewis declared that the Academy "does not represent literary America of today—it represents only Henry Wadsworth Longfellow."[4] Although Lewis acknowledged that the Academy could not be expected to share all his literary tastes, he declared that, *while most of our few giants are excluded, the Academy does have room to include three extraordinarily bad poets, two very melodramatic and insignifi-*

cant playwrights, two gentlemen who are known only because they are university presidents, a man who was thirty years ago known as a rather clever humorous draughtsman, and several gentlemen of whom—I sadly confess my ignorance—I have never heard.[5]

Perhaps because they recognized themselves in his speech, the traditionalists on Audubon Terrace were horrified, and even more determined to exclude individuals such as Lewis from their ranks. They could not, however, for long; by late 1934 Lewis's name again appeared on the Institute ballot, and he was once again elected. This time he accepted graciously. The *Herald Tribune* reported Lewis's change of heart, quoting him as saying, "It has gotten very much more vital. In the past few years they have elected some splendid and admirable people."[6]

Once Lewis joined the Institute, the campaign began to have him elected to the Academy. Clearly the membership was of two minds. Robert Underwood Johnson, in his last Academy battle, led the movement to blackball the "objectionable novelist."[7] He campaigned vigorously by mail and found support from some members, including Booth Tarkington, who wrote, "Of course S. Lewis should never become a member of the Academy after what he said of it when he danced naked before the Swedes in rapture over himself, and I don't think he deserves it anyhow."[8]

Lewis narrowly missed election in 1936 and, to assure his exclusion, Johnson proposed an amendment to the Academy bylaws that would prohibit the election of any candidate who received ten or more negative votes. The directors were not enthusiastic but, unwilling to hurt the feelings of their dying Secretary, they tabled the motion. Less than a week later the Academy's venerable patriarch

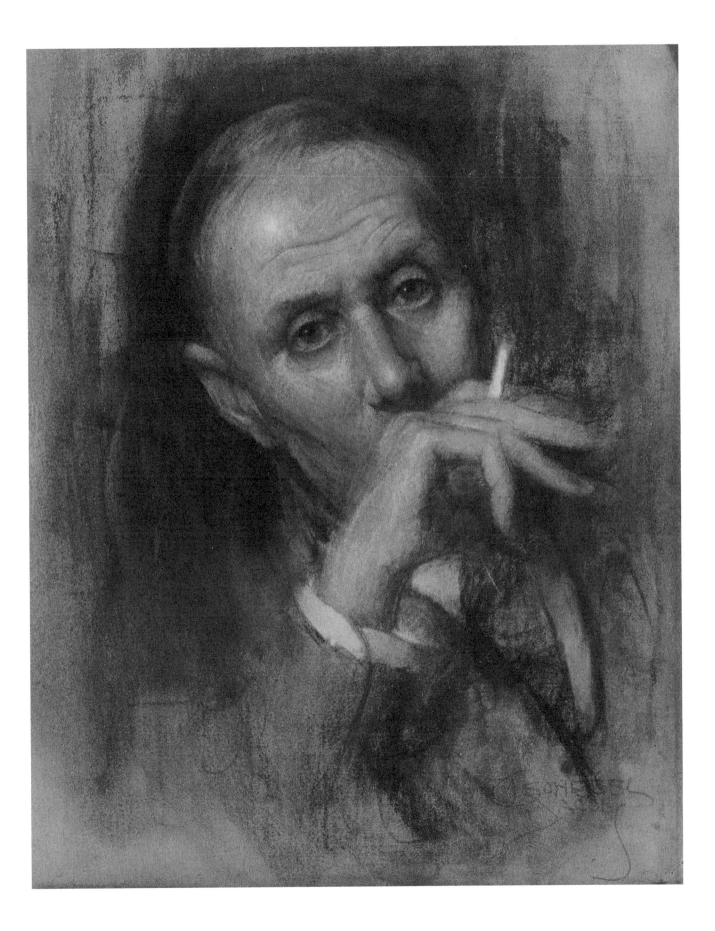

died, and Lewis was subsequently elected. In his acceptance letter, Lewis wrote that he hoped "to be able to participate a little more actively in the affairs of the Academy and the Institute."[9]

The novelist kept his word. Earlier Lewis had donated his manuscript of *Work of Art* (1934) to the archives, and in 1938 he contributed this portrait by Leonebel Jacobs. The drawing had been included in Mrs. Jacobs's *Portraits of Thirty Authors*, published in 1937 with a foreword by John Erskine. Jacobs, who was born in Tacoma, Washington, and studied with George deForest Brush and Charles Hawthorne, portrayed many eminent men and women from all walks of life, including Mrs. Calvin Coolidge and Mrs. Herbert Hoover, Clarence Darrow, Kahlil Gibran, and members of the Chinese Imperial Family. Rather than posing Lewis, Jacobs allowed him to assume a more natural posture. She concentrated on the sitter's ruddy complexion; highlighted his hand, collar, and forehead; and filled the space around his head with a swirling, smoky atmosphere. The eyes that emerge from behind the shielding hand and cigarette are those of Lewis the realist, and meet the viewer directly, even daringly. Although Jacobs's work sometimes took on the qualities of decorative illustration, her portrait of Sinclair Lewis is a penetrating character study.

Lewis continued to take an active role in Academy meetings, recommending candidates for awards (including Booth Tarkington for the 1945 Howells Medal), serving on the board of directors, and registering his opinion on various issues. When, in 1941, Institute president Arthur Train surveyed the membership concerning the proper functions of the organization, Lewis responded with a five-page plan in which he questioned the structure of the bi-level body and proposed a reorganization along the lines of the French Academy. He suggested several small academies—one each for writers, artists, composers; one for actors, choreographers, and directors; and one for scientists, clergymen, and lawyers whose work shows "a creative ability or a quasi-artistic perception which would ally them to the special world of artists in general." Such a structure, he believed, would "give a glorious opportunity for a correction of any errors that still exist in the choice of members." He ended his statement with the claim that the building on 155th Street, though beautiful and grand, was too inconvenient to be useful.[10]

Lewis's suggestions were not acted upon, but he did strike a raw nerve. The organization still periodically considers moving from 155th Street, and since 1983 it has elected film directors and choreographers as American Honorary Members.

Just as Lewis changed his mind about the Academy, it changed its mind about him. After his death in 1951, the Academy held a memorial exhibition of books, letters, manuscripts, photographs, and memorabilia to honor one of its most controversial members.

1. "Sinclair Lewis Changes Mind, Enters Institute," *New York Herald Tribune*, January 18, 1935.

2. Sinclair Lewis, "The American Fear of Literature: An Address by Sinclair Lewis, December 12, 1930, on Receiving the Nobel Prize in Literature" (reprint ed., New York, n.d.), p. 9.

3. Among the members whom he approved Lewis included Edward Arlington Robinson, Robert Frost, Edith Wharton, Hamlin Garland, Booth Tarkington, Owen Wister, and Brand Whitlock. Lewis's list of omissions included Theodore Dreiser (Award of Merit Medal, 1944), H.L. Mencken (refused election), Eugene O'Neill (Institute, 1923; Academy, 1933), Edna St. Vincent Millay (Institute, 1929; Academy, 1940), Carl Sandburg (Institute, 1933; Academy, 1940), Edgar Lee Masters (Institute, 1918; resigned, 1931), Willa Cather (Institute, 1929; Howells Medal, 1930; Academy, 1938), Sherwood Anderson (Institute, 1927), Ernest Hemingway (refused election).

4. Lewis, "American Fear of Literature," pp. 16–17.

5. *Ibid.*, p. 17.

6. "Sinclair Lewis Changes Mind . . .," *Herald Tribune,* January 18, 1935.

7. William Mitchell Kendall to Robert Underwood Johnson, September 8, 1937. Kendall quoted this phrase from Johnson's letter to him of August 28, 1937 (Academy-Institute Archives).

8. Booth Tarkington to Robert Underwood Johnson, August 6, 1937, Academy-Institute Archives.

9. Sinclair Lewis to Grace D. Vanamee, February 9, 1938, Academy-Institute Archives.

10. Sinclair Lewis to Arthur Train, April 18, 1941, pp. 3–4, Academy-Institute Archives.

16.

Charles Follen McKim 1847–1909
INSTITUTE, 1898; ACADEMY, 1905

By Augustus Saint-Gaudens 1848–1907
INSTITUTE, 1898; ACADEMY, 1904

Silvered bronze bas-relief; 18.8 x 13.7 cm. (7⅜ x 5⅜ in.); 1878;
Inscription: MY FRIEND CHARLES MACKIM [sic]/ARCHITECT/AVGVSTVS SAINT-GAUDENS FECIT/PARIS AVGVST MDCCCLXXVIII/IN SOVVENIR
OF THE TEN JOLLY DAYS/I PASSED WITH YOV AND THE ILLVSTRIOVS/STANFORD WHITE IN THE SOVTH OF FRANCE;
[Provenance undetermined]

Early in his career Charles Follen McKim worked for the prominent architect Henry Hobson Richardson but, after receiving commissions for several country houses, he decided in 1872 to establish his own office. McKim took rooms adjoining Richardson's at 57 Broadway in New York, a building that housed many architects' offices, and it was there that he chanced to meet William Rutherford Mead. Just back from his studies at the Accademia de Belle Arte in Florence, Mead had returned to 57 Broadway hoping to recover the job he had left in the office of Russell Sturgis. When he found that Sturgis was out of town, he called on McKim, who was overwhelmed with work and in need of assistance.

McKim and Mead worked together until 1877, when they formed a partnership with William B. Bigelow. McKim had married Bigelow's sister Annie three years earlier but, for reasons that have remained obscure, Mrs. McKim took their young daughter and left her husband in 1878. Eager to escape his personal problems, McKim impulsively sailed to Europe with Stanford White, who had taken over McKim's former position in Richardson's office.

In Paris, McKim and White encountered a group of American artists, among them their friend Augustus Saint-Gaudens. McKim and White were at leisure, while the sculptor was at work on his first important commission, a stature of Admiral David Glasgow Farragut for Madison Square in New York City. The architects repeatedly tried to tempt Saint-Gaudens from his work, but only after some of the sculptor's colleagues from the École des Beaux-Arts told him that he had given Farragut his own bowlegs—a feature about which he was especially sensitive—did Saint-Gaudens smash his plaster model and take off

with McKim and White on the vacation that the architects had been urging.

After the three returned, Saint-Gaudens made this bas-relief portrait. McKim was only thirty-one at the time, but already balding. Saint-Gaudens used a decorative border along the top edge of the plaque, and acanthus leaves borrowed from the vocabulary of classical architecture in the lower-right corner to illustrate McKim's profession. The inscription to Charles McKim, appearing in horizontal bands, is typical in the series of portrait reliefs of his friends that the artist executed around this time.

When Bigelow resigned following his partner's return from Europe, McKim and Mead invited White to join their firm. The architects—White in particular—collaborated with Saint-Gaudens on many important projects, including the *Farragut* (1887–1880), the *Adams Memorial* in Rock Creek Cemetery, Washington, D.C. (1886–1890), and the *Shaw Memorial* in Boston Commons (1884–1897). In turn, Saint-Gaudens received a commission for the Boston Public Library designed by McKim (1887–1895) and, although Saint-Gaudens never completed his work, he advised his friends on artistic matters relating to this and other projects.

By the time the Institute was organized in 1898, McKim, Mead, and White were the preeminent architects of the American Renaissance. Their credits included the Agriculture Building at the World's Columbian Exposition in Chicago (1891–1893); Rhode Island State House (1891–1904); various buildings at Columbia University; the Brooklyn Museum (1893–1927); and the University Club in New York (1896–1900). McKim's plans for New York's grandiose Pennsylvania Station, in part modeled on the ancient Baths of Caracalla, would soon be on the boards.

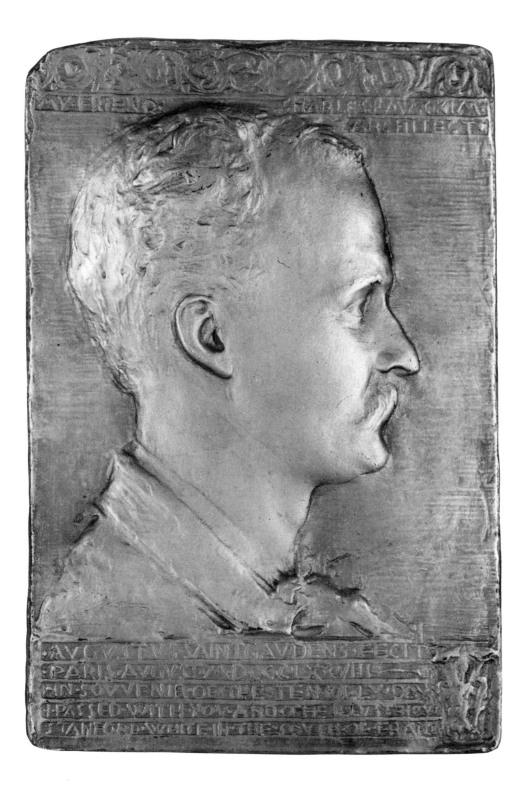

Of the three partners, McKim was the only founding member of the Institute. White would be elected, on McKim's recommendation, shortly before his death in 1906, and Mead would follow his partners into the organization in 1908.

When Archer Huntington gave four city lots and $100,000 toward a building to the Academy in 1914, the Board of Directors acted quickly. Mead, a board member and an Academician since 1910, was appointed chairman of the building committee, whose other members were Thomas Hastings and Cass Gilbert, both of whom began their careers in Mead's office. A year later, the Secretary reported in his minutes that "Copies of the plans for the home of the Academy, made in the office of McKim, Mead, & White, under the counsel of Messrs. Mead, Hastings, and Gilbert, were presented by the Chancellor and received with approval."[1] Although the report presents the design as a collaborative effort, it was actually William Mitchell Kendall, a partner in Mead's firm, who was responsible.

Kendall had entered the office of McKim, Mead, and White in 1882, and Charles McKim became his mentor. He was the primary architect for many of the firm's major commissions, including the Post Office in New York City (1908-1913). As Royal Cortissoz, another McKim, Mead, and White alumnus, noted in his commemorative tribute to Kendall, "He fell into perfect harmony with McKim's austere genius."[2] The Academy's new building reflected Kendall's long association with the Beaux Arts traditions of his teacher. "Kendall was a shining exemplar of that recognition of what is salutary in the lessons of the past which marks the healthily conservative architect," remarked Cortissoz.[3]

The grandeur of Kendall's design proved to be a most appropriate setting for William Milligan Sloane, president of the Academy, who addressed a crowd at the formal opening of the building on February 22, 1923. *We aim at nothing less than the preservation to our people of the great inheritance in beauty, form, and substance . . . we do not forget that our business is conservation first and foremost, conservation of the best and but incidentally, if at all, promotion of the untried. We are to guard tradition, not to seek out and reward innovation, however brilliant it may be.*[4] What had been Charles Follen McKim's innovation four decades earlier was now safely preserved in the hands of his follower.

1. Minutes of the American Academy of Arts and Letters, February 18, 1915, Academy-Institute Archives.

2. Royal Cortissoz, "William Mitchell Kendall," *Commemorative Tributes, 1905–41*, p. 429.

3. *Ibid.*, p. 430.

4. William Milligan Sloane, "Opening Address," *Proceedings at the Formal Opening of the Permanent Home of the American Academy of Arts and Letters* (New York, 1923), pp. 2, 3.

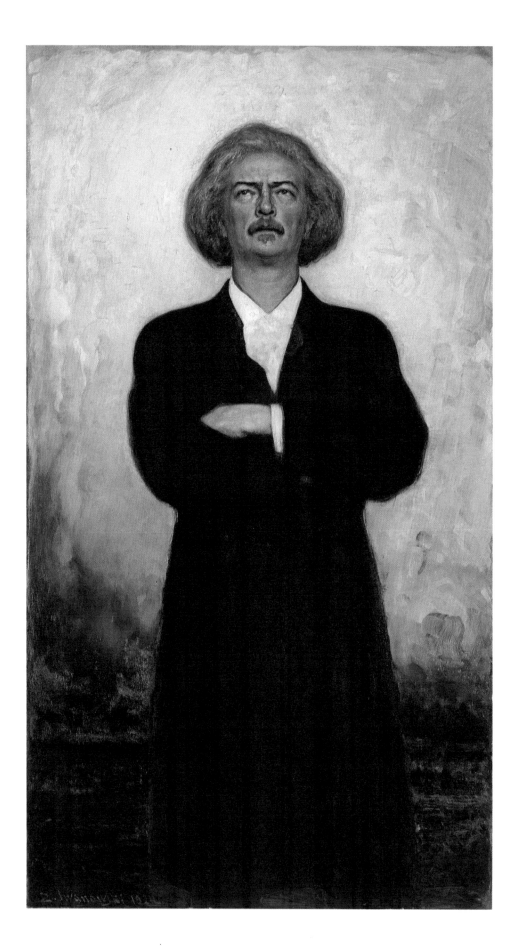

84

17.

Ignace (Ignacy) Jan Paderewski 1860–1941

Honorary Member, 1931

By Sigismund Ivanowski (Zigmunt Iwanowski) 1874–1944

Oil on canvas, signed; 164.3 x 91.9 cm. (64¹¹⁄₁₆ x 36³⁄₁₆ in.); 1924;
Gift of Mary Curtis (Mrs. Edward) Bok, 1943

On its twenty-fifth anniversary in 1929, the Academy created a new category of membership for distinguished foreign artists. Elected as Honorary Corresponding Members that year were four knighted Britons: J.M. Barrie, author of *Peter Pan;* Edward Elgar, composer of the *Pomp and Circumstance* marches; John Galsworthy, creator of the Forsyte novels; and popular genre and portrait painter William Orpen. Two more Englishmen, poets John Masefield and William Watson, were elected in 1930. The following year, Ignace Jan Paderewski was added to the list. Born in 1860 in Kurylowka, Podolia, then known as Russian Poland, he was the first Honorary Member from outside the United Kingdom.

The legendary pianist and composer made his first public appearance at a charity concert when he was eleven, and soon was studying music seriously. He gave his first recitals in Paris and Vienna in 1888, and was already famous when he made his New York debut in 1891. His concerts created a great furor, but it was difficult to know whether it was his performance or his personality that appealed to his legions of devoted fans. Women especially were dazzled by the dashing young pianist, who was described in the press as having an "aureole" of golden red hair, causing jealous husbands to threaten to give "this Paderooski" a haircut. In some cities on his tour, the police had to be called in to rescue the maestro from his adoring public.[1]

A dramatic and passionate performer, Paderewski was also a devoted Polish patriot. A member of the Polish National Committee during the First World War, he donated the proceeds of his concerts to a fund to assist his people, and perhaps it was his influence that helped to persuade President Woodrow Wilson to include Polish Independence in his famous Fourteen Points. In any case, Paderewski returned to his native land following the war and accepted the position of Premier and Minister of Foreign Affairs, forming the Seym, a coalition cabinet of experts in various fields.

The painter Sigismund Ivanowski served in Paderewski's cabinet of experts. A popular portraitist, Ivanowski had studied at the Academy of St. Petersburg, and in Munich, Paris, and Warsaw, before settling in Westfield, New Jersey, in 1903. He became known for his depictions of stage stars in character, including Maude Adams as Peter Pan, Blanche Bates as Madame Butterfly, Ethel Barrymore in Captain Jinks, and Madame Modjeska as Lady Macbeth. Like Paderewski, Ivanowski set aside his creative work in 1915 to serve his country.

This portrait of Paderewski—one of the painter's most famous works—took its inspiration from a moment in 1919 at the opening of the Seym. Paderewski "stood a minute, arms folded, his splendid head thrown back, gathering his thoughts," the painter recalled. "His attitude was that of one proudly accepting challenge, and I saw in his face the spirit of the conqueror."[2] Ivanowski devoted five years of "close and earnest study and literally hundreds of sketches" to this work. "This is the best pose I have used in my portrait of him," he proclaimed.[3]

In this dramatic stance, which suggests his power as a musician as well as statesman, Paderewski looks to the heavens as if daring the muses to inspire him. The turbulent, highly colored ground sharply silhouettes a figure who was able to evoke mystical devotion in all his admirers. The unsettled backdrop might also allude to the problems that Paderewski faced during his tenure. He

had gone to the peace talks at Versailles to make an eloquent plea for the Polish position and to obtain for Poland eastern Galicia, upper Silesia, and the city of Danzig; but his activities at Versailles were not well received back home. When he returned to Poland in November 1919, he found that his support was crumbling. Dispirited, Paderewski resigned on December 9, his private financial resources depleted.

In the early 1920s, Paderewski resumed giving concerts, many to benefit war victims, and experienced continuous success. During his American tour in 1933, the Academy arranged a luncheon to honor their new Honorary Member. A group of about a dozen Academicians agreed to host the famous Paderewski, but the festivities had to be canceled when the pianist suffered an attack of lumbago.

In 1932 Ivanowski gave his portrait of Paderewski to the Curtis Institute of Music in Philadelphia, probably in recognition of the interest taken in Polish affairs by the school's founder, Mary Curtis Bok. The portrait, wrote Ivanowski, "truly represents his [Paderewski's] greatness to future generations."[4] In 1943 Mrs. Bok offered the painting to the Academy, writing to its president, Walter Damrosch, "I make the gift with the greatest pleasure and it seems to me the portrait will now be placed in the most perfect and appropriate surroundings."[5]

1. Obituary, "Paderewski Dead at 80; Ill of Pneumonia 2 Days," *New York Herald Tribune,* June 30, 1941.

2. "The Portrait of Ignace Jan Paderewski," *Overtones* (published by the Curtis Institute of Music) 10, no. 2 (April 1940): 60.

3. *Ibid.*

4. *Ibid.*

5. Mary Bok to Walter Damrosch, February 12, 1943, Academy-Institute Archives.

18.

Frederick Wellington Ruckstull 1853–1942

INSTITUTE, 1898

By Frederick William MacMonnies 1863–1937

INSTITUTE, 1898; ACADEMY, 1915

Bronze bust, signed; 54.8 x 21.3 x 22.8 cm. (21⁹⁄₁₆ x 8⅜ x 9 in.); 1888;
Gift of Mr. Ruckstull, 1923

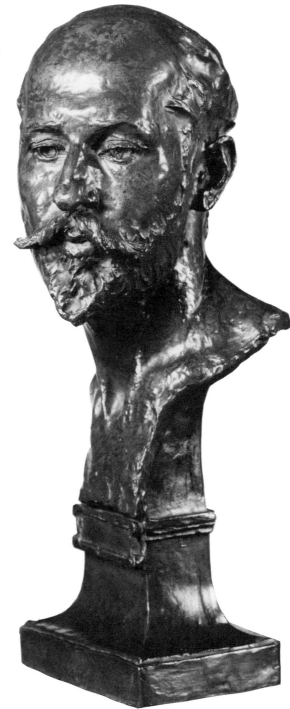

Not many artists would have the audacity to pub-
lish a book entitled *Great Works of Art and What
Makes Them Great,* but F. Wellington Ruckstull, who did
just that in 1925, went so far as to offer his own work as
evidence of his qualifications to judge. The book con-
tained amplified versions of pieces he had written for *Art
World,* a publication he edited, and it was the crowning
achievement of his private war against modernism. This
campaign had gained momentum as he grew older and
had fewer commissions to occupy his time, and the sculp-
tor never minced his words. In a 1933 article about the
problems he saw facing the world of sculpture, he called
modernism "an ego-maniacal pursuit of originality, espe-
cially in the human form, even though that pursuit leads
to insane 'abstractionism.' It means the brutal twisting,
torturing, excessively exaggerating and grotesquing of
the forms of the human body."[1] Ruckstull lambasted
Brancusi, Matisse, Duchamp, Van Gogh, Cézanne, and
Picasso, and used every forum he could find to extoll the
virtues of the European Old Masters and such American
masters as Thomas Cole, John LaFarge, and Edwin
Blashfield.

A charter member of the Institute, Ruckstull became
more active in the organization late in life. When he was
approached in 1931 to lecture in the organization's series,
he warned Mrs. Vanamee, "I am not a *pleasure* lecturer. I
make people *think,* more than merely listen to a lot of
agreeable commonplaces, such as make up the 'stuff' of
most lectures, on Art, which bore me—I *criticize*—the
bad as well as praise the good." Ruckstull would speak
before his fellow members "as a *duty* to the World of Art,
and the great Public—avid of *real* knowledge."

The sculptor planned three lectures: the first would
define art and style, discuss standards, and consider what

makes a work of art great; the second would define beauty
in art and as a beneficent force, and then describe why
ugliness is a spiritual menace; and finally, the third would
be a full-blown attack on the horrors of modern art.[2] His
elaborate plan was subsequently curtailed, and all that
remains in the Academy-Institute's archives is a manu-
script for a short diatribe on modernism. Apparently,

Ruckstull's anti-modernism carried over to literature as well, for in a section of this lecture, which he edited out, he took note of "A notorious book, called 'Ulysses,' by Joyce, [which] is now a *dead* one, because its extravagant style and evil contents, make it incomprehensible."[3]

During his life, Ruckstull remained optimistic in his own cranky way. The manuscript of his speech before the Academy-Institute ends on a hopeful note. *Inspite of this invasion—of false neurotic art, let us not despair. For, a reaction—back to noble art—is bound to come, and I prophesy that within very few years we will have the beginning of a new Renaissance—in fact it is on the way now and it will ultimately result in making America the art centre of the world.*[4]

Ruckstull was twenty-two when he received his first formal art training in night classes at Washington University in his native St. Louis. He made several trips to Paris, studying at the Académie Julian, and turned down an opportunity to work with Rodin, whose work repulsed him. By 1892 he had established a studio in New York. He received national attention when his statue *Evening* (circa 1888; Metropolitan Museum of Art, New York) won the grand medal for sculpture at the World's Columbian Exposition in 1893. Besides sculpting war memorials, ideal figures, and portraits, he actively participated in organizing professional groups and helped to found the National Sculpture Society in 1893. His master feat was the coordination of work for a monument in New York's Madison Square celebrating the triumphant return of Admiral Dewey and his fleet from the South Pacific. Under Ruckstull's direction, an enormous plaster arch and no fewer than eight large sculpture groups were finished and put in place in just six weeks. Ruckstull's work today, although competently sculpted, seems wooden and derivative, and his allegorical groups inarticulate and awkward.

More successful was the work of Ruckstull's portraitist, Frederick William MacMonnies, who began his artistic career at age sixteen as a studio boy for Augustus Saint-Gaudens. Saint-Gaudens recognized his assistant's talents and encouraged him to study at the National Academy of Design and at the Art Students League. Armed with letters of introduction from his mentor, MacMonnies went to France at age twenty, already possessing a solid artistic background. Once there, he enrolled in the École des Beaux-Arts and met with great success. MacMonnies remained in Paris for a number of years, met Ruckstull, and modeled this portrait of him in 1888 for the Salon exhibition. Ruckstull, who was ten years older than MacMonnies, is shown here with a goatee and a balding pate. The artist gives Ruckstull a searching look as if he were already on guard against the dread modernists.

Like Ruckstull, MacMonnies achieved his greatest fame at the Columbian Exposition, when he was elected by Saint-Gaudens to design a huge fountain for the central lagoon. The sculptor was instructed to create a work that would be the antithesis of Daniel Chester French's austere sixty-foot figure of *The Republic,* which was planned for the site. *The MacMonnies Fountain,* as it was known, included twenty-seven elaborate figures surrounding a large ship on which Columbia sat enthroned. An absolute sensation at the fair, the fountain proved to be a great success, and the young sculptor was inundated with commissions.

MacMonnies's most ambitious project later in life was a colossal figure of *France Defiant* for the battlefield of the Marne, erected in Meaux, France. The monument was funded by the private subscription of four million Americans, many of them schoolchildren, and was presented to France in 1926. Like so many of his other works, the monument is a dramatic, rather extravagant representation of a dearly held ideal.

Unlike Ruckstull, MacMonnies's bravado was expressed in his work, not through his behavior. Although his students and associates admired his work—or perhaps because they did—MacMonnies was never satisfied. In a letter to Ruckstull in 1925, he confessed, *The fact is I have been so preoccupied with chasing the rainbow—to try to find the secret of good sculpture—that I have become a sort of will o' the wisp myself. . . . I have been so humiliated by my worthiness as a sculptor & so fatigued with constant effort, always trying always failing—that I have finally come to live a sort of hermit life—no life outside the studio—where endless failures piled up & spurred me on—& now it is over & I feel I have done my best and shot my bolt.*[5]

1. F. W. Ruckstull, "The COLLAPSE of Modernistic Sculpture," *The Skylight* 1, no. 1 (March 1933): 2.

2. F. Wellington Ruckstull to Grace D. Vanamee, March 18, 1931, Academy-Institute Archives.

3. F. W. Ruckstull, untitled manuscript for a lecture at the National Institute of Arts and Letters, p. 4, Academy-Institute Archives.

4. *Ibid.,* p. 10.

5. Frederick MacMonnies to F. W. Ruckstull, November 24, 1925, Academy-Institute Archives.

19.

John Singer Sargent 1856–1925

INSTITUTE, 1905; ACADEMY, 1905

By Augustus Saint-Gaudens 1848–1907

INSTITUTE, 1898; ACADEMY, 1904

Bronze medal; 6 cm. (2⅜ in.) diameter; July 1880;
Inscription: MY FRIEND JOHN/SARGENT PARIS/JVLY MD CCC LXXX/FECE
[monogram] A ST G/BRVTTO/RITRATO ("Sorry portrait");
Gift of Mr. Sargent, 1917

"**N**ow, will you kindly tell me how a certain Mr. John S. Sargent is to be included in our archives," asked Robert Underwood Johnson in December 1916, *who has made a bronze, or a portrait, of you, and what could be better than that you should paint your own portrait for this collection, as doubtless you have done for that of the Uffizzi. Eventually our collection will be a sort of Walhalla, and if you wait until you are dead before you paint your portrait, it may be an excellent spirit picture but it will not be exactly what we want.*[1]

Sargent received Johnson's letter in Boston, where he was completing his work on the Public Library murals and formulating plans for the rotunda of the Museum of Fine Arts. Many requests for contributions had come to him from the Secretary before, but this time Sargent replied, saying that he would try to have a copy made of a small portrait medal by Saint-Gaudens, adding that "Your alternative of my painting my portrait is a nightmare!"[2] Later Sargent told Johnson, "The little medallion that you kindly acknowledged is the only thing that St. Gaudens or anybody else has done of me."[3]

Sargent's portrait is the smallest portrait medallion that Saint-Gaudens ever made. Its size, composition, and the sitter's sharp profile (a pose he favored in his portraits) recall the sculptor's early apprenticeship to a New York cameo cutter. The irregular edges and rather indistinct inscription suggest that it was carved hastily as an informal token of friendship, or perhaps as a model for a larger portrait that was never executed. Although he generally used rectangular compositions for his portraits, Saint-Gaudens returned to this small, circular format for medals commemorating the Centennial of the Inauguration of George Washington (1889), the World's Columbian

Exposition (1892–1894), and, in 1905, in designs for a new currency. Saint-Gaudens's one-cent, ten-, and twenty-dollar coins were put into circulation in the fall of 1907, just after the sculptor's death.

At the time this portrait was taken, Sargent was just twenty-four years old, but already well known in Paris. He had been showing his work at the Salon since 1877 and had received good notices for a portrait of his teacher Carolus-Duran (1879; The Sterling and Francine Clark Art Institute, Williamstown, Massachusetts); in 1878 Sargent's *Oyster Gatherers of Cancale* (Corcoran Gallery of Art, Washington, D.C.) won a second-class medal.

Sargent's work was shown publicly in the United States for the first time in 1878, when he sent *Oyster Gatherers* to New York for the first exhibition of the newly formed Society of American Artists. Saint-Gaudens was a founding member of the Society, which had been organized in 1877 to protest the conservative practices of the National Academy of Design, and was appointed, along with Sargent, Abbott Thayer, and other American artists resident in Paris, as a member of the jury charged with seeking art works for the Society's exhibitions. Sargent's friendship with Saint-Gaudens dates from this time, when artists gathered in the sculptor's studio to discuss the politics of the New York art scene. The two artists remained friendly throughout their lives, and in 1890 Saint-Gaudens did a relief portrait of Sargent's sister Violet (National Portrait Gallery, Smithsonian Institution, Washington, D.C.) in exhange for a Sargent portrait of his wife and son (*Portrait of a Boy,* Carnegie Institute Museum of Art, Pittsburgh). Later Sargent sought Saint-Gaudens's advice regarding relief details in his murals for the Boston Public Library.

When Sargent's name was omitted from the initial roster of members of the National Institute, it was Saint-Gaudens who was instrumental in seeing that he was nominated. Balloting for new members was held for the first time in 1905, and Sargent, along with Winslow Homer, was easily elected. Almost immediately, Sargent's name was placed on the ballot for the Academy, and again he won election without opposition.

In 1909, anxious to develop a program that would be publicly significant, the Institute solicited nominations for its first gold medal award. When the art department was polled for candidates "in the field of art," nine members out of the twenty who replied made Saint-Gaudens their first choice, and two their second.[4] Sargent received the next highest number of votes, with his name appearing on seven ballots.

Saint-Gaudens had been dead for two years when the medal was voted to him. The Academy, however, regarded its presentation to his widow as a good opportunity for a memorial meeting to a distinguished departed colleague. On November 20, 1909, members met at the Fine Arts Society on 57th Street and listened to several speeches, selections of chamber music, and a rambling ode by Robert Underwood Johnson who dubbed Saint-Gaudens "our Donatello."[5]

The committee appointed to conduct the gold-medal poll—Cass Gilbert, Kenyon Cox, and Gari Melchers—had suggested that future medals be given to "living men, or to men who shall not have been dead more than one year . . . [in order to] obviate any tendency to avoid the responsibility of choosing among living candidates by uniformly conferring the honor upon persons whom death had removed from possible rivalry."[6] Their suggestion was acted upon when canvassing was conducted for the Gold Medal for Painting in 1914. When the balloting was completed, John Singer Sargent won by a vote of almost four to one.

Although Sargent could not be present to accept the award, muralist Edwin Howland Blashfield, who placed second in the voting (and received the medal in 1923), presented the medal at a public meeting of the Institute and Academy in New York. Mindful of the infamous Armory Show, which had shocked New York the previous year, Blashfield praised Sargent's work as "never eccentric," noting that, when "innovation lapsed at the hands of some men into incoherency, Sargent held a straight course and remained coherent."[7]

1. Robert Underwood Johnson to John Singer Sargent, December 26, 1916, Academy-Institute Archives.

2. John S. Sargent to Robert Underwood Johnson, December 27, 1916, Academy-Institute Archives.

3. John S. Sargent to Robert Underwood Johnson, February 5, 1917, Academy-Institute Archives.

4. "National Institute of Arts and Letters/Its First Medal to Go to an Artist/Request for Nominations by the Section of Art," printed circular, January 30, 1908, Academy-Institute Archives.

5. Invitation from the National Institute of Arts and Letters to the "presentation to Mrs. Saint-Gaudens of the gold medal of the Institute, November 20, 1909," Academy-Institute Archives; Robert Underwood Johnson, "Saint-Gaudens," *Proceedings of the American Academy of Arts and Letters and of the National Institute of Arts and Letters*, vol. 1, no. 2 (New York, November 1, 1911), p. 10.

6. Report to the National Institute of Arts and Letters from Cass Gilbert, Kenyon Cox, and Gari Melchers (Chairman), n.d. [1909], Academy-Institute Archives.

7. Edwin Howland Blashfield, "Conferring on Mr. Sargent of the Gold Medal of the Institute," *Proceedings of the Public Meetings of the American Academy of Arts and Letters and of the National Institute of Arts and Letters*, vol. 2, no. 2 (New York, September 1, 1915), p. 45.

20.

Self-Portrait

By Albert Edward Sterner 1863–1946

INSTITUTE, 1929

Oil on canvas, signed; 74.9 x 74.9 cm. (29⁷⁄₁₆ x 29⁷⁄₁₆ in.); 1938;
Gift of Mr. Sterner, 1939

At the time of his election to the Institute, Albert Sterner was known primarily for his portraiture, but he had begun his career as an illustrator. Born of American parents in London, he first came to the United States in 1879 and went to work for a Chicago lithographer. Several years later he moved to New York and succeeded in selling a small drawing to *St. Nicholas Magazine.* From this modest beginning he went on to contribute humorous sketches to *Life,* and later to *Harper's* and *The Century.* As soon as he had managed to save four-hundred dollars, he sailed to Paris, where, like so many young Americans, he studied at the Académie Julian and at the École des Beaux-Arts under Gérôme. Back in New York, armed with his newly acquired technical proficiency, Sterner found that he could command larger sums for his illustrations. Still not satisfied, he returned to Paris and sent his first painting to the Salon in 1890, where it received an Honorable Mention.

When he returned home, Sterner won a competition to illustrate a new edition of George William Curtis's *Prue and I* (1892). The success of this project led to others, including the illustrations for a ten-volume edition of the works of Edgar Allan Poe, and soon Sterner was enjoying exhibitions of his drawings as well as his paintings. Whenever he could afford it, the aspiring artist returned to Europe. During the late 1890s he spent two-and-a-half years in Germany, where he worked on his painting and experimented with lithography. Although he still supported himself primarily with his illustrations, he tried to avoid becoming strictly categorized. "I am not an illustrator," he explained, "but I illustrate."[1] It was at this point in his career that Albert Sterner began to devote more of his time to portrait drawings.

Sterner worked in various media—oil, lithography, drypoint, charcoal, pastel, chalk, crayon, tempera—and his style varied with his medium. Where his crayon drawings are finely detailed with controlled and conservative lines, his lithographs tend to be more experimental, employing freely flowing lines and harsh shadows.

Albert Sterner was a vigorous seventy-five when he painted this self-portrait in 1938. The composition, which may reflect the influence of Velásquez, places the full-length figure in the center before his canvas.[2] Light enters from a shaded window behind the artist, picking out highlights in the artist's white suit and paint bottles. Sterner's style of dress reflects his painting style—relaxed but deliberate; idiosyncratic but not overly flashy or unusual. Critics labeled Sterner a "progressive conservative," a curiously opposed pair of words that nonetheless describes his work and his opinions fairly accurately.[3]

Sterner frequently wrote on art and lectured widely, often denouncing modern art. During the 1930s he lashed out against the W.P.A. painters in an open letter to the directors of the Academy-Institute: *There are today all over our United States, thanks to the well-meaning though in my opinion misdirected intervention of government, thousands of young individuals handling paint brushes and turning out puerile and futile records of the "American Scene"; and in all the professions the untried tyro is boosted by cheap publicity into undeserved prominence.*[4] Sterner's anger, based at least in part on aesthetic differences, arose also from financial considerations. The Depression had hit him hard, and in 1937 he was forced to appeal to the Academy for a loan to help pay his studio rent.[5] In an earlier letter, the aging painter had explained his struggles: *The true artist in any profession today, born into our mechanistic and industrial era, is*

willy-nilly called upon not only to evolve his painting, his symphony, his poem or drama but to espouse a double career; he must be an artist and a business man. He must struggle on the one hand with the intricate technique of his craft and the complexities of his vocation, and on the other hand acquire the technique, more vulgar perhaps, but no less exacting, required to procure the means of his material life. He must do this if he is to carry on his work, this higher work which can alone help to stem the ugliness and sordid manifestations of our present sociological conditions.[6]

When the Academy-Institute received a large endowment from Archer Huntington in 1936, it appealed to its members for ideas about how the funds should be used. Sterner did not hesitate to offer his opinion: "To remove the burden of the material struggle for existence from . . . an artist should be the purpose of the administration of this gift to us."[7] Sterner saw his suggestion realized, at least in part. Beginning in 1941, and continuing to the present day, the Academy-Institute has used a portion of Mr. Huntington's endowment to bestow cash gifts on promising artists, writers, and composers. The first awards were each five-hundred dollars; awardees today receive ten times that amount.

1. Ralph Flint, *Albert Sterner: His Life and His Art* (New York, 1927), p. 21.

2. *Ibid.,* p. 32.

3. "Albert Sterner, Noted Artist, 83," obituary, *The New York Times,* December 17, 1946.

4. Albert Sterner to Mr. Chairman and Gentlemen [the directors of the Academy-Institute], February 8, 1936, Academy-Institute Archives.

5. On March 5, 1937, Institute Secretary Henry S. Canby informed the members that an annual appropriation of $1,500 had been made "for the relief of members of the Institute in real distress" (Academy-Institute Archives). The practice of offering emergency financial assistance has continued, and in 1986 $50,000 was allotted for grants to artists, writers, and composers, whether or not they were members.

6. Albert Sterner to Mr. Chairman, February 8, 1936.

7. *Ibid.*

21.

Booth Tarkington 1869-1946

INSTITUTE, 1908; ACADEMY, 1920

By Wayman Adams 1883-1959

INSTITUTE, 1929

Oil on canvas; 206.8 x 99.7 cm. (81⅜ x 39¼ in.); 1916;
Gift of Mrs. Tarkington, 1933

In 1933 Academy administrator Grace Vanamee received a letter from Susannah Tarkington, which began uncertainly, *I have been trying to make up my mind to write you all this past winter . . . to say that if the Academy still wishes the portrait of Mr. Tarkington which they asked for several years ago, I have decided to present them the portrait which Wayman Adams painted of my husband.* Mrs. Tarkington was obviously reluctant. "I love the picture," she confessed. "Mr. Adams gave it to me and I feel very noble in making this offer." Mrs. Vanamee replied at once, assuring her that, with her "generous and beautiful gift," she was "building for a long future when the Museum of the American Academy of Arts and Letters and the National Institute of Arts and Letters will be one of the choicest collections of Americana in the United States."[1] A month later the painting arrived in New York.

Wayman Adams, who was elected to the Institute in 1929, executed this portrait in 1916 when Tarkington was forty-seven. The writer is shown full-length, wearing a fur-collared overcoat and leaning on a walking-stick. Sitting at Tarkingon's feet is Wops, a dark black poodle, whose form almost disappears against his master's broadly painted legs. Like Tarkington, Adams was born in Indiana. He attended the John Herron Art Institute in Indianapolis before spending several years in Europe, where he studied with William Merritt Chase in Italy and with Robert Henri in Spain. Adams's *oeuvre* includes portraits of other fellow Hoosiers, including novelist Meredith Nicholson and poet James Whitcomb Riley. Although primarily a portrait painter, Adams worked in watercolor and at sculpture as well. For many years he and his wife operated an art school in Elizabethtown, New Jersey.

Soon after the Academy received Tarkington's portrait, the novelist was voted the Gold Medal of the Institute for distinguished work in fiction. Tarkington was deeply moved. "No other award so highly honors the recipient," he wrote, "or may so deeply touch him, since it is bestowed upon him by the generous thoughts of his own colleagues in the greatest fellowship in arts and letters known to us." The novelist had recently undergone cataract surgery, which, although it had partially restored his lost eyesight, had left him physically drained. "Bodily disabilities are less powerful than gratitude, yet may prevent the oral expression of it," he complained, confessing his inability to accept the medal in person.[2] Since the presentation speeches were to be broadcasted, Tarkington was instructed by telegram to listen to his radio at his home in Maine. "We heard the whole program perfectly here through the Portland station," he reported, "it was startlingly like being present."[3]

Although Tarkington's physical problems prevented him from attending the organization's meetings, he did participate in its activities by mail, serving on the committee that awarded the William Dean Howells Medal in 1940. This medal, which was endowed by Archer Huntington, was given for the first time in 1925 and every five years thereafter. Although it was intended to provide recognition for the "most distinguished work of American fiction" published during each half-decade, the early award committees interpreted the guidelines loosely. Tarkington's group awarded the medal to Ellen Glasgow, who had been asked to serve on the committee but was prevented because she had just suffered a heart attack. The committee arrived at its decision, according to Tarkington's secretary, in order "to give Miss Glasgow a

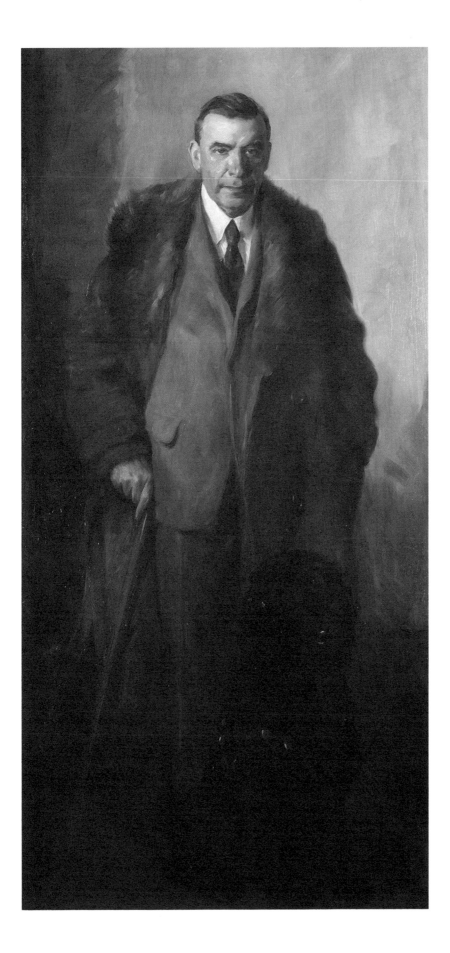

word of cheer while she is ill—and knowledge of the appreciation of her colleagues on the Howells Medal Committee would certainly be of cheer to her."[4]

Five years later, when Tarkington became the first man to receive the Medal, he wrote that he was "virtually speechless with the most grateful kind of astonishment."[5] As was the case when Miss Glasgow received the award, no particular book was singled out for the honor. Tarkington had produced some forty novels and twenty plays since his first book, *The Gentleman from Indiana*, was published in 1899. His novels of boyhood—*Penrod* (1914), *Penrod and Sam* (1916), and *Seventeen* (1916) among them—were popular and often compared to the work of Mark Twain. Tarkington won the Pulitzer Prize in 1918 for *The Magnificent Ambersons*, and again in 1921 for *Alice Adams*, a novel that many critics, such as Chauncey Brewster Tinker, considered "a brilliant specimen of the realistic method."[6]

Sinclair Lewis, who also admired Tarkington's "real-ism" and first suggested him for the Howells Medal, was quoted at length by Academy President Walter Damrosch when he presented the award to Tarkington. The novelist, said Damrosch, *remains one of the chief, of all the discoverers of America in literature—loving his country, proud of it, amused by it, sometimes indignant at phases of it, mocking it, singing it, and always being it. Perhaps as much as Hamlin Garland or Howells or Dreiser he was a pioneer in seeing that our wheatfield and apple trees and old brownstone-fronts are quite as romantic as European marble fauns and secret gardens . . . his incessant humor, shrewd and unfettered, might have kept him from a really serious contemplation of the American way. But it did not, and we owe to Mr. Tarkington as much for his revelation of lasting and solid America as for the delight of his stories as stories. Here, the reader feels, is one honored writer whose personal talk must be as wise and shining as his books; here we feel, is an American—no, more than that: here is a* Man![7]

A year later, the Gentleman from Indiana died at age seventy-six, leaving behind an unfinished novel.

1. Susannah Tarkington to Grace D. Vanamee, April 7, 1933; Grace D. Vanamee to Mrs. Newton Booth Tarkington, April 10, 1933, Academy-Institute Archives.

2. Booth Tarkington, "To the President of the National Institute of Arts and Letters, to Mr. Clayton Hamilton, and the members of the Institute," n.d. [circa November 1933], Academy-Institute Archives.

3. Booth Tarkington to Grace D. Vanamee, November 18, 1933, Academy-Institute Archives.

4. Elizabeth Trotter to Grace D. Vanamee, August 8, 1940, Academy-Institute Archives.

5. Booth Tarkington to Walter Damrosch, January 29, 1945, Academy-Institute Archives.

6. Chauncey Brewster Tinker, "Newton Booth Tarkington, 1869–1946," in *Commemorative Tributes, 1942–50,* p. 56.

7. A typed transcript of Damrosch's speech is in the Academy-Institute Archives.

22.

Carl Van Vechten 1880–1964

Institute, 1961

By Martha Susan Baker 1871–1911

Oil on canvas, signed; 146 x 87.5 cm. (57½ x 34⁷⁄₁₆ in.); 1906;
Gift of Fania Marinoff Van Vechten, 1965

Carl Van Vechten's life spanned more than eight decades and included three consecutive careers. He began in 1904 as a cub reporter for the *Chicago American*, covering police stations, collecting photographs, and contributing tidbits to a gossip column. By mid-1906 the twenty-six-year-old, bored with Chicago, moved to New York, where he settled in an apartment next to the aspiring novelist Sinclair Lewis. There he became assistant music critic for the *New York Times*, and indulged his taste for new music. After a brief stint as the paper's Paris correspondent in 1908–1909, he returned to New York, turned more seriously to music criticism, and soon became one of the most respected commentators in the city. Van Vechten also published several volumes of essays, including *Music After the Great War* (1915), *Music and Bad Manners* (1916), and *Interpreters and Interpretations* (1917). In 1920 at age forty, Van Vechten announced his retirement; by his age, he said, a man experienced "intellectual hardening of the arteries," which inhibits his usual receptiveness to innovation.[1]

With this pronouncement, Carl Van Vechten embarked on his second career: he became a novelist. By 1930 he had published seven works of fiction, including *The Tattooed Countess* (1924) and *Nigger Heaven* (1926). In his first effort, *Peter Wiffle: His Life and Works*, published in 1922, Van Vechten included characters drawn from his own life—the celebrated Greenwich Village salon hostess Mabel Dodge (Luhan) lightly disguised as Edith Dale, the avant-garde writer Gertrude Stein, and the painter Martha Susan Baker.[2]

Van Vechten had befriended Miss Baker during his days in Chicago, and sat to her twice in 1906. In *Peter Wiffle*, the reader first meets the title character in the artist's studio, while the author is sitting for his portrait. "I climbed to the model-chair," says Van Vechten speaking through the first person, "seated myself, grasped the green book that was part of the composition, and automatically assumed that woe-begone expression that is worn by all amateurs who pose for their portraits."[3] In this novelized version, Van Vechten proceeds to argue with a would-be opera singer whom Baker has invited to her studio to amuse her sitter as she paints. Miss Baker's friend finally grows incensed with Carl. "I was amused by her display of emotion," confesses the sitter, *but I was also bored. My face must have showed it. Martha worked on for a moment or two and then flung down her brushes. "It's no good, no good at all," she announced. "You have no expression today. I can't get behind your mask. Your face is completely empty."* The novel's narrator went on to say that this was the last time he sat for this portrait. "She never did get behind the mask," he admitted, adding, "To that extent I triumphed, and the picture still exists to confuse people as to my real personality. It is as empty as if it had been painted by Boldini or McEvoy."[4]

Though Van Vechten's account of his sitting for this portrait is somewhat fictionalized, he obviously admired Baker's talents as a painter, and his comments on her work are generously interspersed with his description of the scene: *She had an uncanny talent for portraiture, a talent which in some respects I have never seen equalled by any of her coevals. . . . Her peculiar form of genius lay in the facility with which she caught her sitters' weaknesses. Possibly this is the reason she did not sell more pictures, for her models were frequently dissatisfied. It was exasperating, doubtless, to find oneself caught in paint on canvas against an unenviable immortality. Her sitters were exposed, so to speak; petty vices shone forth;*

Martha almost idealized the faults of her subjects. It would be impossible for the model to strut or pose before one of her pictures. It told the truth. . . . She tore away men's masks and, with a kind of mystic understanding, painted their insides.[5]

Van Vechten felt that his "insides" had been more truthfully portrayed by Baker in an earlier effort, which shows him in a dressing gown, seated on an upholstered chair. This painting, which the sitter called "sufficiently revealing," and which Mabel Dodge later entitled "The Conscious Despair of Irrevocable Decadence," is more traditional in its composition, but indeed more psychologically provocative.[6]

Van Vechten's observations on Miss Baker's insightful portraiture could also be applied to the work of his third career. Following the publication of *Sacred and Profane Memories* in 1932, Van Vechten decided that he would never publish another book, and he kept his word. Instead, he turned his energies to portrait photography. He captured some fifteen-thousand images on film, comprising an eloquent and wide-ranging record of the most important personalities of twentieth-century arts and letters. His subjects were as varied as his interests, and included painters, authors, jazz legends, composers, playwrights, and movie stars.

In 1961 Carson McCullers nominated Van Vechten, who was eighty-one, for Institute membership with a citation that read: *Mr. Van Vechten's outstanding contribution to creative writing, particularly a series of satiric novels in advance of the fashions of their time, and his championship, in essay form, of modern music and drama and the cause of the Negro, have long since merited the honor of election to the Institute.*[7]

Van Vechten accepted this overdue honor enthusiastically and began participating. He nominated candidates for awards, donated first editions of many of his books to the library, and, as he wrote short pieces during the early 1960s, contributed the manuscripts to the Archives.[8] A major gift was his collection of more than one-hundred photographs of Institute members and other notables. He took great pleasure in his own generosity, and when the Academy-Institute librarian acknowledged his gifts, he wrote, "Your letter made me very happy. I was so pleased that you appreciated the photograph of Malcolm Cowley. I consider it my greatest photograph. It almost seems to breathe."[9]

Carl Van Vechten was an ardent advocate for civil rights, and throughout his career championed the work of black artists. In 1942 he founded the James Weldon Johnson Memorial Collection of Negro Arts and Letters at Yale, consisting of his large collection of recordings, letters, manuscripts, and books relating to black writers, painters, and musicians. It was particularly fitting that Langston Hughes, who was elected to the Institute the same year as Van Vechten, should write a commemorative tribute to his friend. "A sure sign of old age is when a man begins to disapprove of the young," Hughes began. "At the age of eighty-four, Carl Van Vechten had not yet grown old."[10]

1. Langston Hughes, "Carl Van Vechten, 1880–1964," *Proceedings of the American Academy of Arts and Letters and the National Institute of Arts and Letters*, 2d ser., 15 (1965) : 504.

2. Martha Susan Baker was born in Evansville, Indiana, in 1871, and studied at the Art Institute of Chicago. Primarily a portrait painter and miniaturist, she painted more than 250 sitters, many of whom were Chicago society women. Her work was exhibited widely in the United States, as well as at the Royal Academy in London and the Paris Salon, where she won an honorable mention.

3. Carl Van Vechten, *Peter Whiffle: His Life and Works* (New York, 1922), p. 30.

4. *Ibid.*, p. 33.

5. *Ibid.*, pp. 26–27.

6. *Ibid.*, p. 33.

7. National Institute of Arts and Letters Ballot for New Members, 1961, sent to the membership on November 10, 1960, Academy-Institute Archives.

8. For awards Van Vechten nominated Philip Roth, Edward Albee, and James Purdy; later he suggested Martin Luther King for the Blashfield Address.

9. Carl Van Vechten to Hannah Josephson, June 1, 1963, Academy-Institute Archives.

10. Hughes, "Carl Van Vechten," p. 504.

23.

Elihu Vedder 1836–1923
INSTITUTE, 1898; ACADEMY, 1908

By William McGregor Paxton
1869–1941

Oil on canvas; 55.4 x 45.3 cm. (21¹³⁄₁₆ x 17¹³⁄₁₆ in.); 1910;
Inscription: *To Miss A. H. Vedder/Paxton/Capri/1910*;
Gift of Anita H. Vedder, 1938

During the summer of 1910, William McGregor Paxton visited Elihu Vedder for a few days at his villa on the island of Capri, and painted this portrait. Like many other Boston artists of his generation, Paxton had attended the Cowles School and then went to Paris, where he worked at the Académie Julian and in Gérôme's atelier. Back home, he studied with the Boston artist Joseph de Camp, whose influence may have been responsible for his concentration on interior views. In these paintings Paxton used the geometry of rooms to create visual interest in compositions that generally centered on an attractive, pensive young woman in elegant or exotic clothing, surrounded by fashionable bric-a-brac. He was also a popular portraitist, noted for good likenesses combined with fine characterization.

In his painting of Elihu Vedder, Paxton was able to indulge his talent for portraiture and his fascination with exotic costume, such as the kimono and velvet skullcap affected by the aged Vedder. Paxton's sensitively painted portrait appealed to Vedder, who told Robert Underwood Johnson that it was one of the best ever taken of him.[1] The artist inscribed it to Vedder's devoted daughter Anita, who gave it to the Academy in 1938, following an exhibition of her father's work in the organization's galleries.

Several months after her father's death in January 1923, Anita Vedder suggested a retrospective. More than a decade passed before the artist was finally included in the Academy's exhibition schedule, but still his daughter was delighted, and anxious to get her father's work out of Rome, where war threatened.[2] Despite some transatlantic confusion, the show opened on November 12, 1937, and included more than 250 paintings, drawings, and small bronzes, most from Anita's collection. The catalogue, which was written by Anita but published anonymously, contained an appreciation of Vedder's art. "In his work Vedder shows three distinct ways of painting," she noted, citing his imaginative, decorative, and landscape works. "But this was intentional."[3]

Early in his career Vedder had painted small, simple, and very beautiful landscapes, but he acquired notoriety when the first of his imaginative paintings was shown at the National Academy of Design after the Civil War. During an earlier trip abroad the artist had become acquainted with the pre-Raphaelites, and their mysterious melancholy sentiments and style influenced his work. The fanciful ambiguity of *The Questioner of the Sphinx* (1863; Museum of Fine Arts, Boston), *The Lair of the Sea Serpent* (1864; Museum of Fine Arts, Boston), or *The Lost Mind* (1865; Metropolitan Museum of Art, New York), appealed to the public. "Even down into the early eighties there was discussion and explanation of those pictures," recalled John C. Van Dyke. "Who and what was the personified Lost Mind? What was the Questioner asking the Sphinx? Was the Sea Serpent really painted from a large eel?"[4] Vedder himself confessed, "It delights me to tamper and potter with the unknowable."[5]

Following the successful reception of these works, Vedder returned to Europe and in 1867 settled in Rome, where he made his home for the rest of his life. In 1884 the artist illustrated a new edition of *The Rubáiyát of Omar Kháyyam*, which was a stunning success. Later in life he turned to mural decoration, receiving commissions from the Library of Congress and the Walker Art Center at Bowdoin College, and from private citizens, including Collis P. Huntington, stepfather of the Acad-

emy's eventual benefactor. By the time that he was elected to the Academy, Vedder was working on his memoirs, *The Digressions of V*, which were published in 1910.

Following the close of the retrospective exhibition, Miss Vedder sold some pieces in the collection but left the rest at the Academy, only to discover ten years later that the works remained crated in the basement. Obviously disturbed, she wrote to say that, although she had decided to bequeath this collection to the organization, "if now the Academy does not take proper care of them and finds them cumbersome I must think what to do."[6] The Academy-Institute's new administrator, Felicia Geffen, responded with words of cool apology, but it took a disillusioned and ailing Miss Vedder a year-and-a-half to reply. "I only hoped the Academy would take care of them," she lamented, "and keep them as a collection, to be exhibited from time to time. Or loaned occasionally. . . . Indeed, I am sure as time passes the 18th [sic] Cent. artists will be more appreciated, and I trust among them my father."[7]

In April 1954 the Academy received official notice of Anita Vedder's bequest. Since the gift was given without restrictions, the Academy could do with it what it wished. Just five months after Anita's death, in November 1954, it was decided that the organization would make a selec-

tion of the best of Vedder's work for its permanent collection and distribute the remainder to museums throughout the country.[8] There were more than three-hundred-fifty oils, pastels, sketches, and prints in the collection, but, according to an appraiser and the members of the Art Committee—Barry Faulkner, Gifford Beal, William Adams Delano, Leon Kroll, Paul Manship, and Eugene Speicher—"the saleability of the pictures was very dim."[9] Art dealers were invited to handle the sale, but those consulted "did not consider them of any commercial value."[10] By March of 1955 thirty-five museums had received gifts. "Wherever possible, we sent drawings related to paintings already in possession of the galleries concerned," the committee reported.[11]

In retrospect, the distribution of Vedder's work might seem irresponsible. As Vedder's place in American art history becomes more firmly assured, however, the availability of his art throughout the country expands Americans' acquaintance with it, and increases appreciation of his accomplishments. The only loss has been the Academy's, since the organization received no income from the bequest. But, as John C. Van Dyke said in concluding his tribute to Vedder, "There is no reason why [Vedder's] success should not be our pride."[12]

1. Elihu Vedder to Robert Underwood Johnson, September 6, 1915, Academy-Institute Archives.

2. Anita H. Vedder to Grace D. Vanamee, May 20, 1935, Academy-Institute Archives.

3. "Elihu Vedder," *Catalogue: Exhibition of the Works of Elihu Vedder* (American Academy of Arts and Letters, 1937), p. 19.

4. John C. Van Dyke, "Elihu Vedder," in *Commemorative Tributes, 1905–41*, p. 140.

5. *Ibid.*, p. 141.

6. Anita H. Vedder to the American Academy of Arts and Letters, July 11, 1947, Academy-Institute Archives.

7. Anita H. Vedder to Felicia Geffen, February 26, 1949, Academy-Institute Archives.

8. Minutes of a meeting of the Art Committee of the American Academy of Arts and Letters, November 10, 1954, p. 2, Academy-Institute Archives.

9. Minutes of a meeting of the Board of Directors of the American Academy of Arts and Letters, December 3, 1954, p. 948, Academy-Institute Archives.

10. Minutes of a meeting of the Board of Directors of the American Academy of Arts and Letters, February 4, 1955. In contrast to the dealers' evaluations, Miss Vedder cited prices of up to $3,000 for a large oil, and up to $400 for a small landscape (Anita H. Vedder to Robert Underwood Johnson, May 11, 1916, Academy-Institute Archives).

11. Minutes of a meeting of the Art Committee of the American Academy of Arts and Letters, March 24, 1955, p. 974a, Academy-Institute Archives.

12. Van Dyke, "Elihu Vedder," p. 143.

24.

Edith Wharton 1862–1937

INSTITUTE, 1826; ACADEMY, 1930

By Edward Harrison May 1824–1887

Oil on canvas, signed; 118.9 x 71.4 cm. (46¹³⁄₁₆ x 28⅛ in.); 1881;
Gift of Mrs. Wharton, 1930

"Don't you think that we have left Mrs. Howe too long alone in the list of the Academy of Arts and Letters," Thomas Wentworth Higginson wrote to Richard Watson Gilder in 1908, asking Gilder to join him in nominating Edith Wharton, "who is now, I think, plainly in the lead."[1] When the issue of electing women had first been raised three years earlier, Gilder had suggested Mrs. Wharton's name. She had just published *The House of Mirth*, her first important novel, and by the time of Higginson's proposal, she had completed several novels, a collection of short stories, and some nonfiction work. But, despite her growing reputation, Mrs. Wharton would have to wait until 1926 to become a member.

In 1917 Edith Wharton and fellow novelists Margaret Deland and Mary E. Wilkins Freeman received letters asking if they would care to stand for election to the Institute. "It is customary for me to ask this question of all persons nominated," they were told by Secretary Ashley H. Thorndike, "but perhaps I should explain that there is a special reason in your case." Mr. Thorndike went on to describe the continuing controversy over the election of women, but assured his correspondents that, "if women are to be admitted, the three nominated will certainly be selected."[2] Edith Wharton responded that she would "be very glad to be included" in the organization, but asked "to be spoken of simply as 'Mrs. Wharton.' I sign my books naturally, with my christian name," she wrote, "but when it is prefixed by a 'Mrs.,' I feel myself associated with vendors of patent medicines and other categories of females with whom I have no affiliations!"[3]

Edith Wharton's name—without the "Mrs."—appeared on the 1918 ballot. Although she received sixty-four affirmative and just six negative votes in the preliminary election, the council subsequently vetoed the policy of electing women by a vote of seventeen to twenty-three. Each time the issue was raised during the next eight years, discussions became entangled with pettifogging questions about proper parliamentary procedure. The frustratingly brief minutes of these meetings leave the sense that all concerned gave up in exasperation. During a discussion in 1925, Hermann Hagedorn suggested that an effort had repeatedly been made to dodge the issue entirely, and he urged the Council to report on the names of women who had passed the preliminary votes so that they could be elected once and for all. In response, Brander Matthews argued that, since the organization's constitution stated that the Institute was founded by *men*, women were prohibited from being admitted, and therefore could not properly be voted upon. Matthews's resolution carried, and the president was instructed to seek counsel regarding the legality of electing women based on the organization's bylaws. In a long statement, attorney Henry DeForest Baldwin replied that "it does not seem to me that a society organized 'with a view to the advancement of art, music and literature,' even though the organizers happen to have been men, would be radically perverting and changing the purposes of the society by admitting women."[4] Matthews and his cronies had no choice but to give in. Mrs. Wharton was elected in 1926 along with Mrs. Deland, Mrs. Freeman, and Agnes Repplier.

Two years earlier Mrs. Wharton had received the Gold Medal of the Institute, and in 1929 she was voted the Gold Medal of the Academy. Her statement, read by her sister-in-law, Mary Cadwalader Jones, said in part: *I am particularly gratified by the formula used in conferring the medal. You say it is given in recognition of my services to*

Letters. I have tried to serve Letters all my life, and it is because I believe that the word service best expresses the true, the necessary, relation of the artist to his Art—with all that the word implies of faithfulness, application, reverence and devotion—that I am particularly happy in having my work designated in these terms.[5]

In 1930, several weeks after her sister-in-law had been elected the first woman member of the Academy, Mrs. Cadwalader Jones wrote to President Nicholas Murray Butler that the author was anxious to give a portrait of herself to a New York-based organization, and that "she would prefer to have it somewhere connected with the Academy of Arts and Letters, as she felt deeply the honour lately given her." Mrs. Jones described the portrait, noting that *when Edith Wharton was eighteen her fond parents had her portrait painted in Paris by a creditable, although not remarkable American artist named George [sic] May. When the elder Joneses died it went to her brother Harry, and after the death of his widow it was sent back to Edith. Now, she would like to have it in New York, where after all she "belongs."... If I remember rightly the frock is red, and the whole picture is what is usually called "effective."*[6]

Edward Harrison May was born in England and came to the United States when he was ten. He studied with Daniel Huntington and began exhibiting at the National Academy of Design in 1844, where his work met with some success. After collaborating with several other art-

ists on a popular and profitable panorama of *The Pilgrim's Progress* (circa 1850), he traveled abroad and made Paris his permanent home. There May studied with Thomas Couture, whose teachings would guide all his later work. He showed typical historical paintings at the Salon and painted many portraits of French dignitaries and American officials. During his career May was recognized for his ability as a draftsman and for his skillful, academic compositions, although his work sometimes lacked emotional vitality.

May's style was well suited to the reticent Edith Newbold Jones, who had been too shy to dance at her debut two years earlier. The painter described the rich colors and fine textures of the frock and jewelry of an eighteen-year-old who easily could be a character in *The Age of Innocence*, but her penetrating eyes and knowing grin suggest her future as a socially observant novelist.

The Age of Innocence appeared many decades after this picture was painted. "Yes; it's good," commented the actor Walter Berry, writing to Mrs. Wharton about the novel. "But of course you and I are the only people who will ever read it. We are the last people who can remember New York and Newport as they were then, and nobody else will be interested."[7] Berry was wrong, of course. The novel became a best seller when it was published in 1920, and it and Mrs. Wharton herself continue to intrigue readers today.

1. Thomas Wentworth Higginson to Richard Watson Gilder, October 26, 1908, Academy-Institute Archives.

2. Ashley H. Thorndike, secretary, to Mary E. Wilkins Freeman, n.d. [1917], Academy-Institute Archives.

3. Edith Wharton to A. H. Thorndike, December 18, 1917, Academy-Institute Archives.

4. Henry DeForest Baldwin to Henry Hadley, quoted in Minutes of the Annual Meeting of the Institute, November 10, 1926, p. 70, Academy-Institute Archives.

5. "Message from Edith Wharton," accompanying letter from Mary Cadwalader Jones to Grace D. Vanamee, April 21, 1929, Academy-Institute Archives.

6. Mary Cadwalader Jones to Nicholas Murray Butler, December 8, [1930], Academy-Institute Archives.

7. Robert Grant, "Edith Wharton," in *Commemorative Tributes, 1905-41*, p. 367.

BIBLIOGRAPHY

ACADEMY—INSTITUTE PUBLICATIONS

PROCEEDINGS

First published in 1909, the *Proceedings of the American Academy and the National Institute of Arts and Letters* were issued at irregular intervals until 1921 and contain speeches delivered by members and guests at meetings and award presentations, lists of members, bylaws, program notes for concerts, memorial tributes, etc. Issues are collected in two volumes: vol. 1, 1909-1913, 1913; and vol. 2, 1914-1921, 1922.

Additional single volumes were published to record the proceedings of special events such as memorial meetings (Augustus Saint-Gaudens, 1909; Samuel Langhorne Clemens, 1910; William Dean Howells, 1921; John Burroughs, 1921), the centennial of the birth of James Russell Lowell, 1919; the laying of the cornerstone, 1921; opening of the Academy's buildings, 1923, 1930; the three-hundredth anniversary of the birth of Molière, 1922.

Since 1951, a second series of *Proceedings* has been published annually, containing a record of the organization's yearly Ceremonial (at which awards are presented, new members inducted, the Blashfield Address delivered), as well as records of addresses and discussions at dinner meetings and commemorative tributes.

COMMEMORATIVE TRIBUTES

Commemorative Tributes of the American Academy of Arts and Letters, vol. 1, 1905-1941, 1941 (119 memorial essays written by members and reprinted from the *Proceedings* and from pamphlets published between 1922 and 1941); vol. 2, 1942-1951 (tributes to twenty-four deceased Academicians).

Tributes written after 1951 are published in the *Proceedings*, second series. Since 1965, tributes have been written to Institute members as well as to Academicians.

EXHIBITION CATALOGUES

The Academy-Institute has held exhibitions regularly since 1922. Catalogues for early exhibitions generally contain introductory essays and/or biographical notes written by members as well as checklists of the exhibitions; many are illustrated with black-and-white photographs. In addition to several group exhibitions centering on work by members, one-man shows were held for the following artist members: Timothy Cole, 1927; Joseph Pennell, 1927; Childe Hassam, 1927; Edwin Howland Blashfield, 1927; William Merritt Chase, 1928; Edwin Austin Abbey, 1928; Paul Wayland Bartlett, 1931; Gari Melchers, 1932; George deForest Brush, 1933; Charles Dana Gibson, 1934; Cecilia Beaux, 1935; Anna Hyatt Huntington, 1936; Elihu Vedder, 1937; and Charles Adams Platt, 1938.

Following the inception of the Academy-Institute's award program in 1941, the exhibition schedule has generally been as follows:

March–April: Work by candidates for art awards (1961-present).

May–June: Art work and manuscript material by newly elected members and recipients of honors and awards (1943-present); from 1948 to 1957, this exhibition included paintings purchased from the Childe Hassam Fund.

November–December: Thematic or one-man exhibitions of art work and/or manuscript material (1944-1969); group memorial exhibitions for artist members (1970-present); concurrent exhibitions of paintings eligible for purchase from the Hassam Fund (1958-present).

The World War: Utterances Concerning Its Issues and Conduct by Members of the American Academy of Arts and Letters. 1919. Statements, excerpts of speeches and articles (some previously published), and poems concerning World War One.

In Memoriam: A Book of Record Concerning Former Members of the American Academy of Arts and Letters. Vol. 1, 1922, contains an introduction on the need for an Academy and its functions by William Milligan Sloane, and autographs and biographical sketches of fifty-one deceased Academicians. Vol. 2, 1929, contains "The Academy and Its Recent Work" by Robert Underwood Johnson, biographical sketches, etc., of nineteen Academicians.

Three Papers on "Modernist Art." 1924. Reprints of articles by Kenyon Cox, Royal Cortissoz, and Edwin Howland Blashfield.

Academy Papers; Addresses on Language Problems by Members of the American Academy of Arts and Letters. Vol. 1, 1925, addresses delivered under the auspices of the Evangeline Wilbour Blashfield Foundation, 1917-1925, by Paul Elmer More, William

Milligan Sloane, William Crary Brownell; Brander Matthews, Bliss Perry, Paul Shorey, Henry Van Dyke, and Robert Underwood Johnson. Vol. 2, 1951, Blashfield Addresses, 1928-1949, by Wilbur L. Cross, George Pierce Baker, John H. Finley, Irving Babbitt, Chauncey Brewster Tinker, William Lyon Phelps, Agnes Repplier, Owen Wister, Hamlin Garland, Stephen Vincent Benét, Lewis Mumford, Van Wyck Brooks, Archibald MacLeish, Walter Lippmann, J. William Fulbright, Helen Keller, Thornton Wilder, and E. M. Forster.

Four Addresses in Commemoration of the Twentieth Anniversary of the Founding of the American Academy of Arts and Letters. 1926. Addresses by Paul Shorey, David Jayne Hill, Bliss Perry, and Stuart Sherman.

National Institute of Arts and Letters News Bulletin. 5 vols. 1935-1939. News on their activities submitted by members.

Adams, Adeline. *Childe Hassam.* 1938. Illustrated monograph, includes biography, listing of awards and honors, listing of museum collections holding Hassam's work.

ABOUT THE ACADEMY-INSTITUTE

Fenton, Charles A. "The Founding of the National Institute of Arts and Letters in 1898." *The New England Quarterly* 32, no. 4 (December 1959).

Hellman, Geoffrey T. "Profiles: Some Splendid and Admirable People." *The New Yorker* 52, no. 1 (February 23, 1976).

OTHER SOURCES CITED

"Albert Sterner, Noted Artist, 83." *The New York Times,* December 17, 1946.

Barrus, Clara. *The Life and Letters of John Burroughs.* 2 vols. Boston and New York, 1925.

Barzun, Jacques. *A Stroll with William James.* New York, 1983.

The Brooklyn Museum. *The American Renaissance, 1876-1917.* Brooklyn, N.Y., 1979.

Burt, Nathaniel. *Palaces for the People. A Social History of the American Art Museum.* Boston, 1977.

Clifford, Deborah Pickman. *Mine Eyes Have Seen the Glory: A Biography of Julia Ward Howe.* Boston, 1979.

Cortissoz, Royal. "A Loan Exhibition of Various Examples: Portraits by Oswald Birley and Pictures by Quinquela Martin." *New York Herald Tribune,* March 18, 1928.

———. *Art and Common Sense.* London, 1914.

Cox, Kenyon. *The Classic Point of View.* 1911. Reprint. Freeport, N.Y., 1968.

Cox, Kenyon, *et al. Art Museums and Schools. Four Lectures by G. Stanley Hall, Kenyon Cox, Stockton Axson, and Oliver S. Tonks.* New York, 1913.

Crowder, Richard. "The First Years of the American Academy of Arts and Letters and the National Institute of Arts and Letters." Unpublished manuscript dated September 29, 1978. Academy-Institute Archives.

Dictionary of American Biography. New York, 1928 and following.

Edel, Leon. *Henry James: The Master,* 1901-16. Philadelphia and New York, 1972.

Flint, Ralph. *Albert Sterner: His Life and His Art.* New York, 1927.

Higginson, Thomas Wentworth. *Letters and Journals of Thomas Wentworth Higginson, 1846-1906.* Edited by Mary Thacher Higginson. Boston and New York, 1912.

James, Henry. *The Painter's Eye: Notes and Essays on the Pictorial Arts.* Edited by John L. Sweeney. Cambridge, Mass., 1956.

Johnson, Robert Underwood. *Remembered Yesterdays.* Boston, 1923.

"Julia Ward Howe, Author of 'Battle Hymn,' Dead." *Detroit Journal,* October 17, 1910.

Lerman, Leo. *The Museum: 100 Years and the Metropolitan Museum of Art.* New York, 1969.

Lewis, Sinclair, and Erik Axel Karlfeldt. *Addresses by Erik Axel Karlfeldt, Secretary of the Swedish Academy and Sinclair Lewis, Winner of the Nobel Prize in Literature on the Occasion of the Award of the Nobel Prize, Stockholm, December, 1930.* Reprint. New York, n.d.

Maher, James T. *The Twilight of Splendor, Chronicles of the Age of American Palaces.* Boston, 1975.

"Paderewski Dead at 80; Ill of Pneumonia 2 Days." *New York Herald Tribune,* June 30, 1941.

"The Portrait of Ignace Jan Paderewski." *Overtones* (published by the Curtis Institute of Music) 10, no. 2 (April 1940).

Richards, Laura E., and Maud Howe Elliott. *Julia Ward Howe, 1819-1910.* 2 vols. Boston and New York, 1915.

"Royal Cortissoz Art Critic, 79, Dies." *The New York Times,* October 18, 1948.

Ruckstull, F. W. "The Collapse of Modernistic Sculpture." *The Skylight* 1, no. 1 (March 1933).

Santayana, George. *Winds of Doctrine.* New York, 1912.

Semple, Elizabeth Anna. "Art of Robert Aitken, Sculptor." *Overland Monthly* 61, no. 3 (March 1913).

"Sinclair Lewis Changes Mind, Enters Institute." *New York Herald Tribune,* January 18, 1935.

Stedman, Laura E., and George M. Gould. *The Life and Letters of Edmund Clarence Stedman.* 2 vols. New York, 1910.

Turner, Arlin. *George W. Cable: A Biography.* Durham, N.C., 1956.

Twain, Mark. *Mark Twain's Letters.* Arranged with comments by Albert Bigelow Paine. 2 vols. New York and London, 1917.

Twain, Mark, and William Dean Howells. *Mark Twain—Howells Letters: The Correspondence of Samuel L. Clemens and William Dean Howells, 1872-1910.* Edited by Henry Nash Smith and William M. Gibson with the assistance of Frederick Anderson. 2 vols. Cambridge, Mass., 1960.

Twain, Mark, and Charles Dudley Warner. *The Gilded Age: A Tale of To-Day.* Hartford, Conn., 1873.

Van Vechten, Carl. *Peter Wiffle: His Life and Works.* New York, 1922.

Wilkinson, Burke. *Uncommon Clay: The Life and Works of Augustus Saint Gaudens.* San Diego, New York, London, 1985.

Wright, Preston. "Fellow Student Saw Greatness of Talent of Cecilia Beaux, Who Soon Was Honored by Paris Salon." Norfolk, Virginia, *Pilot,* July 25, 1926.

Yonkers, Tescia Ann. "Rudolph Evans: An American Sculptor, 1878-1960." 2 vols. Ph.D. diss., The George Washington University, 1984.

PHOTOGRAPHY CREDITS

American Academy of Arts and Letters:
page 4

Geoffrey Clements, Staten Island, New York:
pages 22, 23, and 25

Peter A. Juley & Son, New York City:
page 26

Eugene Mantie:
pages 10, 13, 14, 15, 16, and 27

Eugene Mantie and Rolland White:
cover illustration and pages 37–104

Courtesy of the National Museum of American Art, Smithsonian Institution:
frontispiece

Designed by Gerard A. Valerio

Composed in Bembo by Harlowe Typography, Inc.,
in Cottage City, Maryland

Printed on Mohawk Superfine by Schneidereith & Sons
in Baltimore, Maryland

INDEX

The years of election to the Institute (I) and to the Academy (A) are given in parentheses
following the member's name.